New Price ___ 450

Used Price ___ 315

SOURCES AND DOCUMENTS IN THE
HISTORY OF ART SERIES

H. W. JANSON, *Editor*

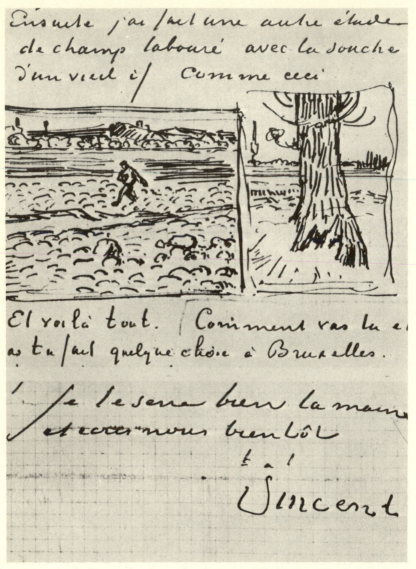

Vincent van Gogh, Manuscript Page of a Letter to His Brother Theo, *Arles [End of October, 1888]. (Photo: New York Graphic Society; from* The Complete Letters of Vincent van Gogh, *Volume III, Greenwich, Conn.: New York Graphic Society, 1959.)*

Impressionism and Post-Impressionism

1874–1904

SOURCES and DOCUMENTS

Linda Nochlin

Vassar College

PRENTICE-HALL, INC.

Englewood Cliffs, New Jersey

© 1966 by PRENTICE-HALL, INC., *Englewood Cliffs, New Jersey*
All rights reserved. No part of this book may be reproduced
in any form or by any means
without permission in writing from the publisher.

Library of Congress Catalog Card Number: 66-23610

Printed in the United States of America C-45200

Current Printing (Last Digit):

10 9 8 7 6 5 4 3 2 1

PRENTICE-HALL INTERNATIONAL, INC., *London*
PRENTICE-HALL OF AUSTRALIA, PTY. LTD., *Sydney*
PRENTICE-HALL OF CANADA, LTD., *Toronto*
PRENTICE-HALL OF INDIA (PRIVATE) LTD., *New Delhi*
PRENTICE-HALL OF JAPAN, INC., *Tokyo*

Preface

The period encompassed by this volume is remarkable for the range, diversity, controversiality, and sheer intensity of its artistic production. At no preceding time in the history of art had there been such a rapid succession of styles and movements, such vehement affirmations and denials of the validity of crucial aesthetic positions, such active and vocal participation in artistic discussion on the part of critics and men of letters. Time and again, the most basic questions—about the relation between art and nature, perception and reality, about the nature of reality itself—were raised by the Impressionists and the painters who followed them and reacted against them. In all cases, the advanced painters of the epoch struggled to free themselves from the bonds of traditional formulas and ready-made solutions to the problems of art and, at the same time, strove to attain authentic vision and to create valid pictorial metaphors for reality as they conceived of it. A sense of the pervasive *difficulty* of this enterprise runs through the writings of the Impressionists and Post-Impressionists alike, the personal struggle to realize the self through artistic work being exacerbated by the more public struggle to overcome massive hostility, to achieve a measure of critical recognition, or simply to gain a livelihood.

In order to convey a sense of the richness and variety of the documents of the period, I have, as in the volume, *Realism and Tradition in Art, 1848–1900,* attempted to strike a balance between familiar and less well-known sources; at the same time, I have included a representative selection of the views of those literary spokesmen who played such an important role in the formulation of programs and doctrines, often putting into words, whether accurately or not, the aspirations of the artists themselves.

Translations from foreign languages are by the editor of this volume, unless otherwise specified. An attempt has been made to preserve a sense of the locution and flavor of the original texts, in so far as this was possible. Once more I should like to acknowledge the help of Assistant Professor Olga Bernal of the French Department of Vassar College in preparing these translations. In addition, I wish to express my gratitude to: Associate Professor Evert Sprinchorn of the Drama Department of Vassar College for suggestions about the Strindberg-Gauguin correspondence; Miss Christine Smith for the preparation of the intro-

ductory material on Gustave Moreau; Mrs. Katherine Finkelpearl, Art Librarian, and Mrs. Barbara Caswell of the Vassar College Library staff; Misses Elizabeth Vinton and Sarah Plotz, research aides; Miss Mary Delahoyd, my diligent assistant through all stages of the preparation of this manuscript; and Mrs. Mary Ann Bruno, my typist. I should also like to acknowledge the kindness of those who permitted me to reprint material from other volumes; this debt will, of course, be acknowledged in citations throughout the text.

<div align="right">LINDA NOCHLIN</div>

Contents

I

Impressionism:
Critical Views

EDMOND DURANTY: 1833–1880

The New Painting: Concerning the Group of Artists Exhibiting at the Durand-Ruel Galleries (1876)

The critic and man of letters Duranty, who had edited the short-lived review, Le Réalisme, *in 1856–1857, turned to a defense of the "group of artists exhibiting at the Durand-Ruel Galleries" in 1876—the year of the second Impressionist Exhibition (although Duranty avoids the term Impressionist). The exhibition included works by Degas, Monet, Morisot, Pissarro, Renoir, Bazille, Sisley, and others.*

Duranty is actually, primarily, a spokesman for Degas, and the latter exhibited a pastel portrait of Duranty in the fifth Impressionist Exhibition of 1880. Yet, despite the fact that Degas' ideas probably influenced those of his friend, and that certain passages in The New Painting *certainly refer specifically to Degas, this does not mean, as has been suggested, that this pamphlet was written by the painter. The connecting link between the two is Duranty's conception of naturalism and his championing of the artist who is an observer of modern life, a mordant commentator on contemporary manners, movement, and gesture. Duranty is far less interested in current landscape painting: about the other Impressionists—Monet, Renoir, and Pissarro—he expressed certain reservations. A comparison of Duranty's ideas in this brochure and those expressed in Degas' notebooks (see below, pp. 60 to 63) reveals the extent of the artist's influence on his friend.*

Here they are then, these artists who exhibit in the Durand-Ruel Gallery, linked to those who preceded or accompany them.[1] They are no longer isolated. One must not consider them as thrown upon their own devices.

I have, therefore, less in view the present exhibition than the *cause* and the *idea*.

What do they produce? What does the movement produce? And, consequently, what do these artists produce, wrestling with tradition body-to-body, admiring it and wanting to destroy it at the same time, realizing that it is great and powerful, and for that very reason attacking it?

Why then should we be interested in them? Why do we then forgive them for too often producing (though not out of laziness) nothing but sketches and abbreviated summaries?

1 Duranty has just indicated that the origins of the new movement could be found in the innovations of such painters as Courbet, Millet, Corot, Jongkind, Boudin, Legros, Whistler, Fantin-Latour, and Manet, who, in fact, had not participated in this second Impressionist Exhibition.

It is really because it is a great surprise in a period like this one, when it seemed that there was no longer anything left to discover, when preceding periods had been analyzed so much, when we seem stifled beneath the mass and weight of the creations of past centuries, to see new ideas suddenly spring up, a special creation. A young branch has developed on the old tree trunk of art. Will it cover itself with leaves, flowers, and fruits? Will it extend its shade over future generations? I hope so.

What, then, have they produced?

A color scheme, a kind of drawing, and a series of original views.

Among their number, some limit themselves to transforming tradition and attempt to translate the modern world without turning too far from the old and magnificent formulas which served to express preceding worlds, while others sweepingly discard the techniques of the past.

As far as method of coloring is concerned, they have made a real discovery, whose origin cannot be found elsewhere—neither with the Dutch, nor in the pale tones of fresco painting, nor in the light tonalities of the eighteenth century. They are not merely concerned with that fine, flexible play of colors which results from the observation of the most delicate value in tones which contrast with or penetrate one another. Their discovery actually consists in having recognized that full light *de-colors* tones, that the sun reflected by objects tends (because of its brightness) to bring them back to that luminous unity which melts its seven prismatic rays into a single colorless radiance: light.

Proceeding from intuition to intuition, they have little by little succeeded in breaking down sunlight into its rays, its elements and to reconstitute its unity by means of the general harmony of spectrum colors which they spread on their canvases. From the point of view of sensitivity of the eye, of subtle penetration of the art of color, it is a completely extraordinary result. The most learned physicist could find nothing to criticize in their analyses of light. . . .

The romantic artist, in his studies of light, was only familiar with the orange colored strip of the sun setting beneath dark hills, or the white impasto, tinged with either chrome yellow or rose lake, which he threw over the bituminous opacities of his forest floors. No light without bitumen, without ivory black, without Prussian blue, without contrasts which, it is said, make the tone appear warmer, more heightened. He believed that light added color and animation to the tone and he was persuaded that it [light] only existed on condition that it was surrounded by shadows. The basement with a ray of light coming through a narrow air hole—such was the governing idea of the romantic artist. Even today, in every country, the landscape is treated like the depths of a fireplace or the interior of the back of a shop.

And yet everyone has gone through some thirty leagues of country-

side in the summer and has been able to see how hillocks, meadow, and field vanished, so to speak, in a single light-filled reflection which they receive from the sky and give back to it; for this is the law which engenders light in nature—aside from the particular blue, green, or composite ray which each substance absorbs; and over and above this ray, it [light] reflects both the ensemble of all the rays and the color of the vault which covers the earth. Now indeed, for the first time, painters have understood and reproduced, or tried to reproduce, these phenomena. In some of their canvases we can feel the light and the heat vibrate and palpitate. We feel an intoxication of light, which, for painters educated outside of and in opposition to nature, is a thing without merit, without importance, much too bright, too clear, too crude, and too explicit. . . .

And the aim of drawing, in these modern attempts, is precisely that of becoming so intimately acquainted with nature and of embracing it so strongly that it [drawing] will become unexceptionable in all its relationships of form and familiar with the inexhaustible diversity of character. Farewell to the human body treated like a vase with a decorative, swinging curve; farewell to the uniform monotony of the framework, the flayed figure jutting out beneath the nude; what we need is the particular note of the modern individual, in his clothing, in the midst of his social habits, at home or in the street. . . .

By means of a back, we want a temperament, an age, a social condition to be revealed; [2] through a pair of hands, we should be able to express a magistrate or a tradesman; by a gesture, a whole series of feelings. A physiognomy will tell us that this fellow is certainly an orderly, dry, meticulous man, whereas that one is carelessness and disorderliness itself. An attitude will tell us that this person is going to a business meeting, whereas that one is returning from a love tryst. *A man opens a door; he enters; that is enough: we see that he has lost his daughter.* Hands that are kept in pockets can be eloquent. The pencil will be steeped in the marrow of life. We will no longer see mere outlines measured with a compass, but animated, expressive forms, logically deduced from one another. . . .

The idea, the first idea, was to take away the partition separating the studio from everyday life. . . . It was necessary to make the painter leave his sky-lighted cell, his cloister where he was in contact with the sky alone, and to bring him out among men, into the world. . . .

For the observer, there is a whole logic of color-method and drawing which proceeds from a viewpoint, according to whether it was chosen at a certain hour, in a certain season, in a certain place. This viewpoint cannot

[2] This passage and the ones that follow refer specifically to Degas.

be expressed, this logic cannot be captured by using Venetian fabrics against Flemish backgrounds. . . .

If one imagines . . . that at a given moment one could take a colored photograph of an interior, one would have a perfect accord, a truthful and typical expression, everything participating in the same feeling. If one waited until a cloud came to veil the daylight and immediately took a new picture, one would obtain a result similar to the first. But if one now took a portion of the details of the first photograph and joined them to a portion of the details of the second to make a painting, then homogeneity, accord, truthfulness, the impression—all would disappear, replaced by a false, inexpressive note. This is, however, what is done every day by painters who do not deign to observe and instead use extracts from ready-made painting. . . .

Views of people and things have a thousand ways of being unexpected in reality. Our point of view is not always in the center of a room with two lateral walls receding toward that of the rear; it does not always gather together the lines and angles of cornices with a mathematical regularity and symmetry. Nor is it always free to suppress the great swellings of the ground and of the floor in the foreground; it [one's viewpoint] is sometimes very high, sometimes very low, missing the ceiling, getting at objects from their undersides, unexpectedly cutting off the furniture. . . .

From within, we communicate with the outside through a window; and the window is the frame that ceaselessly accompanies us. . . . The window frame, depending upon whether we are near or far, seated or standing, cuts off the external view in the most unexpected, most changeable way, obtaining for us that eternal variety and unexpectedness which is one of the great delights of reality.

If one now considers the person, whether in a room or in the street, he is not always to be found situated on a straight line at an equal distance from two parallel objects; he is more confined on one side than on the other by space. In short, he is never in the center of the canvas, in the center of the setting. He is not always seen as a whole: sometimes he appears cut off at mid-leg, half-length, or longitudinally.[3] At other times, the eye takes him in from close-up, at full height, and throws all the rest of a crowd in the street or groups gathered in a public place back into the small scale of the distance. A detailed description of all these viewpoints would go on infinitely, as would a description of all the settings: the railway, the linen-draper's shop, the scaffoldings of construction, the lines of gas lights, the boulevard benches with the newspaper stands, the omnibus

[3] As Marcel Guérin points out in his edition of Duranty's essay, this is of course an allusion to the characteristics of Degas' compositions.

and the carriage, the café with its billiard tables, the restaurant with its tablecloths and place settings.[4]

They [the Impressionists] have tried to render the walk, the movement, the tremor, the intermingling of passersby, just as they have tried to render the trembling of leaves, the shivering of water, and the vibration of air inundated with light, and just as, in the case of the rainbow colorings of the solar rays, they have been able to capture the soft ambiance of a grey day. . . .

However, when I see these exhibitions, these attempts, I become a bit melancholy in my turn and say to myself: these artists, who are almost all my friends, whom I have seen, with pleasure, take off on an unknown path, who answered in part the demands of those art programs we set forth in our youth—where are they going? Will they increase their endowment and keep it?

Will these artists be the primitives of a great movement of artistic renewal and will their successors, if they are relieved of the first difficulties of sowing and manage to reap abundantly, have the piety toward their precursors that the sixteenth-century Italians had for the *quattrocentists?* . . .

And now, I wish a good wind to the fleet, so that it may be carried to the Islands of the Blessed. I urge the pilots to be careful, resolute, and patient. The navigation is dangerous, and they should have set sail in larger and sturdier boats; several vessels are quite small and narrow, good only for coastline painting. Let us remember that, on the contrary, it is a question of ocean-bound painting! [5]

THÉODORE DURET: 1838–1927

The Impressionist Painters (1878)

Théodore Duret, politician and journalist, art critic and collector, became the chief defender of Manet and the Impressionists and was one of the circle at the Café Guerbois in the late sixties; he published Les Peintres français *in 1867 and had his portrait painted by Manet the year after. Duret frequently came to the aid of his friends in his Salon reviews during the seventies, favoring especially Manet, Pissarro, Fantin, and Degas, and purchasing their canvases. He recommended, however, that his*

[4] Degas, in his notebooks, had indicated a similar program as early as 1859; see below, pp. 62 to 63.

[5] Edmond Duranty, *La Nouvelle Peinture: A propos du groupe d'artistes qui expose dans les Galeries Durand-Ruel* (1876), ed. Marcel Guérin (Paris: Librairie Floury, 1946), pp. 38–47, 53, 55.

*friends participate in the official Salons, rather than resorting to separate
exhibitions. Traveling extensively, he became familiar with the art of the
Far East, and was especially enthusiastic about Japanese painting, whose
bold effects of coloring and composition he saw echoed in the art of his
French protégés.*

In The Impressionist Painters, *first published as a pamphlet in 1878,
from which an excerpt is printed below, Duret tries to convince the pub-
lic that all great artists are laughed at in the beginning, and singles out
Monet, Pissarro, Renoir, and Morisot as leaders of the group. The critic
gave the young artists concrete assistance in finding prospective patrons
by linking them to the great traditions of Western art itself. Duret later
published numerous studies of Realist and Impressionist painters, includ-
ing Courbet, Manet, Renoir, Whistler, and a general history of the Im-
pressionist painters as a group.*

☞ The Impressionists did not create themselves all alone; they did not
grow like mushrooms. They are a product of a regular evolution of the
modern French school. *Natura non fecit saltum* [6]—no more in painting
than in anything else. The Impressionists descend from the naturalistic
painters; their fathers are Corot, Courbet, and Manet. It is to these three
masters that the art of painting owes the simplest methods of construction
and that impulsive brushwork proceeding by means of large strokes and
masses, which alone defies time. It is to them that we owe light-colored
painting, finally freed from litharge, from bitumen,[7] from chocolate, from
tobacco juice, from burnt fat and bread crumbs. It is to them that we owe
the out-of-doors study, the sensation not merely of colors, but of the slight-
est nuances of colors, the tones, and still further, the search for the con-
nection between the condition of the atmosphere which illuminates the
painting and the general tonality of the objects which are painted in it.
To that which the Impressionists received from their predecessors was
added the influence of Japanese art.

If you stroll along the banks of the Seine, at Asnières for example,
you can take in with a single glance the red roof and the dazzlingly white
wall of a cottage, the tender green of a poplar, the yellow of the road, the
blue of the river. At noon, in the summer, every color will seem harsh to
you, intense, without possible loss of saturation or shrouding in a general
half-tone. Well, this may seem odd, but it is true nevertheless; we had to
wait until the arrival of Japanese albums before anyone dared to sit down
on the bank of a river to juxtapose on canvas a boldly red roof, a white

[6] "Nature makes no leaps." Duret is here trying to establish a connection be-
tween the Impressionists and the tradition of Western art in general and of recent
French painting in particular.

[7] Litharge is lead monoxide, straw yellow in color; bitumen is a dark brown
paint made by mixing asphalt with a drying oil and frequently used as underpainting
in traditional art.

wall, a green poplar, a yellow road, and blue water. Before Japan it was impossible; the painter always lied. Nature with its frank colors was in plain sight yet no one ever saw anything on canvas but attenuated colors, drowning in a general half-tone.

As soon as people looked at Japanese pictures, where the most glaring, piercing colors were placed side by side, they finally understood that there were new methods for reproducing certain effects of nature which had been neglected or considered impossible to render until then, and which it might be good to try. For these Japanese pictures, which so many people at first took for a mere gaudy mixture of colors, are strikingly faithful. Ask those who have visited Japan. I find myself continually rediscovering on a fan or in an album the precise sensation of the scenes and landscape I saw in Japan. I look at a Japanese album and say: yes, yes, that is exactly how Japan looked to me. . . . Japanese art conveys the specific appearances of nature by means of bold, new methods of coloring. It cannot fail to strike inquiring artists, and thus [it] strongly influenced the Impressionists.

After the Impressionists had taken from their immediate predecessors in the French school their forthright manner of painting out-of-doors from the first impression with vigorous brushwork, and had grasped the bold, new methods of Japanese coloring, they set off from these acquisitions to develop their own originality and to abandon themselves to their personal sensations.

The Impressionist sits on the banks of a river; depending on the condition of the sky, the angle of vision, the hour of the day, the calm or agitation of the atmosphere, the water takes on a complete range of tones; without hesitating, he paints on his canvas water which has all these tones. When the sky is overcast, the weather rainy, he paints glaucous, heavy, opaque water. When the sky is clear, the sun bright, he paints sparkling, silvery, brilliant blue water. When there is wind, he paints the reflections produced by the ripples; when the sun sets and darts its rays into the water, the Impressionist, in order to fasten down these effects, plasters his canvas with yellow and red. At this point, the public begins to laugh.

When winter comes, the Impressionist paints snow. He sees that the shadows on the snow are blue in the sunlight; unhesitatingly, he paints blue shadows. Now the public laughs outright. If certain clayey soils of the countryside have a lilac tinge, the Impressionist paints lilac landscapes. At this point, the public begins to get indignant.

Under the summer sun, with reflections of green foliage, skin and clothing take on a violet tint. The Impressionist paints people in violet woods. Then the public lets loose violently, the critics shake their fists, call the painter a "communist" and a rascal. The poor Impressionist vainly asserts his complete honesty, declares that he only reproduces what he

sees, that he remains faithful to nature; the public and the critics con
demn him. They don't bother to find out whether or not what they dis-
cover on the canvas corresponds to what the painter has actually observed
in nature. Only one thing matters to them: what the Impressionists put
on their canvases does not correspond to what is on the canvases of pre-
vious painters. If it is different, then it is bad.[8]

LOUIS LEROY: 1812–1885

A Satiric Review of the First Impressionist Exhibition

On April 15, 1874, the Société anonyme des artistes, peintres, sculp-
teurs, graveurs, *etc., opened its first exhibition at the studio of the photog-
rapher Nadar. One hundred and sixty-five works were shown, including
paintings by Cézanne, Degas, Monet, Berthe Morisot, Pissarro, Renoir,
Sisley, Boudin, and many others, now forgotten. The painters were quickly
dubbed "Impressionists" by hostile critics and public, after the title of
one of Monet's paintings:* Impression, Sunrise. *During the four weeks it
ran, about 3,500 people came to see the show, mainly for entertainment
or to express indignation. The critics were for the most part silent or else
hostile and cruelly sarcastic, although the group received a few favorable
reviews from friends such as Philippe Burty, Armand Silvestre, and Castag-
nary, the latter expressing certain reservations.*

Louis Leroy, critic for the satirical journal, Le Charivari, *bitingly
summed up the public attitude toward the exhibition in an article en-
titled "Exhibition of the Impressionists"—a title indicating the mocking
tone of the review itself, since this was the first time the painters were
given this appellation. The review also reveals what difficulty the general
public, accustomed to the relatively refined brushwork and careful finish
of the usual Salon painting, must have had in actually "reading" these
works—that is, in managing to obtain a coherent image from the bold,
rough brushstrokes and brilliant, broken color patches spotted all over
the surface, characteristic of the Impressionists' style.*

Oh, it was indeed a strenuous day . . . when I ventured into the
first exhibition on the boulevard des Capucines in the company of M.
Joseph Vincent, landscape painter, pupil of [the academic master] Bertin,
recipient of medals and decorations under several governments! The rash
man had come there without suspecting anything; he thought that he
would see the kind of painting one sees everywhere, good and bad, rather
bad than good, but not hostile to good artistic manners, devotion to form,

[8] Théodore Duret, *Les Peintres Impressionistes* (Paris: Librairie Parisienne, 1878),
pp. 12–16.

and respect for the masters. Oh, form! Oh, the masters! We don't want them any more, my poor fellow! We've changed all that.

Upon entering the first room, Joseph Vincent received an initial shock in front of the *Dancer* by M. Renoir.

"What a pity," he said to me, "that the painter, who has a certain understanding of color, doesn't draw better; his dancer's legs are as cottony as the gauze of her skirts."

"I find you hard on him," I replied. "On the contrary, the drawing is very tight."

Bertin's pupil, believing that I was being ironical, contented himself with shrugging his shoulders, not taking the trouble to answer. Then, very quietly, with my most naïve air, I led him before the *Ploughed Field* of M. Pissarro. At the sight of this astounding landscape, the good man thought that the lenses of his spectacles were dirty. He wiped them carefully and replaced them on his nose.

"By Michalon!" [9] he cried. "What on earth is that?"

"You see . . . a hoarfrost on deeply ploughed furrows."

"Those furrows? That frost? But they are palette-scrapings placed uniformly on a dirty canvas. It has neither head nor tail, top nor bottom, front nor back."

"Perhaps . . . but the impression is there."

"Well, it's a funny impression! Oh . . . and this?"

"*An Orchard* by M. Sisley. I'd like to point out the small tree on the right; it's gay, but the impression . . ."

"Leave me alone, now, with your impression . . . it's neither here nor there. But here we have a *View of Melun* by M. Rouart,[10] in which there's something to the water. The shadow in the foreground, for instance, is really peculiar."

"It's the vibration of tone which astonishes you."

"Call it sloppiness of tone and I'd understand you better—Oh, Corot, Corot, what crimes are committed in your name! It was you who brought into fashion this messy composition, these thin washes, these mud-splashes in front of which the art lover has been rebelling for thirty years and which he has accepted only because constrained and forced to it by your tranquil stubbornness. Once again, a drop of water has worn away the stone!"

The poor man rambled on this way quite peacefully, and nothing led me to anticipate the unfortunate accident which was to be the result of his visit to this hair-raising exhibition. He even sustained, without

[9] Achille Etna Michalon (1796–1822), a painter of classical landscapes who was Corot's first master.

[10] Henri Rouart (1833–1912), painter who exhibited with the Impressionists several times, but who is better known as an art collector, and especially as the close friend of Degas; the latter painted Rouart's portrait several times.

major injury, viewing the *Fishing Boats Leaving the Harbor* by M. Claude Monet, perhaps because I tore him away from dangerous contemplation of this work before the small, noxious figures in the foreground could produce their effect.

Unfortunately, I was imprudent enough to leave him too long in front of the *Boulevard des Capucines,* by the same painter.

"Ah-ha!" he sneered in Mephistophelian manner. "Is that brilliant enough, now! There's impression, or I don't know what it means. Only, be so good as to tell me what those innumerable black tongue-lickings in the lower part of the picture represent?"

"Why, those are people walking along," I replied.

"Then do I look like that when I'm walking along the boulevard des Capucines? Blood and thunder! So you're making fun of me at last?"

"I assure you, M. Vincent. . . ."

"But those spots were obtained by the same method as that used to imitate marble: a bit here, a bit there, slapdash, any old way. It's unheard of, appalling! I'll get a stroke from it, for sure."

I attempted to calm him by showing him the *St. Denis Canal* by M. Lépine and the *Butte Montmartre* by M. Ottin,[11] both quite delicate in tone; but fate was strongest of all: the *Cabbages* of M. Pissarro stopped him as he was passing by and from red he became scarlet.

"Those are cabbages," I told him in a gently persuasive voice.

"Oh, the poor wretches, aren't they caricatured! I swear not to eat any more as long as I live!"

"Yet it's not their fault if the painter . . ."

"Be quiet, or I'll do something terrible."

Suddenly he gave a loud cry upon catching sight of the *Maison du pendu* by M. Paul Cézanne. The stupendous impasto of this little jewel accomplished the work begun by the *Boulevard des Capucines; père* Vincent became delirious.

At first his madness was fairly mild. Taking the point of view of the impressionists, he let himself go along their lines: "Boudin has some talent," he remarked to me before a beach scene by that artist; "but why does he fiddle so with his marines?"

"Oh, you consider his painting too finished?"

"Unquestionably. Now take Mlle Morisot! That young lady is not interested in reproducing trifling details. When she has a hand to paint, she makes exactly as many brushstrokes lengthwise as there are fingers, and the business is done. Stupid people who are finicky about the drawing of a hand don't understand a thing about impressionism, and great Manet would chase them out of his republic."

[11] Stanislas Lépine (1835–1892), pupil of Corot and painter of delicate and sensitive landscapes. "Ottin" perhaps refers to Léon Auguste Ottin (dates unknown).

"Then M. Renoir is following the proper path; there is nothing superfluous in his *Harvesters*. I might almost say that his figures . . ."

". . . are even too finished."

"Oh, M. Vincent! But do look at those three strips of color, which are supposed to represent a man in the midst of the wheat!"

"There are two too many; one would be enough."

I glanced at Bertin's pupil; his countenance was turning a deep red. A catastrophe seemed to me imminent, and it was reserved to M. Monet to contribute the last straw.

"Ah, there he is, there he is!" he cried, in front of No. 98. "I recognize him, *papa* Vincent's favorite! What does that canvas depict? Look at the catalogue."

"*Impression, Sunrise.*"

"*Impression*—I was certain of it. I was just telling myself that, since I was impressed, there had to be some impression in it . . . and what freedom, what ease of workmanship! Wallpaper in its embryonic state is more finished than that seascape."

In vain I sought to revive his expiring reason . . . but the horrible fascinated him. *The Laundress,* so badly laundered, of M. Degas drove him to cries of admiration. Sisley himself appeared to him affected and precious. To indulge his insanity and out of fear of irritating him, I looked for what was tolerable among the impressionist pictures, and I acknowledged without too much difficulty that the bread, grapes, and chair of *Breakfast,* by M. Monet, were good bits of painting. But he rejected these concessions.

"No, no!" he cried. "Monet is weakening there. He is sacrificing to the false gods of Meissonier. Too finished, too finished! Talk to me of the *Modern Olympia!* That's something well done."

Alas, go and look at it! A woman folded in two from whom a Negro girl is removing the last veil in order to offer her in all her ugliness to the charmed gaze of a brown puppet. Do you remember the *Olympia* of M. Manet? Well, that was a masterpiece of drawing, accuracy, finish, compared with the one by M. Cézanne.

Finally, the pitcher ran over. The classic skull of *père* Vincent, assailed from too many sides, went completely to pieces. He paused before the municipal guard who watches over all these treasures and, taking him to be a portrait, began for my benefit a very emphatic criticism.

"Is he ugly enough?" he remarked, shrugging his shoulders. "From the front, he has two eyes . . . and a nose . . . and a mouth! Impressionists wouldn't have thus sacrificed to detail. With what the painter has expended in the way of useless things, Monet would have done twenty municipal guards!"

"Keep moving, will you!" said the "portrait."

"You hear him—he even talks! The poor fool who daubed at him must have spent a lot of time at it!"

And in order to give the appropriate seriousness to his theory of aesthetics, *père* Vincent began to dance the scalp dance in front of the bewildered guard, crying in a strangled voice: "Hi-ho! I am impression on the march, the avenging palette knife, the *Boulevard des Capucines* of Monet, the *Maison du pendu* and the *Modern Olympia* of Cézanne. Hi-ho! Hi-ho!" [12]

JULES LAFORGUE: 1860–1887

Impressionism

The brilliant, short-lived French poet Jules Laforgue, whose far-ranging interests included the realms of science, philosophy, and art as well as that of literature, began as a disciple of Taine, whose lectures he audited at the Ecole des Beaux-Arts in 1880–1881, but soon rejected Taine's stringent determinism and fixed standards of aesthetic value, turning instead to the German philosopher Eduard von Hartmann's theory of the Unconscious and Darwin's theory of evolution. At the same time, late in 1880, he became assistant to Charles Ephrussi, one of the editors of the Gazette des Beaux-Arts, *who had early taken up the cause of the Impressionists, writing encouraging articles on them in the* Gazette *and buying their works; through Ephrussi, Laforgue met most of the Impressionists, whose aims in painting were so close to his own in poetry; at the same time, at the age of twenty, Laforgue became an art critic for the* Gazette des Beaux-Arts. *He worked in Ephrussi's room, surrounded by Impressionist paintings. When he looked up from his desk, he could see "Two Pissarro fans, solidly constructed with little brushstrokes. . . . The Sisleys—the Seine with telegraph poles and a springtime sky, or a river bank on the outskirts of Paris, with a tramp taking his enjoyment out-of-doors . . . and blossoming apple trees climbing up a hill, by Monet . . . and Renoir's girl with wild hair . . ." Laforgue's double interest in art and in science, exhibited in the essay below, must have found an enthusiastic echo in his friendship with Charles Henry, that remarkably versatile student of science and art who was later to become head of the experimental psychology laboratory at the Sorbonne, who was the friend of Seurat and the Neo-Impressionist painters, who had written on music and on the life of Watteau, and who, like the young Laforgue, attempted a kind of syn-*

[12] Louis Leroy, "L'Exposition des impressionistes," *Charivari* (April 25, 1874), in John Rewald, *The History of Impressionism,* revised ed. (New York: The Museum of Modern Art, 1961), pp. 318–324. Reprinted by permission of the Museum of Modern Art, New York.

thesis of all fields of human sensibility, thought and action, science and art.

In the remarkable essay that follows—originally written for a small exhibition which included works by Pissarro, Degas, and Renoir, at the Gurlitt Gallery in Berlin in October, 1883, but obviously the fruit of a great deal of prior experience and thought—Laforgue combines his scientific knowledge, including evolutionary ideas, with the philosophical theories of the Unconscious developed by von Hartmann, and above all, his own remarkable powers of insight, sensibility, and expression, to write one of the earliest and most penetrating analyses of the Impressionist movement and its implications. "Object and subject," wrote Laforgue, "are . . . irretrievably in motion, inapprehensible and unapprehending. In the flashes of identity between subject and object lies the nature of genius." One can say that Laforgue's essay is the first coherent expression of the modern view of art, continuing in the path of Baudelaire, who had written as early as 1860, in The Painter of Modern Life: *"Modernity is the transitory, the fleeting, the contingent . . ."*

Physiological Origin of Impressionism: The Prejudice of Traditional Line. It is clear that if pictorial work springs from the brain, the soul, it does so only by means of the eye, the eye being basically similar to the ear in music; the Impressionist is therefore a modernist painter endowed with an uncommon sensibility of the eye. He is one who, forgetting the pictures amassed through centuries in museums, forgetting his optical art school training—line, perspective, color—by dint of living and seeing frankly and primitively in the bright open air, that is, outside his poorly lighted studio, whether the city street, the country, or the interiors of houses, has succeeded in remaking for himself a natural eye, and in seeing naturally and painting as simply as he sees. Let me explain.

Leaving aside the two artistic illusions, the two criteria on which *aestheticians* have foolishly insisted—*Absolute Beauty* and *Absolute Human Taste*—one can point to three supreme illusions by which technicians of painting have always lived: *line, perspective, studio lighting.* To these three things, which have become second nature to the painter, correspond the three steps of the Impressionist formula: form obtained not by line but solely by vibration and contrast of color; theoretic perspective replaced by the natural perspective of color vibration and contrast; studio lighting—that is, a painting, whether representing a city street, the country, or a lighted drawing room, painted in the even light of the painter's studio, and worked on at any hour—this replaced by *plein-air,* open air —that is, by the painting done in front of its subject, however impractical, and in the shortest possible time, considering how quickly the light changes. Let us look in detail at these three points, these three dead language procedures, and see them replaced by Life itself.

Line is an old deep-rooted prejudice whose origin must be sought in the first experiments of human sensation. The primitive eye, knowing only white light with its indecomposable shadows, and so unaided by distinguishing coloration, availed itself of tactile experiment. Then, through continual association and interdependence, and the transference of acquired characteristics between the tactile and visual faculties, the sense of form moved from the fingers to the eye. Fixed form does not originate with the eye: the eye, in its progressive refinement, has drawn from it the useful sense of sharp contours, which is the basis of the childish illusion of the translation of living non-dimensional reality by line and perspective.

Essentially the eye should know only luminous vibration, just as the acoustic nerve knows only sonorous vibration. The eye, after having begun by appropriating, refining, and systematizing the tactile faculties, has lived, developed, and maintained itself in this state of illusion by centuries of line drawings; and hence its evolution as the organ of luminous vibration has been extremely retarded in relation to that of the ear, and in respect to color, it is still a rudimentary intelligence. And so while the ear in general easily analyzes harmonics like an auditory prism, the eye sees light only roughly and synthetically and has only vague powers of decomposing it in the presence of nature, despite the three fibrils described by Young, which constitute the facets of the prisms.[13] Then a natural eye—or a refined eye, for this organ, before moving ahead, must first become primitive again by ridding itself of tactile illusions—a natural eye forgets tactile illusions and their convenient dead language of line, and acts only in its faculty of prismatic sensibility. It reaches a point where it can see reality in the living atmosphere of forms, decomposed, refracted, reflected by beings and things, in incessant variation. Such is this first characteristic of the Impressionist eye.

The Academic Eye and the Impressionist Eye: Polyphony of Color. In a landscape flooded with light, in which beings are outlined as if in colored grisaille, where the academic painter sees nothing but a broad expanse of whiteness, the Impressionist sees light as bathing everything not with a dead whiteness but rather with a thousand vibrant struggling colors of rich prismatic decomposition. Where the one sees only the external outline of objects, the other sees the real living lines built not in geometric forms but in a thousand irregular strokes, which, at a distance, establish life. Where one sees things placed in their regular respective planes according to a skeleton reducible to pure theoretic design, the other sees perspective established by a thousand trivial touches of tone and brush, by the varieties of atmospheric states induced by moving planes.

[13] According to the Young-Helmholtz theory of color vision, there are three elementary retinal and post-retinal processes, which produce sensations of red, yellow-green (chlor), and blue; all other colors, including white, are blendings of these.

The Impressionist eye is, in short, the most advanced eye in human evolution, the one which until now has grasped and rendered the most complicated combinations of nuances known.

The Impressionist sees and renders nature as it is—that is, wholly in the vibration of color. No line, light, relief, perspective, or chiaroscuro, none of those childish classifications: all these are in reality converted into the vibration of color and must be obtained on canvas solely by the vibration of color.

In the little exhibition at the Gurlitt Gallery, the formula is visible especially in the work of Monet and Pissarro . . . where everything is obtained by a thousand little dancing strokes in every direction like straws of color—all in vital competition for the whole impression. No longer an isolated melody, the whole thing is a symphony which is living and changing like the "forest voices" of Wagner, all struggling to become the great voice of the forest—like the Unconscious, the law of the world, which is the great melodic voice resulting from the symphony of the consciousness of races and individuals. Such is the principle of the *plein-air* Impressionist school. And the eye of the master will be the one capable of distinguishing and recording the most sensitive gradations and decompositions on a simple flat canvas. This principle has been applied not systematically but with genius by certain of our poets and novelists.

False Training of the Eyes. Now everyone knows that we do not see the colors of the palette in themselves but rather according to the illusions which the paintings of the past have developed in us, and above all we see them in the light which the palette itself gives off. (Compare the intensity of Turner's most dazzling sun with the flame of the weakest candle.) What one might call an innate harmonic agreement operates automatically between the visual effect of the landscape and the paint on the palette. This is the proportional language of painting, which grows richer in proportion to the development of the painter's optical sensibility. The same goes for size and perspective. In this sense, one might even go so far as to say that the painter's palette is to real light and to the tricks of color it plays on reflecting and refracting realities what perspective on a flat canvas is to the real planes of spatial reality. On these two things, the painter builds.

Mobility of Landscape and Mobility of the Painter's Impressions. You critics who codify the beautiful and guide the development of art, I would have you look at this painter who sets down his easel before a rather evenly lighted landscape—an afternoon scene, for example. Let us suppose that instead of painting his landscape in several sittings, he has the good sense to record its tonal values in *fifteen minutes*—that is, let us suppose that he is an Impressionist. He arrives on the scene with his own individual optic sensibility. Depending on the state of fatigue or preparation the painter has just been through, his sensibility is at the same time either bedazzled or receptive; and it is not the sensibility of a single

organ, but rather the three competitive sensibilities of Young's fibrils. In the course of these fifteen minutes, the lighting of the landscape—the vibrant sky, the fields, the trees, everything within the insubstantial network of the rich atmosphere with the constantly undulating life of its invisible reflecting or refracting corpuscles—has undergone infinite changes, has, in a word, lived.

In the course of these fifteen minutes, the optical sensibility of the painter has changed time and time again, has been upset in its appreciation of the constancy and relative values of the landscape tones. Imponderable fusions of tone, opposing perceptions, imperceptible distractions, subordinations and dominations, variations in the force of reaction of the three optical fibrils one upon the other and on the external world, infinite and infinitesimal struggles.

One of a myriad examples: I see a certain shade of violet; I lower my eyes toward my palette to mix it and my eye is involuntarily drawn by the white of my shirt sleeve; my eye has changed, my violet suffers.

So, in short, even if one remains only fifteen minutes before a landscape, one's work will never be the real equivalent of the fugitive reality, but rather the record of the response of a certain unique sensibility to a moment which can never be reproduced exactly for the individual, under the excitement of a landscape at a certain moment of its luminous life which can never be duplicated.

There are roughly three states of mind in the presence of a landscape: first, the growing keenness of the optical sensibility under the excitement of this new scene; second, the peak of keenness; third, a period of gradual nervous exhaustion.

To these should be added the constantly changing atmosphere of the best galleries where the canvas will be shown, the minute daily life of the landscape tones absorbed in perpetual struggle. And, moreover, with the spectators the same variation of sensibility, and with each an infinite number of unique moments of sensibility.

Subject and object are then irretrievably in motion, inapprehensible and unapprehending. In the flashes of identity between subject and object lies the nature of genius. And any attempt to codify such flashes is but an academic pastime.

Double Illusion of Absolute Beauty and Absolute Man! Innumerable Human Keyboards. Aestheticians have always talked a great deal of nonsense about one or the other of two illusions: the objectivity of Absolute Beauty, and the subjectivity of Absolute Man—that is, Taste.

Today we have a more exact feeling for the life within us and outside us.

Each man is, according to his moment in time, his racial milieu and social situation, his moment of individual evolution, a kind of keyboard on which the exterior world plays in a certain way. My own keyboard is

perpetually changing, and there is no other like it. All keyboards are legitimate.

The exterior world likewise is a perpetually changing symphony (as is illustrated by Fechner's law,[14] which says that the perception in differences declines in inverse proportion to their intensities).

The optical arts spring from the eye and solely from the eye.

There do not exist anywhere in the world two eyes identical as organs or faculties.

All our organs are engaged in a vital struggle: with the painter, it is the eye that is dominant; with the musician, the ear; with the philosopher, the powers of the mind, etc.

The eye most deserving of our admiration is the one which has evolved to the greatest extent; and consequently the most admirable painting will be not that which displays the academic fancies of "Hellenic beauty," "Venetian color," "Cornelius' thought," etc., but rather that which reveals this eye in the refinement of its nuances or the complication of its lines.

The atmosphere most favorable to the freedom of this evolution lies in the suppression of schools, juries, medals, and other such childish paraphernalia, the patronage of the state, the parasitism of blind art critics; and in the encouragement of a nihilistic dilettantism and open-minded anarchy like that which reigns amid French artists today: *Laissez faire, laissez passer.* Law, beyond human concerns, must follow its automatic pattern, and the wind of the Unconscious must be free to blow where it will.

Definition of Plein-Air Painting. Open air, the formula applicable first and foremost to the landscape painters of the Barbizon School (the name is taken from the village near the forest of Fontainebleau) does not mean exactly what it says. This open air concept governs the entire work of Impressionist painters, and means the painting of beings and things in their appropriate atmosphere: out-of-door scenes, simple interiors, or ornate drawing rooms seen by candlelight, streets, gas-lit corridors, factories, market places, hospitals, etc.

Explanation of Apparent Impressionist Exaggerations. The ordinary eye of the public and of the non-artistic critic, trained to see reality in the harmonies fixed and established for it by its host of mediocre painters—this eye, as eye, cannot stand up to the keen eye of the artist. The latter, being more sensitive to luminous variation, naturally records on canvas the relationship between rare, unexpected, and unknown

14 Gustav Theodor Fechner (1801–1887), experimental physiologist and formulator of the famous law known as Weber's or Fechner's law: "In order that the intensity of a sensation may increase in arithmetical progression, the stimulus must increase in geometric progression." Fechner's idea that sensation could be measured exactly was of great importance to the future of laboratory psychology.

subtleties of luminous variation. The blind, of course, will cry out against willful eccentricity. But even if one were to make allowance for an eye bewildered and exasperated by the haste of these impressionistic notes taken in the heat of sensory intoxication, the language of the palette with respect to reality would still be a conventional tongue susceptible to new seasoning. And is not this new seasoning more artistic, more alive, and hence more fecund for the future than the same old sad academic recipes?

Program for Future Painters. Some of the liveliest, most daring painters one has ever known, and also the most sincere, living as they do in the midst of mockery and indifference—that is, almost in poverty, with attention only from a small section of the press—are today demanding that the State have nothing to do with art, that the School of Rome (the Villa Medici) be sold, that the Institute be closed, that there be no more medals or rewards, and that artists be allowed to live in that anarchy which is life, which means everyone left to his own resources, and not hampered or destroyed by academic training which feeds on the past. No more official beauty; the public, unaided, will learn to see for itself and will be attracted naturally to those painters whom they find modern and vital. No more official salons and medals than there are for writers. Like writers working in solitude and seeking to have their productions displayed in their publishers' windows, painters will work in their own way and seek to have their paintings hung in galleries. Galleries will be their salons.

Framing. In their exhibitions the Independents have substituted intelligent, refined, imaginative frames for the old gilt frames which are the stock in trade of academic convention. A green sunlit landscape, a white winter page, an interior with dazzling lights and colorful clothes require different sorts of frames which the respective painters alone can provide, just as a woman knows best what material she should wear, what shade of powder is most suited to her complexion, and what color of wallpaper she should choose for her boudoir. Some of the new frames are in solid colors: natural wood, white, pink, green, jonquil yellow; and others are lavish combinations of colors and styles. While this new style of frame has had repercussions in official salons, there it has produced nothing but ornate bourgeois imitations.[15]

[15] Jules Laforgue, "Impressionism," published under the title "Impressionism: The Eye and the Poet," trans. William Jay Smith, *Art News*, LV (May, 1956), 43–45. Reprinted by permission of *Art News*. Laforgue had planned to have this essay translated and published in a German paper. It was later published as "L'Impressionisme," in *Mélanges posthumes*, in Jules Laforgue, *Oeuvres complètes*, 4th ed. (Paris: Mercure de France, 1902–1903), III, 133–145.

DIEGO MARTELLI: 1833–1896

A Lecture on the Impressionists

Diego Martelli, a Florentine and an early friend of the painter Telemaco Signorini, entered the circle of Italian avant-garde painters, known as the Macchiaioli, when a very young man, at which time he probably met another lifelong friend, Edgar Degas, whom he must have encountered again in Paris in 1860, 1868, 1878, and 1879. During his first stay in the French capital he probably became acquainted with Corot, Millet, Daumier, Courbet, and Manet. In 1878, during his longest stay in Paris, he renewed contact with Degas and Pissarro and persuaded the latter to exhibit two paintings at the exhibition of the Promotrice Fiorentina of 1878. Degas executed two portraits of Martelli seated in his room, viewed from above, at a paper-strewn table. Martelli's art criticism was mainly connected with the defense of the Macchiaioli in the Gazzettino delle arti del disegno, which he founded conjointly with Signorini in 1867, and in the Giornale artistico which he helped found in 1873.

Martelli's was the first tribute paid the French Impressionists by a foreign critic; below are excerpts from his famous lecture held at the Circolo Filologico di Livorno [Philological Club of Leghorn] in 1879, published in Pisa as a pamphlet in 1880 with a dedication to his French friends. This account of the activities of the Impressionists is noteworthy not merely because even in Paris itself the latter were still considered dangerous madmen, but because of its particularly sensitive appreciation of Martelli's friend Degas. Some of the descriptions, particularly the one of Manet, seem to depend heavily on Zola.

LADIES AND GENTLEMEN:

When at another time in this room I had the honor to read something about art and about the artists, I indicated to you how the instinct for art and for ornament in man perhaps precedes the feeling for scientific reflection; how in the maturity of the history of a people, artistic expression might be clearly defined and appear complete to us; and how, when a period of civilization is exhausted, the old forms lose their vitality and are replaced by others that contain in themselves (note the Byzantines) all the agony of the present, all the potentialities of the future; and, in concluding, I recounted to you the vicissitudes of the artistic life of the Englishman, Turner, and the struggles and suffering of our so-called "Macchiaioli" and exhorted you to be benevolent and attentive toward those who study and suffer, because in the work of these poor men there is contained a great lesson and the seeds of a great future.

When I spoke to you thus in 1877, I did not know that the following year I would be swept by the vicissitudes of fortune to the Universal Exposition in Paris, nor did I know that, given time, I would find myself in that great center of human thought, once more living the life of an artist, and coming close to a society of painters who were in the midst of privation and struggle, pushed on out of necessity by the new forms that dominate modern thought; despised by the crowd, offended and trampled on by the authorities, they nevertheless follow their own way, animated by the spirit of the apostles that enjoins them to find the new truth through paths unknown to the satisfied masses.

I come before you today to describe the phases and relate the history of this movement, believing that your time will not be spent in vain; not because of my own poor self and my humble words, but because of the importance of the events that I shall unfold before your eyes.

The bad customs of modern society, always oscillating between quick gains and sudden losses, pushes the masses toward luxury and pleasure, reviving the adage of the Romans of the decadence, *Edamus et bibamus, post mortem nulla voluptas.*[16] Thus the super-strength of gold has given real social importance to the "Nana's"[17] that rule over caprice and vie in luxury and exaggeration with the richest and most aristocratic ladies of the manor today.

For this reason also, art has taken on a particular manner that the French call "chic" and that characterizes art of the "mode." This art, which came especially from Paris rather than elsewhere, requires brilliance of handiwork rather than brilliance of the brain . . .

It always happens, however, that—when the traditions of the past burn themselves out, just like a torch for lack of fuel, and when the flood of adventurers and adventuresses, revelling, invade the proscenium—a few men of genius and of good will, recognizing the futility of going against the current of the times [and] scornful of a present that has meaning only in the label of hairdressers, concentrate once more upon themselves, and with prophetic minds strain toward the future and deepen themselves in the search for truth. Some of those who are most conscious of their position arm themselves with the whip of satire and caricature and they lash it around without pity; others, unconscious of themselves, work with the security and tranquility of masters, aware of their greatness, ignorant, however, of their social importance.

The first of these two types died a poor man in a country village on the outskirts of Paris at the age of eighty: Honoré Daumier, son of a glass-worker from Marseilles. . . .

16 "Let us eat and drink, for after death there is no more pleasure."
17 An ambitious, greedy female.

Daumier is very strong with the chiaroscuro, which he forces a bit too much, misusing the asphalts and the bitumens in the manner of Decamps,[18] and he is almost unbeatable in the analysis of forms and the character of movements. I like to recall, among many others, a little picture representing an acrobat Hercules, stupidly leaning against one of the wings backstage in a theater, on the stage of which one sees two of his companions who are fighting like dogs . . .

A giant of the second type was Gustave Courbet, whom, since his death, all France honors, although he was wrong to have demolished the Vendôme column and to belong to the Commune.[19] Just as in the compositions of Daumier one discovers the thinker and the satirist beneath the brush and pencil of the artist, so beneath the brush of Courbet one finds only the finely organized eye that sees well and the hand that successfully reproduces that which the eye has seen. . . .

The following words summarize the entire biography of the famous artist: knowledge without consciousness, the gift of seeing an effect in its truth and of knowing how to find upon the palette the colors for seeing it. A man created with so much power of spontaneous assimilation must necessarily be a very important coefficient in the revolution of ideas. With the indifference and serenity of a pachyderm, he literally had to crush all the Liliputian painters of cabinet pictures and all the mummies of the Academy, and show by his actions that art is something that lives by and for itself. As devoid of thought as he was full of natural energy, he beat his own indomitable way onward, confident of himself and an enemy of every artificiality; perfectly in equilibrium, he was and felt himself to be a great artist. When he wanted to discuss ideas, everyone recognized in him an ignorant man; when he worked, [they saw] a painter of the first order.

I remember in 1863, when I had gone to Paris, I saw two pictures by Courbet at the Salon: one, very large, a snow scene, represented *The Stag Hunt;* the other, not small, *Midday Siesta in a Field in Normandy,* and I must confess I was very disconcerted by the absolute lack of unusualness revealed by these canvases. The two paintings were done with great sincerity and breadth, but did not confirm the reputation of eccentricity of which their author had taken advantage.

In that same exhibition I saw for the first time the works of Edward Manet, which seemed ugly to me and whose originality seemed to me absolutely pretended. . . .

18 Alexandre-Gabriel Decamps (1803–1860), a well-known romantic painter of oriental subjects.

19 Courbet was accused of having directed the tearing down of the Vendôme column under the Commune in 1871. After the fall of the radical government he was condemned to pay an enormous fine; being unable to do so, he had to flee across the border into Switzerland, where he died in exile six years later.

I told you shortly before that I did not like Manet and now I must add that I like Manet very much, and moreover, I like those same works that at first made such a bad impression upon me. In 1878, as soon as I arrived in France, I had the luck, through my friends, Desbutin [sic] and Zandomeneghi,[20] to meet this artist, who by this time was famous and who, together with many of his kind, frequented the café Nouvelle Athènes on the Place Pigalle, a café which, considering the change of time and the different city, reminded me of the very gay confusion of the old café Michelangiolo in Florence, which also played such a big part in the rebirth of art in our country.

Edward Manet is a handsome man of forty-seven, tall and with blond beard and hair, in the midst of which streaks of silvery white are beginning to appear. His eyes are very lively and acute, his mouth expresses the irony of a good boy, a characteristic of Parisians, and his manners are the exquisitely courteous ones of a well brought up person. . . .

Degas, working more for his own edification than out of desire to offer canvases to the admiration of the public, was struck by the effort and by the specialized kind of movement that the ironers make when they work and by the interesting play of light produced in their shops by the great quantity of whites that one finds hung up all about. Those white collarless blouses, a big hole for the neck, reflected by the surrounding whites, the design and the color of the arms, stirred by the particular action of the woman who holds the iron, became, after the first look, the starting point for a series of very penetrating and beautiful studies that constitute a large part of his work.

Just as the ironers were his subjects by day, so the ballerinas of the *Foyer de l'Opéra* were by night, and we find in the portfolios of this master a series of most admirable studies that have been, and are, used for his graceful compositions.

We must not forget that the great Leonardo da Vinci, roaming through the countryside, continually studied human deformities and drew very witty caricatures; the relationship between the study of the beautiful and that of the ugly is intimate, and Degas, through his own genius, had to wed and harmonize these two sentiments in an originality all his own, by means of which the feeling for truth of the primitives is invested with the light and phosphorescent scintillations of our times.

Up to now I have spoken to you about artists who represent modernity in an outstanding way, but I have not spoken to you of true and

20 Marcellin-Gilbert Desboutin (1823–1902), French painter and writer who worked a great deal in Italy. He excelled at dry point, especially in portraits of his contemporaries executed in this medium. Federigo Zandomeneghi (1841–1917), Italian friend of Degas, born in Venice, who participated in the Impressionist exhibitions of 1879, 1880, 1881, and 1886, and was also extremely capable as a photographer.

actual *Impressionists,* who more at the present moment represent in their works the dawn of the future, and it is absolutely necessary for me to throw you into a field that is a little abstract and metaphysical, in which I hope you will have the patience to follow me with your kind attention.

Impressionism is not only a revolution in the field of thought, but is also a physiological revolution of the human eyes. It is a new theory that depends on a different way of perceiving the sensations of light and of expressing the impressions. Nor do the *Impressionists* fabricate their theories first and then adapt the paintings to them, but on the contrary, as always happens with discoveries, the pictures were born of the unconscious visual phenomenon of men of art who, having studied, afterward produced the reasoning of the philosophers.[21]

[21] Diego Martelli, "Gli Impressionisti" first published as a pamphlet, Pisa, 1880, reprinted in *Scritti d'arte di Diego Martelli* (Florence: Sansoni, 1952), pp. 98–101, 103, 105–106. Reprinted by permission of the publisher.

2

Impressionism:
Major Masters

CLAUDE MONET: 1840–1926

Monet Viewed by Théodore Duret

Claude Monet was indeed, as Duret pointed out as early as 1878, the "Impressionist par excellence." Throughout his long and extraordinarily productive career, the original impulse of Impressionism, although it might evolve, vary, and change—often with extraordinary rapidity—never ceased to guide his work. With increasing urgency, until the very end of his life, when it almost became a mystical quest for an evanescent absolute, Monet pursued the fleeting, momentary impression—the visual equivalent of Bergson's instantané—and attempted to capture it with the greatest possible degree of spontaneous fidelity.

Raised in Le Havre, the son of middle-class parents, the young Monet became known throughout the city for his extraordinary caricatures; he soon became acquainted with Boudin, who introduced him to plein-air painting. Monet went to Paris in 1859 and there became interested in the works of the Barbizon School. Military service in Algeria was stimulating from a visual point of view, but after two years his father bought him out of the army and in 1862 he entered the studio of the painter Gleyre, where he met Bazille, Renoir, and Sisley. He first exhibited in the 1865 Salon, where he received favorable reviews, despite the confusion of his name with that of the scandalous Manet, who was showing the notorious Olympia in the same Salon. By the middle sixties he formed a part of the circle at the Café Guerbois, and from this time on he experienced frequent official rejection and greater and greater financial difficulty. Yet he continued, seemingly undaunted, in his chosen direction, and was one of the first to suggest that a group exhibition be given—a suggestion ultimately resulting in the founding of the "Anonymous Society of painters, sculptors, graphic artists, etc.," of which he was a charter member, in 1873, and in the first Impressionist Exhibition in 1874.

Most of the characteristics of Monet's style pointed out by Duret in 1878 in the section of The Impressionist Painters *devoted to him, seem not merely a summary of his work until that point, but a prediction of Monet's future direction as well.*

If the word "Impressionist" was found good and definitively accepted to designate a group of painters, it is certainly the particular qualities of Claude Monet's painting which first suggested it. Monet is the Impressionist par excellence.

Claude Monet has succeeded in setting down the fleeting impressions which his predecessors had neglected or considered impossible to render with the brush. The thousand nuances that the water of the sea

and rivers takes on, the play of light in the clouds, the vibrant coloring of flowers, and the checkered reflections of foliage in the rays of a burning sun have been seized by him in all their truth. No longer painting merely the immobile and permanent aspect of the landscape, but also the fleeting appearances which the accidents of the atmosphere present to him, Monet transmits a singularly lively and striking sensation of the observed scene. His canvases really do communicate impressions. One might say that his snow scenes make you cold and that his brightly lighted canvases give off warmth and sunshine.

Claude Monet had first attracted attention with figure painting. His *Green Woman*,[1] now in the collection of M. Arsène Houssaye,[2] had made a sensation at the 1865 Salon, and at that time, something like the career pursued by M. Carolus-Duran was prognosticated for the artist.[3] Monet has since forsaken the figure, which no longer plays anything but a secondary role in his work. He has devoted himself almost exclusively to the study of the out-of-doors and to the painting of landscape.

Monet is not at all attracted by rustic scenes; you scarcely ever see uncultivated fields in his canvases: you won't find any cattle or sheep there, still less any peasants. The artist feels drawn toward embellished nature and urban scenes. He prefers to paint flowery gardens, parks, and groves.

Water, however, plays the main role in his work. Monet is above all the painter of water. In previous landscape painting, water appeared in a fixed and regular way with its "color of water," like a simple mirror for reflecting objects. In the work of Monet, it no longer has its own, unvarying color but assumes an infinite variety of appearances, which are due to the state of the atmosphere, the nature of the bed it flows through, or the clay it carries along with it. It is clear, opaque, calm, agitated, running, or still, depending upon the momentary appearance that the artist finds in the sheet of water before which he sets up his easel.[4]

Letters to Bazille

It is hard to realize the extent of the hardships and discouragement suffered by the advanced painters of the 19th century; the ultimate success of an artist like Monet tends to make one forget that the early days were dark with external privation and internal doubt. And yet at the same time, flowing beneath the gloomy tone of many of these letters, of

[1] *The Woman in the Green Dress* (*Camille*), c. 1866, now in the Kunsthalle, Bremen. It was exhibited at the 1866 Salon, not the one of 1865, as Duret asserts.

[2] Arsène Houssaye (1815–1896), versatile literary figure, author of plays, novels, and art criticism, for many years director of the journal *L'Artiste*.

[3] Carolus-Duran, professional name of Charles Auguste Emile Durand (1837–1917), fashionable portrait and genre painter.

[4] Théodore Duret, *Les Peintres Impressionistes* (Paris: Librairie Parisienne, 1878), pp. 17–19.

Monet, written in the sixties to his friend and fellow artist Bazille, is that stream of energy, confidence, courage, and youthful involvement in life and work which, in retrospect, seems clearly manifested in Monet's early paintings.

Letter of July 15, 1864, from Honfleur [5]

I wonder what you can be doing in Paris in such beautiful weather. It is lovely here, dear chap, and each day I discover still more beautiful things; it's enough to drive me mad, I want to do everything so much: my head is bursting with it! It's decidedly frightfully difficult to do a thing completely in every respect; I think there are only people who are satisfied with almost doing it. Very well, dear fellow, I want to struggle, to scrape out, to begin again; one can do what one wants and what one understands, for it seems to me, when I see nature, that I see it ready-made, completely written—but then, try to do it! All this proves that one must think of nothing but this; it is by dint of observation and reflection that one makes discoveries. So let's dig away and dig away without cease. Are you making headway? Yes, I am sure of it! But I am sure that you don't work hard enough and not in the right way. It's not with gay blades like your Villa [6] and others that you can work. It would be better to be alone, and yet, all alone, there are things you can't figure out; well, it's all terrible and it's a tough business. Have you done your life size figure? I am thinking up terrific things for myself when I go to Sainte-Adresse and Paris in the winter. Are you going to the country sometime? And above all, come and see me, I am waiting for you, and if it's not immediately, at least the first of August. While waiting, I extend a hearty handclasp,

Your good friend.

CLAUDE MONET.

Letter of June 29, 1868

I am writing you a few hasty words to ask your help very quickly. I was certainly born beneath an unlucky star. I was just thrown out of the inn, naked as the day I was born. I found a place to shelter Camille and my poor little Jean [7] in the country for a few days. I am leaving for Le

[5] While Gaston Poulain, in the source from which this letter was taken (*Bazille et ses amis* [Paris: La Renaissance du Livre, 1932], p. 38), dates this letter July 15, 1863, John Rewald (*The History of Impressionism*, rev. ed. [New York: The Museum of Modern Art, 1961], n. 29, p. 136) assigns it to 1864, and asserts that the letter itself as published in Poulain's book differs in several respects from the same document as printed by Poulain in an earlier article.

[6] Louis Emile Villa (1836– ?), a fellow pupil in Gleyre's studio who, like Bazille, had been born in Montpellier and who later became a painter of genre subjects and animals.

[7] Camille was Monet's mistress, later his wife, and Jean was their little son.

Havre tonight to try to get something out of my art lover. My family no longer wants to do anything for us. I still don't know where I am going to sleep tomorrow. Your very disturbed friend.

CLAUDE MONET.

P.S. I was so upset yesterday that I made the blunder of throwing myself into the water. Fortunately, there were no bad results.

Letter of Early Winter, 1868, from Fécamp

I am surrounded here by everything I love. I spend my time out-of-doors on the beach when the weather is bad or when boats go out fishing; or else I go into the countryside, which is so beautiful here that I find it perhaps more pleasant in winter than in summer; and of course I have been working all this time and I think that this year I will do some important things. And then in the evening, dear friend, I find a good fire and a nice little family in my little cottage. If you could only see how sweet your godchild is now. Dear fellow, it's delightful to see this little being grow, and my word, I am very glad to have him. I am going to paint him for the Salon, with other figures around, of course. I am going to do two paintings of figures this year: an interior with a baby and two women, and some sailors out-of-doors, and I want to do this in a splendid fashion. Thanks to that gentleman of Le Havre who comes to my aid, I enjoy the most perfect peace of mind. I wish I could remain this way always, in a very peaceful corner of nature, just as it is here. So I don't envy your being in Paris. Don't you think that one does better when one is alone with nature? One is too preoccupied with what one sees and hears in Paris, no matter how strong one may be, and what I will do here will at least have the merit of not looking like anyone else, because it will just be the impression of what I shall have felt, I, all alone. The further I go, the sorrier I am about how little I know: it is this that bothers me the most. I hope you are full of enthusiasm and will become a really hard worker. You who are in such a fortunate situation should do wonders. Happy mortal, tell me what you will have in the Salon and whether you are glad. . . .

Letter of September 25, 1869, from Saint-Michel

Monet wrote this sharp reply to Bazille, who was visiting his family in Montpellier, after the latter had advised him to find some sort of work, part-time at least, more lucrative than painting.

The present letter is to inform you that I have not followed your advice (inexcusable) of walking to Le Havre. I've been a bit happier this month in comparison to the preceding ones, for I'm still in a hopeless

state. I have sold a still life and I've been able to work a little. But, as usual, here I am brought up short because of no paints. Happy mortal, you will bring back quantities of canvases! I alone this year will have done nothing. This makes me angry at everyone; I am jealous, wicked; I'm furious; if I were able to work, everything would be all right. You tell me it's neither fifty francs nor 100 that will get me out of this situation; that's possible, but in that case there's nothing for me to do but break my head against the wall, for I can't look forward to any instantaneous fortune, and, if all those who spoke to me as you did had sent me fifty or forty francs, etc., certainly, I wouldn't be in this spot. I am re-reading your letter, my dear friend. It is certainly very comical and, if I didn't know you, I would take it as a joke. You tell me seriously, because you think it's so, that in my place you would chop wood. Only people in your position believe this, and if you were in mine, perhaps you would be more baffled than I am. It is tougher than you think, and I bet you wouldn't chop much wood. No, don't you see, advice is very hard to give and, I think, useless—no offense meant. All this doesn't change the fact that my troubles probably aren't over. The winter is coming, not a very pleasant season for the unfortunate. Then comes the Salon. Alas! I won't be represented there, since I won't have done anything. I do have a dream, a painting, the baths of La Grenouillère for which I've done a few bad rough sketches, but it is a dream. Renoir, who has just spent two months here, also wants to do this painting.[8] Apropos of Renoir, that reminds me that at his brother's house I drank wine that he had just received from Montpellier and which was awfully good. This also reminds me that it's absurd to have a friend in Montpellier and not be able to get a shipment of wine from him. Come now, Bazille, this is the time when wine should not be lacking in Montpellier. Couldn't you send us a cask the price of which you would deduct from what you still owe me? At least we would drink water less often and it would be cheap. You can't realize what a favor that would be to us, because it's a big expense, and I would be much obliged to you.[9]

Letters to Gustave Geffroy

After years of struggle and poverty, Monet had, at the age of fifty, achieved success. Yet, as these excerpts from letters written in 1890 to his intimate friend and biographer, Gustave Geffroy, reveal, he was more

[8] Monet and Renoir frequently went together in 1869 to La Grenouillère, a restaurant and swimming place at Croissy. At this point, often considered crucial for the emergence of impressionist formal qualities *per se,* the styles of Monet and Renoir were almost indistinguishable. The two important paintings that resulted from the artists' work together in 1869 at this spot are Monet's *La Grenouillère* in the Metropolitan Museum and Renoir's in the *Nationalmuseum,* Stockholm.

[9] Claude Monet, Letters to Frédéric Bazille, in Gaston Poulain, *Bazille et ses amis,* pp. 38–39, 119–120, 130–131, 160–162. Reprinted by permission of the publisher.

than ever haunted by the will-o'-the-wisp of instantaneity and the impossibility of ever capturing his fleeting vision by means of paint on canvas.

The first two letters are concerned with the series of Nymphéas (Waterlilies) or Paysages d'eau ("Waterscapes"), upon which Monet was then embarking at his Water Garden at Giverny. The excerpt from the letter of October 7, 1890, is about his series of Haystacks—fifteen paintings representing the subject under all different conditions of atmosphere and illumination—which he exhibited at Durand-Ruel's gallery in 1891.

JUNE 22, 1890

I have once more taken up things that can't be done: water with grasses weaving on the bottom. . . . It's wonderful to see, but it's maddening to try to paint it. But I'm always tackling that sort of thing!

JULY 21, 1890

. . . I am very depressed and deeply disgusted with painting. It is really a continual torture. Don't expect to see anything new; the little I was able to do is destroyed, scraped or torn apart. You can't imagine the dreadful weather we have had without interruption for two months. It's enough to drive one raving mad, when one tries to capture the weather, the atmosphere, the surroundings.

And with all these troubles, here I am stupidly afflicted with rheumatism. I am paying for my sessions out in the rain and snow, and it makes me unhappy to think that I will have to give up braving the weather and working out-of-doors, except when it is fine. What a nuisance life is!

Well, enough complaints; come see me as soon as possible. Best wishes to you.

OCTOBER 7, 1890

. . . I am working away: I am set on a series of different effects (haystacks), but at this time of year, the sun goes down so quickly that I cannot follow it. . . . I am working at a desperately slow pace, but the further I go, the more I see that I have to work a lot in order to manage to convey what I am seeking: "instantaneity," above all, the envelopment, the same light spread over everywhere; and more than ever, easy things achieved at one stroke disgust me. Finally, I am more and more maddened by the need to convey what I experience and I vow to go on living not too much as an invalid, because it seems to me that I am making progress.[10]

[10] Claude Monet, Letters to Gustave Geffroy, in Geffroy's *Claude Monet: Sa Vie, son temps, son oeuvre* (Paris: Les Editions G. Crès et Cie, 1922), pp. 188–189.

Lilla Cabot Perry: Claude Monet's Ideas about Art

Monet always had a horror of theories and strenuously avoided any kind of systematic construction of doctrine, which, in fact, would have been wholly inconsistent with his empirical, intensely personal approach to art. In place of any formal theory, however, there exists in the memoirs of friends and admirers a record of Monet's approach to his work. These reminiscences, written in 1927 after the painter's death, by a young American artist, Lilla Cabot Perry, who had met Monet in 1889 and was obviously much impressed by him, are among the most revealing of these personal recollections of the master's philosophy of art.

In spite of his intense nature and at times rather severe aspect, he was inexpressibly kind to many a struggling young painter. He never took any pupils, but he would have made a most inspiring master if he had been willing to teach. I remember his once saying to me:

"When you go out to paint, try to forget what objects you have before you—a tree, a house, a field, or whatever. Merely think, here is a little square of blue, here an oblong of pink, here a streak of yellow, and paint it just as it looks to you, the exact color and shape, until it gives your own naïve impression of the scene before you."

He said he wished he had been born blind and then had suddenly gained his sight so that he could have begun to paint in this way without knowing what the objects were that he saw before him. He held that the first real look at the *motif* was likely to be the truest and most unprejudiced one, and said that the first painting should cover as much of the canvas as possible, no matter how roughly, so as to determine at the outset the tonality of the whole. As an illustration of this, he brought out a canvas on which he had painted only once; it was covered with strokes about an inch apart and a quarter of an inch thick, out to the very edge of the canvas. Then he took out another on which he had painted twice, the strokes were nearer together and the subject began to emerge more clearly.

Monet's philosophy of painting was to paint what you really see, not what you think you ought to see; not the object isolated as in a test tube, but the object enveloped in sunlight and atmosphere, with the blue dome of Heaven reflected in the shadows.

He said that people reproached him for not finishing his pictures more, but that he carried them as far as he could and stopped only when he found he was no longer strengthening the picture. A few years later he painted his "Island in the Seine" series. They were painted from a boat, many of them before dawn, which gave them a certain Corot-like effect, Corot having been fond of painting at that hour. As he was showing them to me, I remarked on his having carried them further than

many of his pictures, whereupon he referred to this conversation and said again that he always carried them as far as he could. This was an easier subject and simpler lighting than usual, he said, therefore he had been able to carry them further. This series and the "Peupliers" series also were painted from a broad-bottomed boat fitted up with grooves to hold a number of canvases. He told me that in one of his "Peupliers" the effect lasted only seven minutes, or until the sunlight left a certain leaf, when he took out the next canvas and worked on that. He always insisted on the great importance of a painter noticing when the effect changed, so as to get a true impression of a certain aspect of nature and not a composite picture, as too many paintings were, and are. He admitted that it was difficult to stop in time because one got carried away, and then added: "J'ai cette force-là, c'est la seule force que j'ai!" [11]

An Interview with the Artist in 1900

In 1900, when the artist was sixty years old, he granted an interview, in the form of an autobiographical statement, to the Parisian newspaper, Le Temps. Rich, racy, and often humorous, it is an important document of the artist's youth, at least as he remembered it from the vantage point of his maturity.

I am a Parisian from Paris. I was born in 1840, under good King Louis-Philippe, in a circle entirely given over to commerce and where all professed a contemptuous disdain for the arts. But my youth was passed at Le Havre, where my father had settled in 1845 to follow his interests more closely, and this youth was essentially that of a vagabond. By birth I was undisciplined; never, even as a child, would I bend to a rule. It was at home that I learned the little I know. School always seemed a prison, and I never could make up my mind to stay there, even for four hours a day, when the sunshine was inviting, the sea smooth.

Until I was fourteen or fifteen, I led this irregular life to the despair of my poor father. Between times I had picked up in a haphazard way the rudiments of arithmetic and a smattering of spelling. This was the limit of my studies. They were not too tiresome for I intermingled them with distractions, drawing wreaths on the margins of my books. I decorated the blue paper of my copybooks with ultra-fantastic ornaments; and I represented thereon, in the most irreverent fashion, deforming them as much as I could, the faces or profiles of my masters.

I soon acquired much skill at this game. At fifteen I was known all over Le Havre as a caricaturist. My reputation was so well established

[11] Cited in French in the original text: "I have that strength; it is the only strength I have." Lilla Cabot Perry, "Reminiscences of Claude Monet from 1889 to 1909," *The American Magazine of Art,* XVIII (March, 1927), 119–125. Reprinted by permission of the American Federation of Arts.

that I was sought after from all sides and asked for caricature portraits. The abundance of orders and the insufficiency of the subsidies derived from maternal generosity inspired me with a bold resolve which naturally scandalized my family: I took money for my portraits. According to the appearance of my clients, I charged ten or twenty francs for each portrait, and the scheme worked beautifully. In a month my patrons had doubled in number. I was now able to charge twenty francs in all cases without lessening the number of orders. If I had kept on, I would be a millionaire today.

I was soon an important personage in town. In the show-window of the only framemaker who was able to make his expenses in Le Havre, my caricatures arrogantly displayed themselves. And when I saw the loungers crowd before them in admiration and heard them, pointing them out, say "That is so-and-so," I nearly choked with vanity and self-satisfaction.

Still, there was a shadow in all this glory. Often in the same show-window, I beheld, hung over my own productions, seascapes that I, like most of my fellow citizens, found disgusting. And, at heart, I was much annoyed at having to endure this contact and never ceased to abuse the idiot who, thinking he was an artist, had enough self-complacency to sign them—this idiot was Boudin.[12] In my eyes—accustomed as they were to the seascapes of Gudin,[13] to arbitrary colorations, to the false notes and fantastic arrangements of the painters then in vogue—the sincere little compositions of Boudin, the truth in his little figures, his ships so accurately rigged, his skies and his water so exact, drawn and painted from nature, had nothing artistic, and their fidelity struck me as more than suspicious. Therefore his painting inspired me with an intense aversion, and, without knowing the man, I hated him. The framemaker would often say to me: "You should make the acquaintance of M. Boudin. He studied art in Paris, in the studios of the Ecole des Beaux-Arts. He could give you some good advice."

And I resisted with silly pride. What, indeed, could such a ridiculous man teach me?

Still, the day came, fatal day, when chance brought me in spite of myself face to face with Boudin. He was in the rear of the shop and, not noticing his presence, I entered. The framemaker grasped the opportunity and without consulting me introduced us: "Just see, M. Boudin, this is the young man who has so much talent for caricature." And without hesitation Boudin came to me, complimented me in his gentle voice and said: "I always look at your sketches with much pleasure; they are

[12] Eugène Boudin (1824–1898), painter of extremely fresh, original sea-scenes, who worked outdoors in the area of Le Havre.

[13] Jean-Antoine-Théodore Gudin (1802–1880), student of the neo-classical artist Girodet-Trioson, who later fell under romantic influence and exhibited frequently in the Salons.

amusing, clever, bright. You are gifted; one can see that at a glance. But I hope you are not going to stop there. It is very well for a beginning, but soon you will have enough of caricaturing. Study, learn to see and to paint, draw, make landscapes. The sea and the sky are so beautiful—the animals, the people, and the trees, just as nature has made them, with their characters, their real way of being, in the light, in the air, just as they are."

But the exhortations of Boudin did not take. The man himself was pleasing to me. He was earnest, sincere; I felt it but I could not digest his painting, and when he offered to take me with him to sketch in the fields, I always found a polite pretext to decline. Summer came—my time was my own—I could make no valid excuse. Weary of resisting, I gave in at last, and Boudin, with untiring kindness, undertook my education. My eyes were finally opened, and I really understood nature. I learned at the same time to love it. I analyzed its forms with a pencil. I studied its colorations. Six months later, in spite of the entreaties of my mother, who had begun seriously to worry because of the company I kept, and who thought me lost in the society of a man of such low repute as Boudin, I announced to my father that I wished to become a painter and that I was going to settle down in Paris to learn.

"You shall not have a cent!"

"I shall get along without it!"

Indeed I could get along without it. I had long since made my little pile. My caricatures had done that for me. Often in one day I had executed seven or eight caricature portraits. At twenty francs apiece, my receipts had been large, and I had made it a practice from the start to entrust my earnings to one of my aunts, keeping just little sums for pocket money. At sixteen one feels rich with two thousand francs. I set out posthaste for Paris.

It took me a little time at first to decide on my line of action. I called on some artists to whom I had letters of introduction. I received excellent advice from them; I also received some very bad advice. Troyon wanted me to enter the studio of Couture. Needless to say, my refusal was emphatic. I even admit that it cooled, temporarily at least, my esteem and admiration for Troyon. I began to see less and less of him, and eventually associated only with artists who were experimenting. At this juncture I met Pissarro, who was not then thinking of posing as a revolutionary, and who was tranquilly working in Corot's style. The model was excellent; I followed his example; but during my whole stay in Paris, which lasted four years, and during which time I frequently visited Le Havre, I was governed by the advice of Boudin, although inclined to see nature more broadly.

I reached my twentieth year. The hour for conscription into the

army was about to strike. I saw its approach without fear. And so did my family. They had not forgiven my flight; they had let me live as I chose during those four years only because they thought they would catch me when the time came for me to do military duty. They thought that once my wild oats were sown, I should tame down sufficiently to return home and bow at last to commerce. If I refused, they would stop my allowance.

They made a mistake. The seven years of service that appalled so many were full of attraction for me. A friend who was in the regiment of the *Chasseurs d'Afrique* and who adored military life had communicated to me his enthusiasm and inspired me with his love of adventure. Nothing attracted me so much as the endless cavalcades under the burning sun, the *razzias,*[14] the crackling of gunpowder, the saber thrusts, the nights in the desert under a tent; and I replied to my father's ultimatum with a superb gesture of indifference. I succeeded by personal insistence in being drafted into an African regiment and set out.

In Algeria, I spent two really charming years. I incessantly saw something new; in my moments of leisure I attempted to render what I saw. You cannot imagine to what extent I increased my knowledge, and how much my vision gained. I did not quite realize it at first. The impressions of light and color that I received there were not to classify themselves until later; but they contained the germ of my future researches.

At the end of two years I fell ill, quite seriously. I was sent home to recuperate. Six months of convalescence were spent in drawing and painting with redoubled energy. Seeing me thus persisting, worn as I was by the fever, my father became convinced that no will could curb me, that no ordeal would get the better of so determined a vocation; and as much from weariness as from fear of losing me—for the doctor had led him to expect this should I return to Africa—he decided toward the end of my furlough to buy me out.

"But it is understood," he told me, "that this time you are going to work in dead earnest. I wish to see you in an atelier, under the discipline of a well known master. If you resume your independence, I will stop your allowance without further ado. Is it a bargain?" This arrangement only half suited me, but I felt it necessary not to oppose my father when he for once entered into my plans. I accepted. It was agreed that at Paris I should have an artistic tutor in the person of the painter Toulmouche,[15] who had just married one of my cousins; he would guide me and furnish regular reports of my labors.

I landed one fine morning at Toulmouche's with a stock of studies

14 Raids or forays.

15 Auguste Toulmouche (1829–1890), French painter, a pupil of Gleyre, who received several medals in the Salons.

which he said pleased him very much. "You have a future," he said, "but you must direct your efforts in some given channel. You will enter the studio of Gleyre.[16] He is the sober and wise master that you need."

And, grumbling, I placed my easel in the studio full of pupils presided over by this celebrated artist. The first week I worked there most conscientiously, and made with as much application as spirit a nude study from the model. The following Monday, when Gleyre came to me, he sat down and, solidly planted on my chair, looked attentively at my production. Then—I can still see him—he turned around, and leaning his grave head to one side with a satisfied air, said: "Not bad! Not bad at all, that thing there, but it is too much in the character of the model—you have before you a short, thick-set man; you paint him short and thick-set. He has enormous feet; you render them as they are. All that is very ugly. I want you to remember, young man, that when one executes a figure, one should always think of the antique. Nature, my friend, is all right as an element of study, but it offers no interest. Style, you see, style is everything."

I saw it all. Truth, life, nature, all that which moved me, all that which constituted in my eyes the very essence, the only *raison d'être* of art, did not exist for this man. I no longer wished to remain under him. I felt that I was not born to begin over again in his wake the *Illusions perdues* [17] and other bores. So, why persist?

Nevertheless I waited several weeks. In order not to exasperate my family, I continued to appear regularly at the class, remaining only long enough to execute a rough sketch from the model, and to be present for the attendance record, and then I skipped. Moreover, I had found congenial companions at Gleyre's. They were Renoir and Sisley,[18] of whom I was never thereafter to lose sight—and Bazille, who immediately became my close friend, and who would have become famous had he lived longer. None of them manifested, any more than I did, the slightest enthusiasm for a mode of teaching that antagonized both their logic and their temperament. I preached rebellion to them. An exodus was decided on; we left; Bazille and I took a studio together.

A short time before, I had made the acquaintance of Jongkind.[19]

[16] Marc-Gabriel-Charles Gleyre (1808–1874), Swiss-born artist, painter of genre and history, higher in aspiration than in pictorial energy, who took over the studio of Delaroche, and was the teacher—soon to be rejected—of the young future Impressionists: Monet, Renoir, Sisley, and Bazille.

[17] *Evening, or Lost Illusions,* Gleyre's extremely successful allegorical painting which had appeared in the Salon of 1843.

[18] Alfred Sisley (1839–1899), a minor member of the Impressionist group, whose landscapes exhibit a lyrical serenity and freshness.

[19] Johann Barthold Jongkind (1819–1891), painter of Dutch origin, for a while a member of the Barbizon group, whose quick, vibrant brushwork and attempt to capture fleeting effects of light had a strong influence on Sisley, Monet, and Pissarro. Jongkind was also well known for his landscape etchings.

During my convalescence furlough, one fine afternoon I was working on a farm in the neighborhood of Le Havre. A cow was grazing in the meadow; I conceived the idea of making a drawing of her. But the beast was capricious and every moment shifted her position. My easel in one hand, my stool in the other, I followed, trying with more or less success to regain my point of view. My wanderings must have been very amusing, for I heard a hearty burst of laughter behind me. I turned round and beheld a puffing colossus. But the colossus was good natured. "Wait a minute," he said, "I will help you." And the colossus in huge strides comes up to the cow and, grabbing her by the horns, tries to make her pose. The cow, unused to such treatment, takes it in bad part. It was now my turn to laugh. The colossus, quite discomfited, lets go the beast and comes over to chat with me.

He was an Englishman, a visitor, very much in love with painting and very well posted on what was going on in our country.

"So you make landscapes," he said, "do you know Jongkind?"

"No, but I have seen his work."

"What do you think of it?"

"It is very strong."

"Right you are. Do you know he is here?"

"You don't say!"

"He lives in Honfleur. Would you like to know him?"

"Decidedly yes. But are you one of his friends?"

"I have never seen him, but as soon as I learned of his presence, I sent him my card. I am going to invite him to lunch with you."

To my great surprise the Englishman kept his promise, and the following Sunday we were all three lunching together. Never was there a merrier feast. In the open air, in a country garden, under the trees, in presence of good rustic cooking, his glass well filled, seated between two admirers whose sincerity was above suspicion, Jongkind was beside himself with contentment. The impromptu of the adventure amused him; moreover he was unaccustomed to being thus sought after. His painting was too new and in a far too artistic strain to be then, in 1862, appreciated at its true worth. Neither was there ever any one so modest and retiring. He was a simple good-hearted man, murdering French atrociously, and very timid. That day he was very talkative. He asked to see my sketches, invited me to come and work with him, explained to me the why and the wherefore of his manner, and thereby completed the teachings that I had already received from Boudin. From that time on he was my real master, and it was to him that I owed the final education of my eye.

I frequently saw him again in Paris. My painting gained by it. I made rapid progress and three years later I exhibited [at the Salon]. The two seascapes that I had sent were received with highest approval

and hung on the line in a good position. It was a great success. Same unanimity of praise in 1866 for a large portrait, the *Woman in Green*. The papers carried my name even back to Le Havre. My family at last gave me back their respect. With their esteem came also a resumption of my allowance. I floated in opulence—temporarily at least, for later on we were to quarrel again—and I threw myself body and soul into the *plein air*.

It was a dangerous innovation. Up to that time no one had indulged in it, not even Manet, who only attempted it later, after me. His painting was still very classical and I have never forgotten the contempt that he showed for my beginnings. It was in 1867; my manner had shaped itself, but, after all, it was not revolutionary in character. I was still far from having adopted the principle of the subdivision of colors that set so many against me, but I was beginning to try my hand at it partially, and I was experimenting with effects of light and color that shocked accepted customs. The jury that had received me so well at first turned against me and I was ignominiously blackballed when I presented this new painting to the Salon.

Still I found a way to exhibit, but elsewhere. Touched by my entreaties, a dealer on the Rue Auber consented to display in his window a seascape that had been refused at the Palais de l'Industrie. There was a general hue and cry. One evening when I had stopped in the street in the midst of a group of loungers to listen to what was being said about me, I saw Manet coming along with two or three of his friends. They stopped to look, and Manet, shrugging his shoulders, cried disdainfully, "Just look at this young man who attempts to do the *plein air!* As if the ancients ever thought of such a thing!"

Moreover, Manet had an old grudge against me. At the Salon of 1866, at the *vernissage,* he had been received from the very moment of his entrance with such acclamations as: "Excellent picture, my boy!" And then handshakings, bravos, and felicitations. Manet, as you can well believe, was exultant. Imagine his surprise when he noticed that the canvas about which he was being congratulated was by me! It was the *Woman in Green.* The saddest part of it all was that in hurriedly taking his leave he should fall upon a group of painters among whom were Bazille and I. "How goes it?" asked one of the crowd. "Ah, my boy, it is disgusting. I am furious. I am complimented only on a painting not by me."

When Astruc [20] told him the next day that he had given vent to his ill humor before the author of the picture, and when he offered to introduce me to him, Manet, with a sweeping gesture, refused. He felt bitter toward me on account of the trick I had unconsciously played upon him.

[20] Zacharie Astruc (1835–1907), painter, sculptor, literary figure, and friend of many advanced figures in the art world of his time. Manet painted his portrait in c. 1864; Bazille in c. 1869.

Only once had he been congratulated for a master-stroke, and that master-stroke had been made by another. How bitter it must have been for one whose sensitivity was always bared to the quick as his was!

It was only in 1869 that I saw him again, and then we at once became fast friends. At our first meeting he invited me to join him every evening in a café at the Batignolles where he and his friends gathered after working hours to talk. There I met Fantin-Latour and Cézanne, Degas, who had recently returned from Italy, the art critic Duranty, Emile Zola, who was then making his debut in literature, and several others. I took Sisley, Bazille, and Renoir there. Nothing could be more interesting than these *causeries* with their perpetual clash of opinions. They kept our wit sharpened, they encouraged us in sincere and disinterested research, they provided us with stores of enthusiasm that for weeks and weeks kept us up, until the final shaping of an idea was accomplished. From them we emerged tempered more highly, with a firmer will, with our thoughts clearer and more distinct.

War was declared on Germany. I had just married. I went over to England. In London, I found Bonvin [21] and Pissarro. I suffered want. England did not care for our paintings. It was hard. By chance I ran across Daubigny, [22] who formerly had manifested some interest in me. He was then painting scenes on the Thames that pleased the English very much. He was moved by my distress. "I see what you need," he said, "I am going to bring a dealer to you." The next day I made the acquaintance of M. Durand-Ruel. [23]

During fifteen years and more, my paintings and those of Renoir, Sisley, and Pissarro had no other outlet but through him. The day came when he was compelled to restrict his orders, make his purchases less frequent. We thought ruin stared us in the face, but it was the advent of success. Our works found buyers at Georges Petit and the Boussods. [24] The public began to find them less bad. At Durand-Ruel's the collectors would have none of them. Seeing them in the hands of other dealers they grew more confident. They began to buy. The momentum was given. Today nearly everyone appreciates us to some degree. [25]

21 François Bonvin (1817–1887), extremely talented genre painter, whose simple, richly painted yet austere canvases, heavily dependent upon Chardin and the Dutch little masters, were in the vanguard of the Realist movement; an early friend, and cicerone at the Louvre, of Courbet.

22 Charles-François Daubigny (1817–1878), one of the most distinguished members of the Barbizon School of painters.

23 Paul Durand-Ruel (1831–1922), adventurous and astute art dealer who first supported the Barbizon painters and then the Impressionists.

24 Georges Petit and Boussod and Valadon were art dealers who became Durand-Ruel's most serious rivals.

25 Claude Monet, in Thiébault-Sisson, "Claude Monet, An Interview," *Le Temps*, Nov. 27, 1900; trans. and reprinted by Durand-Ruel, and republished as "Claude Monet: The Artist as a Young Man," *Art News Annual*, 1957, Part II (November, 1956), pp. 127–128, 196–199. Reprinted by permission of *Art News*.

Monet in His Old Age

In the last years of his life, plagued by failing eyesight and increasing anguish over the difficulties of the tasks he set for himself, Monet created the series of large panels of "waterscapes" which, paradoxically, seem a final paean to serenity and painterly fulfillment. In 1914 his closest friend, Georges Clemenceau, encouraged him to commence work on the last series of waterlily panels, which ultimately, after the artist's death in 1926, formed the cycle of almost abstract paintings in the two oval rooms in the Orangerie in Paris. The following passages would seem to have been written during these last years of Monet's life.

Colors no longer looked as brilliant to me as they used to do, I no longer painted shades of light so correctly. Reds looked muddy to me, pinks insipid, and the intermediate or lower notes in the color scale escaped me. As for forms, I could see them as clearly as ever, and render them as decisively. At first I tried pertinacity. How many times I have remained for hours near the little bridge, exactly where we are now, in the full glare of the sun, sitting on my camp-stool, under my sunshade, forcing myself to resume my interrupted task and to recapture the freshness my palette had lost! A waste of effort. What I painted was more and more mellow, more and more like an "old picture," and when the attempt was over and I compared it with what I used to do in the old days, I would fall into a frantic rage, and I slashed all my pictures with my penknife. . . .

Though I remained insensitive to the subtleties and delicate gradations of color seen at close quarters, my eyes at least did not deceive me when I drew back and looked at the subject in its broad lines, and this was the starting point of new compositions. A very modest starting point, to tell the truth. I distrusted myself, I was resolved to leave nothing to chance. Slowly I tried my strength in innumerable rough sketches which convinced me, in the first place, that the study of bright light was now, once and for all, impossible for me—but also reassured me by showing that while I could no longer go in for playing about with shades or for landscapes in delicate colors, I could see as clearly as ever when it came to vivid colors isolated in a mass of dark tones.

How was I to put this to use?

My intentions gradually became clearer. Ever since I entered my sixties I had had the idea of setting about a kind of "synthesis" in each of the successive categories of themes that held my attention—of summing up in one canvas, sometimes in two, my earlier impressions and sensations. I had given up the notion. It would have meant traveling a great deal and for a long time, revisiting, one by one, all the places through which my life as a painter had taken me, and verifying my for-

mer emotions. I said to myself, as I made my sketches, that a series of general impressions, captured at the times of day when I had the best chance of seeing correctly, would not be without interest. I waited for the idea to consolidate, for the grouping and composition of the themes to settle themselves in my brain little by little, of their own accord; and the day when I felt I held enough cards to be able to try my luck with a real hope of success, I determined to pass to action, and did so.[26]

PIERRE-AUGUSTE RENOIR: 1841–1919

The Society of Irregularists

Like Monet, a Gleyre pupil, a member of the Café Guerbois circle, and one of the initiators of the first Impressionist Exhibition in 1874, Pierre-Auguste Renoir throughout his life remained more traditional than Monet in his attachment to the human form—more specifically, the female form—and its associated qualities of warmth, sensuality, and loveliness. Thus, although his paintings of the seventies and early eighties, like the Moulin de la Galette *(1876) and the* Luncheon of the Boating Party *(c. 1881), are completely Impressionistic in their diaphanous brushwork and in the quivering evanescence of the iridescent light and transparent shadow in which the charming, informally grouped figures are bathed, by the middle eighties, Renoir began to suffer grave doubts about his, and Impressionism's, lack of form and composition—doubts which eventually led to a crisis and to Renoir's subsequent return, after a trip to Italy in 1881–1882, to a more disciplined kind of drawing and modeling and to a stricter formal arrangement: what has been called his "dry" or "harsh" period.*

The following manifesto, which is actually an artistic "credo" in the form of a proposal for a society of artists, was probably written in 1884, and, along with an introduction to an edition of the treatise on painting by the late 14th-century artist Cennino Cennini, which he wrote at the request of his friend Mottez, it is Renoir's only attempt at any kind of coherent, organized theoretical statement.

In all the controversies matters of art stir up daily, the chief point to which we are going to call attention is generally forgotten. We mean irregularity.

Nature abhors a vacuum, say the physicists; they might complete their axiom by adding that she abhors regularity no less.

[26] Claude Monet in Richard Friedenthal, ed., *Letters of the Great Artists: From Blake to Pollock,* trans. Daphne Woodward (New York: Random House, 1963), pp. 131–132.

Observers actually know that despite the apparent simplicity of the laws governing their formation, the works of nature are infinitely varied, from the most important to the least, no matter what their species or family. The two eyes of the most beautiful face will always be slightly unlike; no nose is placed exactly above the center of the mouth; the quarters of an orange, the leaves of a tree, the petals of a flower are never identical; it thus seems that every kind of beauty draws its charm from this diversity.

If one looks at the most famous plastic or architectural works from this viewpoint, one easily sees that the great artists who created them, careful to proceed in the same way as that nature whose respectful pupils they have always remained, took great care not to transgress her fundamental law of irregularity. One realizes that even works based on geometric principles, like St. Mark's,[27] the little house of Francis I in the Cours La Reine . . . as well as all the so-called Gothic churches . . . have not a single perfectly straight line, and that the round, square, or oval forms which are found there and which it would have been extremely easy to make exact, never are exact. One can thus state, without fear of being wrong, that every truly artistic production has been conceived and executed according to the principle of irregularity; in short, to use a neologism which expresses our thought more completely, it is always the work of an irregularist.

At a time when our French art, until the beginning of this century still so full of penetrating charm and exquisite imagination, is about to perish of regularity and dryness, when the mania for false perfection makes engineers diagram the ideal, we think that it is useful to react against the fatal doctrines which threaten to annihilate it, and that it is the duty of all men of sensitivity and taste to gather together without delay, no matter how repugnant they may otherwise find combat and protest.

An association is therefore necessary.

Although I do not want to formulate a final platform here, a few projected ideas are briefly submitted:

The association will be called the society of irregularists, which explains the general ideas of the founders.

Its aim will be to organize as quickly as possible exhibitions of all artists, painters, decorators, architects, goldsmiths, embroiderers, etc., who have irregularity as their aesthetic principle.

Among other conditions for admission, the rules stipulate precisely, as far as architecture is concerned: All ornaments must be derived from nature, with no motif—flower, leaf, figure, etc., etc.—being exactly repeated; even the least important outlines must be executed by hand with-

[27] St. Mark's Cathedral in Venice.

out the aid of precision instruments; as far as the plastic arts are concerned, the goldsmiths and others . . . will have to exhibit alongside of their finished works the drawings or paintings from nature used to create them.

No work containing copies of details or of a whole taken from other works will be accepted.

A complete grammar of art, dealing with the aesthetic principles of the organization, setting forth its tendencies, and demonstrating its usefulness, will be published by the founding committee with the collaboration of the members who offer their services.

Photographs of celebrated monuments or decorative works which bring forth evidence of the principle of irregularism will be acquired at the expense of the society and placed in a special room for the public.[28]

Renoir's Aphorisms

While Renoir had a horror of any kind of systematically formulated "theory" about art or life, he was not in the least reticent about expressing his individual opinions in forceful, often pungent language, as the occasion might demand. His admiration for the disappearing virtues of craftsmanship, artistic vitality, and human sensitivity, his hatred of pretense and progress are clearly manifested both in the verbal statements recorded by his son Jean, and in the writing—probably notes for a proposed "Grammar for Young Architects"—found by the latter among his father's papers. As to the accuracy of Jean Renoir's memory of his father's words, it is appropriate to cite the former's own warning at the beginning of Renoir, My Father:

"The Reader: It is not Renoir you are presenting to us, but your own conception of him.

The Author: *Of course, History is a subjective genre, after all."*

Sayings on Art

I like beautiful materials, rich brocades, diamonds flashing in the light, but I would have had a horror of wearing such things myself. I am grateful to those who do wear them, provided they allow me to paint them. On the other hand, I would just as soon paint glass trinkets and cotton goods costing two sous a yard. It is the artist who makes the model. —Yes and no. I need to feel all the excitement of life stirring around me, and I'll always need it.

I have a horror of the word "flesh," which has become so shopworn. Why not "meat," while they're about it? What I like is skin, a young

28 Pierre-Auguste Renoir, "La Société des irregularistes," in Lionello Venturi, *Les Archives de l'Impressionisme* (Paris, New York: Durand-Ruel, 1939), I, 127–129. Reprinted by permission of the publisher.

girl's skin that is pink and shows that she has a good circulation. But what I like above all is serenity.

It's all very well to be sentimental about the past. Of course, I miss those plates decorated by hand, and the furniture made by the village carpenter; the days when every workman could use his imagination and put something of himself into whatever little practical object he was making. To get that kind of pleasure nowadays you have to be an artist and sign your work, which is something I detest. On the other hand, under Louis the Fifteenth I would have been obliged to paint nothing but specified subjects. And what seems most significant to me about our movement is that we have freed painting from the importance of the subject. I am at liberty to paint flowers, and call them simply flowers, without their needing to tell a story.

The artist who seeks to present himself entirely naked to his public ends by revealing a conventional character, which is not even himself. It is merely romanticism, with its self-confession, tears, and agony, in reality the posings of a third-rate actor. But it sometimes happens that a Raphael who only wished to paint nice girls with little children—to whom he gave the title of "Virgin"—reveals himself with the most touching intimacy.

I've spent my life making blunders. The advantage of growing old is that you become aware of your mistakes more quickly.

There isn't a person, a landscape, or a subject that doesn't possess at least some interest—although sometimes more or less hidden. When a painter discovers this hidden treasure, other people immediately exclaim at its beauty. Old Corot opened our eyes to the beauty of the Loing, which is a river like any other; and I am sure that the Japanese landscape is no more beautiful than other landscapes. But the point is that Japanese painters knew how to bring out their hidden treasure.[29]

From Renoir's Notebook

Everything that I call grammar on primary notions of Art can be summed up in one word: Irregularity.

The earth is not round. An orange is not round. Not one section of it has the same form or weight as another. If you divide it into quarters, you will not find in a single quarter the same number of pips as in any of the other three; nor will any of the pips be exactly alike.

Take the leaf of a tree—take a hundred thousand other leaves of the same kind of tree—not one will exactly resemble the other.

29 Pierre-Auguste Renoir in Jean Renoir, *Renoir, My Father,* trans. Rudolph and Dorothy Weaver (Boston and Toronto: Little, Brown and Company, 1962), pp. 102, 114–115, 186, 221–222. Reprinted by permission of the publisher. Copyright © Jean Renoir 1958, 1962.

Take a column. If I make it symmetrical with a compass, it loses its vital principle.

Explain the irregularity in regularity. The value of regularity is in the eye only . . . the non-value of the regularity of the compass.

It is customary to prostrate oneself in front of the (obvious) beauty of Greek art. The rest has no value. What a farce! It is as if you told me that a blond is more beautiful than a brunette; and vice versa.

Do not restore; only remake the damaged parts.

Do not think it is possible to repeat another period.

The artist who uses the least of what is called imagination will be the greatest.

To be an artist you must learn to know the laws of nature.

The only reward one should offer an artist is to buy his work.

An artist must eat sparingly and give up a normal way of life.

Delacroix never won a prize.

How is it that in the so-called barbarian ages art was understood, whereas in our age of progress exactly the opposite is true.

When art becomes a useless thing, it is the beginning of the end. . . . A people never loses half, or even just a part, of its value. Everything comes to end at the same time.

If art is superfluous, why caricature or make a pretense of it? . . . I only wish to be comfortable? Therefore I have furniture made of rough wood for myself, and a house without ornament or decoration. . . . I only want what is strictly necessary. . . . If I could obtain that result, I should be a man of taste. But the ideal of simplicity is almost impossible to achieve.

The reason for this decadence is that the eye has lost the habit of seeing.

Artists do exist. But one doesn't know where to find them. An artist can do nothing if the person who asks him to produce work is blind. It is the eye of the sensualist that I wish to open.

Not everyone is a sensualist just because he wishes to be.

There are some who never become sensualists no matter how hard they try.

Someone gave a picture by one of the great masters to one of my

friends, who was delighted to have an object of undisputed value in his drawing room. He showed it off to everyone. One day he came rushing in to see me. He was overcome with joy. He told me naïvely that he had never understood until that morning why the picture was beautiful. Until then he had always followed the crowd in being impressed only by the signature. My friend had just become a sensualist.

It is impossible to repeat in one period what was done in another. The point of view is not the same, any more than are the tools, the ideals, the needs, or the painters' techniques.

A gentleman who has become newly rich decides that he wants a château. He makes inquiries as to the style most in fashion at the time. It turns out to be Louis XIII; and off he goes. And of course, he finds an architect who builds him an imitation Louis XIII. Who is to blame?

The art lover is the one who should be taught. He is the one to whom the medals should be given—and not to the artist, who doesn't care a hang about them.

Painters on porcelain only copy the work of others. Not one of them would think of looking at the canary he has in a cage to see how its feet are made.

They ought to have cheaply priced inns in luxuriant surroundings for those in the decorative arts. I say inns; but, if you wish, schools minus teachers. I don't want my pupils to be polished up any more than I want my garden to be tidied up.

Young people should learn to see things for themselves, and not ask for advice.

Look at the way the Japanese painted birds and fish. Their system is quite simple. They sat down in the countryside and watched birds flying. By watching them carefully, they finally came to understand movement; and they did the same as regards fish.

Don't be afraid to look at the great masters of the best periods. They created irregularity within regularity. Saint Mark's Cathedral in Venice: symmetrical, as a whole, but not one detail is like another!

An artist, under pain of oblivion, must have confidence in himself, and listen only to his real master: Nature.

The more you rely on good tools, the more boring your sculpture will be.

The Japanese still have a simplicity of life, which gives them time to go about and contemplate. They still look, fascinated, at a blade of

grass, or the flight of birds, or the wonderful movements of fish, and they go home, their minds filled with beautiful ideas, which they have no trouble in putting on the objects they decorate.

I believe that I am nearer to God by being humble before this splendor (nature); by accepting the role I have been given to play in life; by honoring this majesty without self-interest, and, above all, without asking for anything, being confident that He who has created everything has forgotten nothing.

I believe, therefore, without seeking to understand. I don't wish to give any name, and especially I do not wish to give the name of God, to statues or to paintings. For He is above everything that is known. Everything that is made for this purpose, is, in my humble opinion, *a fraud.*

Go and see what others have produced, but never copy anything except nature. You would be trying to enter into a temperament that is not yours and nothing that you would do would have any character.

The greatest enemy of the worker and the industrial artist is certainly the machine.

The modern architect is, generally speaking, art's greatest enemy.

Since you love the Republic so much, why are there no statues of the Republic as beautiful as the Athenas of the Greeks? Do you love the Republic less than the Greeks did their gods?

There are people who imagine that one can re-do the Middle Ages and the Renaissance with impunity. One can only copy: that is the watchword. And after such folly has continued long enough, go back to the sources. You will see how far away we have got from them.

God, the King of artists, was clumsy.[30]

Renoir's Palette

"Renoir's palette," according to the account of his son Jean, "was always as clean as a new coin." The artist himself describes its composition in the following note, probably from the Impressionist period. It was only after the Italian trip of 1881–1882 that he added black to his palette, and later on, toward the end of his life, he simplified it even further. He always mixed his colors on the canvas.

Silver white, chrome yellow, Naples yellow, ocher, raw sienna, vermilion, rose lake, Veronese green, viridian, cobalt blue, ultramarine blue.

30 *Ibid.,* pp. 240–245.

Palette knife, scraper, oil, turpentine—everything necessary for painting. The yellow ocher, Naples yellow, and sienna earth are intermediate tones only, and can be omitted since their equivalents can be made with other colors. Brushes made of marten hair; flat silk brushes.[31]

Letters to Durand-Ruel

While Renoir came late to the attention of the Impressionists' art dealer, friend, and supporter, Paul Durand-Ruel—after the middle seventies—the latter more than compensated for his initial error in neglecting the painter: his relationship with Renoir for the rest of his life was closer and warmer than with any other artist.

In 1881, when Durand-Ruel was able to assure him of fairly regular purchases, Renoir took off on a series of trips, leading him first to Algiers, from where he wrote a letter to the art dealer explaining why he felt it necessary to submit works to the official Salon, and then to Italy, where, from Naples, he speaks of his admiration for Raphael's frescoes, seen from the viewpoint of Ingres. It was soon after this encounter with Raphael's art that Renoir renounced his own quest for "the impossible" —that is to say, the Impressionist venture—and returned to a more classical, linear, finished style, at least for the time being. Yet in his latest works, Renoir fuses the classical grandeur of the Renaissance masters with the painterly brio and coloristic splendor of Impressionism to create a late style which goes beyond both in its lyrical expansiveness and abstract sensuality.

ALGIERS, MARCH 1881

MY DEAR MONSIEUR DURAND-RUEL,

I have just been trying to explain to you why I send pictures to the Salon. In Paris there are scarcely fifteen people capable of liking a painter who doesn't show at the Salon. There are 80,000 who won't buy so much as a nose from a painter who is not hung at the Salon. That's why I send in two portraits every year, little as that is. Besides, I do not want to fall in with the mania for believing that a thing is bad because of where it happens to be. In short, I don't want to waste time cherishing grudges against the Salon. I don't even want to seem to do so. In my opinion one should paint as well as possible, and that is all. Ah! If I were accused of neglecting my art, or sacrificing my opinions to idiotic ambition, I would understand my critics. But as that is not so, there is nothing they can reproach me with; on the contrary. At this moment, as always, I am concerned solely with doing good work. I want to paint stunning pictures that you can sell for very high prices. I shall manage it before long, I hope. I have been keeping away from all other painters, in the sun, to think things out. I believe I have come to an end and found what

[31] *Ibid.*, p. 386.

I wanted. I may be wrong, but it would very much surprise me. Be patient for a little longer, and I hope I shall soon prove to you that one can show at the Salon and still do good painting.

So please plead my cause with my friends. I send to the Salon for purely commercial reasons. Anyhow, it's like with certain medicines. If it does no good, it does no harm.

I think I'm quite fit again now. I'm going to be able to work hard and make up for lost time.

At which point I wish you excellent health. And a lot of rich collectors. But keep them till I get back. I shall stay here another month. I don't want to leave Algiers without bringing back something from this marvelous country.

A thousand greetings to my friends and to you.

RENOIR [32]

NAPLES, 21 NOVEMBER 1881

DEAR MONSIEUR DURAND-RUEL,

I have been meaning to write to you for a long time, but I wanted to send you a mass of pictures as well. But I am still bogged down in experiments—a malady. I'm not satisfied, so I clean things off, again and again. I hope the mania is coming to an end; that is why I am giving you this sign of life. I do not think I shall bring back very much from my travels. But I think I shall have made progress, which always happens after experimenting for a long time. One always comes back to one's first love, but with a note added. Anyhow, I hope you will forgive me if I don't bring you back a great deal. Besides, you'll see what I shall do for you in Paris.

I am like a child at school. The new page is always going to be neatly written, and then pouf! . . . a blot. I'm still making blots . . . and I am forty years old. I went to look at the Raphaels in Rome. They are very fine and I ought to have seen them earlier. They are full of skill and wisdom. He didn't try to do the impossible, like me. But his work is fine. I prefer Ingres for oil paintings. But the frescoes are admirable in their simplicity and nobility.

I take it you are well, as usual, and your little family too. But I shall be seeing you soon, for Italy is very fine. But Paris . . . Ah! Paris . . .

I am beginning something. I won't tell you what, because then I should spoil it. I have my superstitions.

A thousand greetings,

RENOIR [33]

[32] Pierre-Auguste Renoir, Letter to Paul Durand-Ruel from Algiers, March, 1881, in Friedenthal, *Letters,* pp. 133–136.

[33] Pierre-Auguste Renoir, Letter to Paul Durand-Ruel from Naples, November 21, 1881, in Friedenthal, *Letters,* p. 136.

CAMILLE PISSARRO: 1830–1903

Letter to Durand-Ruel

Camille Pissarro had been one of the most consistent and dependable members of the Impressionist group, the only one to show in all eight of the group exhibitions, and an unshakeable adherent of Impressionist tenets of form and attitude, despite constant discouragement and financial distress. A close friend of both Degas and Cézanne, he led the latter to abandon the turgid, densely painted style of his earlier works and to turn to a fresh confrontation of nature for his motifs; he had also helped and inspired Gauguin to free his vision. His landscapes of the seventies and early eighties were sometimes forceful, often delicate and disarming in their unassuming visual rectitude, with a freshness and simplicity that marked them as his own. Yet in the middle of the eighties, when the Impressionist impulse seemed to have spent itself, Pissarro took refuge in the solidity and apparently scientific universality of Neo-Impressionism, a convert at the age of fifty-five to the "systematized" color division and painstaking, dotted brushwork of the young Neo-Impressionists, who were led by Seurat. The radical political ideals of certain members of the Neo-Impressionist group, such as Signac (see below, pp. 123 to 125), may also have helped Pissarro to abandon the older style for a new, more stringent artistic credo.

In this letter of 1886, in answer to a request from the dealer Paul Durand-Ruel for "as complete a write-up as possible on yourself first, and then on your beliefs, to send to New York," Pissarro clearly indicates his allegiance to Neo-Impressionism.

ERAGNY, NOVEMBER 6, 1886

MY DEAR M. DURAND-RUEL,

I am sending you the enclosed account of myself and my new artistic doctrines that you requested.

You may complete it by consulting the brochure of M. Félix Fénéon [34] recently published under the title: "The Impressionists in 1886," on sale at Soiret's in Montmartre and the major bookstores.

If your son prepares a publication on this subject, I should like him to make it quite clear that M. Seurat, an artist of great worth, was the first to have the idea and to apply the scientific theory, after having studied them fully. I have only followed, as have my other colleagues, Signac

[34] Félix Fénéon (1861–1944), one of the major spokesmen for the Neo-Impressionists. See below, pp. 107 to 112.

and Dubois-Pillet,[35] the example given by Seurat. I hope your son will be kind enough to do me this favor for which I will be truly grateful.

Theory

Seek for the modern synthesis with scientifically based means which will be founded on the theory of colors discovered by M. Chevreul and in accordance with the experiments of Maxwell and the measurements of N. O. Rood.[36]

Substitute optical mixture for the mixture of pigments. In other words: break down tones into their constituent elements because optical mixture creates much more intense light effects than the mixture of pigments.

As for execution, we regard it as inconsequential, of very little importance: art has nothing to do with it; originality consists only in the quality of drawing and the vision particular to each artist.

Here is my biography: Born at St. Thomas (Danish Antilles) July 10, 1830. Came to Paris in 1841 to enter the Savary boarding school at Passy. I returned to St. Thomas at the end of 1847, where I began to draw and at the same time was employed by a commercial firm. In 1852 I gave up trade and left, with Mr. Fritz Melbye,[37] a Danish painter, for Caracas (Venezuela) where I stayed until 1855; I went back into trade in St. Thomas. Finally, I came back to France at the end of 1855, in time to see, for three or four days, the Universal Exposition.

Since then, I have stayed in France; as for the rest of my story as a painter, it is tied up with the Impressionist group.[38]

Two Letters to Lucien

Lucien Pissarro (1863–1944) was the eldest of Camille Pissarro's five sons, a talented artist in his own right, and, like his father, closely linked with the originators of the Neo-Impressionist movement. When he left for England at the age of twenty, his father wrote him almost daily letters, giving him advice, admonishment, and encouragement on

[35] Paul Signac (1863–1935), an active member of the Neo-Impressionist group and its chief theorist (see below, pp. 116 to 123), who remained faithful to its doctrine and was president of the Société des Indépendants for twenty-six years. Albert Dubois-Pillet (1845–1890), one of the founders of the Salon des Indépendants, whose works are exceedingly rare.

[36] Michel-Eugène Chevreul (1786–1889), James Clerk Maxwell (1831–1879), and Ogden N. [Pissarro has reversed the initials] Rood (1831–1902), scientists concentrating on the investigation of color, whose work—chiefly, Chevreul's *De la loi du contraste simultané des couleurs* (1839), Maxwell's "Perception of Colour," (c. 1855–1872), and Rood's *Modern Chromatics* (1871)—exerted a powerful influence upon Neo-Impressionist color theory. See below, pp. 114 to 116.

[37] Fritz Melbye (1826–1896), Danish painter of landscape and marine subjects.

[38] Camille Pissarro, Letter to Paul Durand-Ruel, Eragny, November 6, 1886, in Venturi, *Archives,* II, 24–25.

every aspect of art and life, sharing with him in the most intimate way his own daily enthusiasms and disappointments. In their informality and heartfelt sincerity, the letters offer an insight into the deepest feelings of one of the most authentic and honest artistic figures of his times.

The first of the letters printed here has to do with Camille Pissarro's participation, as a Neo-Impressionist, along with Signac and in opposition to the more "conventional" Impressionists like Monet, Renoir, and Sisley, in the International Show which opened at Georges Petit's gallery on May 7, 1887.

The second letter, one of advice to his son, reveals how closely Pissarro's views on art were linked to his passionate commitment to social justice. He instinctively reacted against the artifice of art-for-art's-sake, the betrayal of humanity he felt inherent in a style that abandoned nature for fantasy or self-conscious symbolism. Elsewhere, Pissarro sharply criticized Gauguin, not for having painted a rose colored background in one of his works but for "not applying his synthesis to our modern philosophy which is absolutely social, anti-authoritarian, and anti-mystical . . ."; he also accused Gauguin of being a schemer who sensed that the bourgeoisie was moving to the right.

PARIS, MAY 8, 1887

MY DEAR LUCIEN,

I went to Asnières with Signac, still exhausted from the hanging. . . . I had all I could stand from that confounded exhibition which smells to heaven of bourgeois values. But just the same I wanted the experience of seeing my pictures hanging with those of the leaders and followers of triumphant impressionism.

Evidently, for the test to be decisive, I would have needed at least fifteen canvases to be in harmony with the other exhibitors, and also my works should not have been scattered about as they were. The Monets, Renoirs, Sisleys, Cazins, Raffaëllis,[39] Whistlers were shown in groups. Just the same it is clear, it is very evident that we have more luminosity and more design; still a bit too much stiffness; badly framed and the tapestries are in contradiction with our harmonies. I am not too dissatisfied; what enraged me, though, was the offhand way I was treated. M. Petit, to please a foreign painter who was blinded by my luminosity, withdrew my *Plain of Eragny*, withdrew it altogether and hung in its place a dark Monet. I was so angered that I was simply incapable of being polite to my guests. I was furious and complained bitterly; if it

[39] Jean-Charles Cazin (1841–1901), French artist who attempted to revive encaustic painting and was best known for melancholy, richly painted landscapes. Jean-François Raffaëlli (1850–1924), painter of genre and picturesque views of Paris and its suburbs, for a time a friend and follower of Degas, who attempted, without success, to introduce him into the Impressionist exhibitions.

had not been for John Lewis Brown [40] I should have made a furor. I reflected that after all it was better to calm down and take it up later. But you cannot conceive to what degree this milieu enslaves one, and how easy it is for the powerful to restrict the liberty of others. Even my poor little panel was put aside; I protested once again this morning and was promised that space for my work would be found. De Bellio [41] seems to like my pictures, he called me a magician. . . . I am afraid this is just flattery. As for M. Chocquet,[42] it would be an exaggeration to say that he was flattering; he cannot abide my work; I sense his dislike, but it means nothing to me.

Finally I am completely exhausted, for we spent from nine o'clock last night until seven in the morning hanging paintings.

I am off to the exhibition; I will write you later about certain ideas expressed by Monet which are most extraordinary coming from such an artist. . . . They can only be explained by the fact that he is in opposition. . . .[43]

ERAGNY, JULY 8, 1891

MY DEAR LUCIEN,

I received your letter this morning. —Yes, my dear Lucien, I recognized at once the sentimental and *Christian* tendency in your crowned figure *[Sister of the Woods];* it was not the drawing, but the attitude, the character, the expression, the general physiognomy. I know that your first plan was conventional as compared with your last. But the figure itself is conventional in relation to your art. —There is not only this jarring note, but also, I insist, a sentimental element characteristically English and quite Christian, an element found in many of the Pre-Raphaelites . . . and elsewhere. As for the idea, my son, there are hundreds of ideas in your other engravings, which belong to you, anarchist and lover of nature, to the Lucien who reserves the great ideal for a better time when man, having achieved another mode of life, will understand the beautiful differently. In short, sentimentalism is a tendency for Gauguin, not as a style, but as an idea. Scorn compliments!

[40] John Lewis Brown (1829–1890), French artist of Irish origin who made his reputation with paintings of horses, dogs, sporting and military scenes.

[41] Dr. Georges de Bellio, Rumanian medical man, friend of the Impressionists, and collector of works by Monet, Renoir, and other members of the group.

[42] Victor Chocquet, a minor official in the French customs bureau, the most impassioned early collector and fervent defender of the Impressionists, whose portrait was painted by Renoir and Cézanne. In the sale of Chocquet's collection in 1899 were included thirty-one paintings by Cézanne, eleven each by Monet and Renoir, five by Manet, one by Pissarro and one by Sisley.

[43] Camille Pissarro, Letter to Lucien Pissarro, Paris, May 8, 1887, in Camille Pissarro, *Letters to his Son, Lucien,* ed. John Rewald, trans. Lionel Abel (New York: Pantheon Books, Inc., 1943), pp. 106–107. Reprinted by permission of the publisher.

Proudhon says in *La Justice* that love of earth is linked with revolution, and consequently with the artistic ideal. —That is why we do not care for Crane: [44] he is not conscious of what he should admire in art. Contradiction! Yes, one's work is cut out for one in that milieu, but one has to find one's style elsewhere and impose it and make the reasons for it clearly understood. For this, a certain authority is necessary—but haven't we Degas and all the impressionists? We have taken the right path, the logically necessary path, and it will lead us to the ideal, *at least that is how it appears to me.*

I am at this moment reading J. P. [sic] Proudhon. He is in complete agreement with our ideas. His book *La Justice dans la Révolution* must be read from beginning to end. If you had an opportunity to study it you would understand that those who follow the new tendency are influenced by bourgeois reaction. Look how the bourgeois woo the workers! Isn't everybody socialist, hasn't even the Pope fallen into line? Reaction! The purpose behind all this, my dear boy, is to check the movement, which is beginning to define itself; so we must be suspicious of those who under the pretext of working for socialism, idealist art, pure art, etc., etc., actually support a false tendency, a tendency a thousand times false, even though, perhaps, it answers the need of certain types of people, but not our needs; we have to form a totally different ideal! Paul Adam, Aurier,[45] and all the young writers are in this counter-revolutionary movement, unconsciously, I am almost sure, or perhaps out of weakness . . . and for all that they believe they are doing something new! Fortunately the revolution that raised the problem has seen many other things. I hope a first-rate mind will be discovered. How beautifully Gustave Kahn might have filled this lack; but it is impossible, he does not believe in the Justice inherent in man.[46] So much the worse for them, they too will pass! My dear boy, it is amazing how contemporary this book on *Justice* is. Every young man ought to read it, while disregarding certain passages in which the author argues that the good society can be achieved by means of an almost state organization—but this is no great matter.[47]

[44] Walter Crane (1845–1915), English painter and decorative artist, associated with William Morris, particularly known for linear, decorative book illustration presaging *Art Nouveau*. Lucien himself, when he finally settled in England, set up the *Eragny-Press,* where he published works illustrated with his own woodcuts or with engravings after his father's drawings.

[45] Paul Adam (1862–1920) and G.–Albert Aurier (1865–1892), Symbolist writers and critics, closely associated with similar tendencies in the advanced art of the eighties and nineties in Paris. For Aurier's art criticism, see below, pp. 135 to 139.

[46] Gustave Kahn (1859–1939), Symbolist poet, critic, and writer on art, who became editor of the Symbolist journal, *La Vogue,* in 1889.

[47] Camille Pissarro, Letter to Lucien, Eragny, July 8, 1891, in Camille Pissarro, *Letters,* pp. 179–180.

14

Abandonment of Divisionism

By 1896—in fact, even before this time—Pissarro found it impossible to continue within the stringent program of Neo-Impressionism. As early as 1888 he had confided to his son Lucien that he was continually searching for some way of painting without the obligatory, mechanical, divisionist "dot," and trying to find some way of combining the purity and simplicity of the pointillist technique with the fullness, spontaneity, and freshness of sensation of Impressionist art. In this letter, sent to another member of the group, the Belgian Henri Van de Velde (also an exhibitor with Les Vingt and later to become an influential figure in the Art Nouveau movement), on March 27, 1896, Pissarro protests against the inclusion of his name in a list of Neo-Impressionists. He then sets forth his reasons for his rejection of the doctrines of the movement and his return to the direct experience of nature.

I believe that it is my duty to write you frankly and tell you how I now regard the attempt I made to be a systematic divisionist, following our friend Seurat. Having tried this theory for four years and having now abandoned it, not without painful and obstinate struggles to regain what I had lost and not to lose what I had learned, I can no longer consider myself one of the neo-impressionists who abandon movement and life for a diametrically opposed aesthetic which, perhaps, is the right thing for the man with the right temperament but is not right for me, anxious as I am to avoid all narrow, so-called scientific theories. Having found after many attempts (I speak for myself), having found that it was impossible to be true to my sensations and consequently to render life and movement, impossible to be faithful to the so random and so admirable effects of nature, impossible to give an individual character to my drawing, I had to give up. And none too soon! [48]

Pissarro's Advice to a Young Artist

By 1897 Pissarro had returned with renewed vigor to faith in his own sensations and feelings before the ever-changing spectacle of the natural world as the only guiding principle of his art. It was indeed during his later years that he created many of his most spontaneous and fulfilled works, including the masterly series of Parisian cityscapes. This advice, offered in 1896–1897 to a young painter of his acquaintance, Louis Le Bail, and taken from the latter's private notes, would seem to

[48] Camille Pissarro, Letter to Henri Van de Velde, sent to the latter on March 27, 1896, but perhaps drafted earlier; cited in John Rewald, *Georges Seurat* (New York: Wittenborn, 1946), p. 68. Reprinted by permission of George Wittenborn, Inc.

sum up the Impressionist attitude toward art in general, as well as Pis-sarro's personal convictions in particular.

Look for the kind of nature that suits your temperament. The motif should be observed more for shape and color than for drawing. There is no need to tighten the form which can be obtained without that. Precise drawing is dry and hampers the impression of the whole; it destroys all sensations. Do not define too closely the outlines of things; it is the brush stroke of the right value and color which should produce the drawing. In a mass, the greatest difficulty is not to give the contour in detail, but to paint what is within. Paint the essential character of things, try to convey it by any means whatsoever, without bothering about technique. When painting, make a choice of subject, see what is lying at the right and at the left, then work on everything simultaneously. Don't work bit by bit, but paint everything at once by placing tones everywhere, with brush strokes of the right color and value, while noticing what is along-side. Use small brush strokes and try to put down your perceptions im-mediately. The eye should not be fixed on one point, but should take in everything, while observing the reflections which the colors produce on their surroundings. Work at the same time upon sky, water, branches, ground, keeping everything going on an equal basis and unceasingly re-work until you have got it. Cover the canvas at the first go, then work at it until you can see nothing more to add. Observe the aerial perspective well, from the foreground to the horizon, the reflections of sky, of foliage. Don't be afraid of putting on color, refine the work little by little. Don't proceed according to rules and principles, but paint what you observe and feel. Paint generously and unhesitatingly, for it is best not to lose the first impression. Don't be timid in front of nature: one must be bold, at the risk of being deceived and making mistakes. One must have only one master—nature; she is the one always to be consulted.[49]

EDGAR DEGAS: 1834–1917

Degas' Notebooks

Edgar Degas, the most aristocratic of the Impressionists, was the one most consistently concerned with drawing throughout his long artis-tic career. He began his studies in the studio of Louis Lamothe, a pupil of Ingres, painting historical scenes and supplementing his acquaintance with the art of the past by visits to Italy, where part of his family lived. Less interested in painting out-of-doors than the other members of the

[49] From the notes of the painter Louis Le Bail, cited in John Rewald, *The His-tory of Impressionism*, p. 458.

group, Degas nevertheless, after his rejection of more traditional themes and his adherence to the Impressionist circle, was vitally involved with contemporary subjects, with grasping the very appearance, attitude, and character of his own times through the medium of line and color; it is no accident that he, like Manet, to whom he was most similar in background, should be the most successful of the Impressionists as a portrait painter. While unsystematic in his theoretical program, Degas was both intelligent and intellectually adventurous, turning to investigate the art of Japan or photography, or striving after that strict yet supple union of form and feeling demanded by the sonnet form.

The following excerpts from his notebooks, of which there are thirteen—copiously illustrated—preserved in the Bibliothèque Nationale in Paris, provide an invaluable insight into his chief preoccupations as an artist. Personal, penetrating, obviously meant to be private—to the point of being ungrammatical at times—they reveal an artist intrigued by all the possibilities offered by the visible world about him, and above all, by the range of novelties and revelations into this seemingly commonplace subject matter which might be provided by the infinite variation of viewpoint or position of the artist himself: a most modern idea indeed! Many of these statements reveal a kinship with the ideas of Degas' friend, the critic Duranty, whose La Nouvelle Peinture *was published in 1876. (See above, pp. 3 to 7.)*

From Degas' Notebook: 1863–1867

What is certain is that putting a bit of nature in place and drawing it are two entirely different things.[50]

I don't like to hear people saying like children in front of rosy and glowing flesh: "Oh, what life, what blood!"—the human skin is as varied in appearance, especially among us, as the rest of nature: fields, trees, mountains, water, forests. It is possible to meet with as many resemblances between a face and a pebble as between two pebbles because everyone still wants to see a likeness between two faces. (I am speaking in terms of the question of form, not bringing up that of coloring, since we often find so much connection between a pebble and a fish, a mountain and a dog's head, clouds and horses, etc.)

Therefore, it is not merely instinct which makes us say that we must search for a method of coloring everywhere, for the affinities among what is alive, what is dead and what vegetates. I can, for example, easily recall the color of some hair, because I got the idea that it was hair made

[50] See below, p. 64, for Paul Valéry's explanation of this statement of Degas: "He meant to distinguish what he called the *mise en place,* or the conventional representation of objects, from what he called the 'drawing' or the alteration which this exact representation . . . undergoes from a particular artist's way of seeing and working."

out of polished walnutwood, or else flax, or horse-chestnut shells. The rendering of the form will make real hair, with its softness and lightness or its roughness or its weight out of this tone which is almost precisely that of walnutwood, flax, or horse-chestnut shell. And then one paints in such different ways on such different supports that the same tone might be one thing in one place, another in another.[51]

From Degas' Notebook: 1869

Do expressive heads (academic style) a study of modern feeling . . . It is Lavater,[52] but a more relativistic Lavater, so to speak, with symbols of today rather than the past. . . .

Work a lot on night effects, lamp, candle, etc. The fun is in not always showing the source of light but rather the effect of the light. This part of art can become immense today—is it possible not to see it? Draw a lot. Oh, beautiful drawing! —Ornament is the intelligence connecting one thing and another or [one] overcomes this gap by a connection between the two things and that's the source of ornament. . . .

Make portraits of people in familiar and typical positions, above all, give their faces the same choice of expression one gives their bodies. Thus, if laughter is typical of a person, make him laugh—there are, naturally, feelings that one cannot render. . . .[53]

From Degas' Notebook: 1878–1884

After having done portraits seen from above, I will do them seen from below—sitting very close to a woman and looking at her from a low viewpoint, I will see her head in the chandelier, surrounded by crystals, etc.; do simple things like draw a profile which would not move, [the painter] himself moving, going up or down, the same for a full face—a piece of furniture, a whole living room; do a series of arm-movements of the dance, or of legs that would not move, himself turning either around or—etc. Finally study a figure or an object, no matter what, from every viewpoint. One could use a looking glass for that, one would not [have to] stir from one's place. Only the looking glass would be lowered or tilted. One would turn about. Studio projects: Set up tiers [a series of benches] all around the room so as to get used to drawing things from

[51] Edgar Degas, Notebook CI (1863–1867), B.N. carnet 327 d rés., 8, formerly E, published by Jean Sutherland Boggs, "Degas Notebooks at the Bibliothèque Nationale —III: Group C (1863–1866)," *The Burlington Magazine*, C (July, 1958), 243; translation by Linda Nochlin of all material from Degas' Notebooks; the dates are those ascribed by Miss Boggs. Reprinted by permission of the publisher.

[52] Johann Kaspar Lavater (1741–1801), Swiss poet, mystic, and theologian who developed a system of physiognomy by means of which one could arrive at a penetrating knowledge of human nature.

[53] Edgar Degas, Notebook CII (1869), B.N. carnet 327 d rés., 21, formerly R, in Boggs, *Burlington*, pp. 243–244.

above and below. Only let myself paint things seen in a looking glass to get used to hatred of trompe-l'oeil.

For a portrait, make someone pose on the ground floor and work on the first floor to get used to keeping hold of the forms and expressions and never draw or paint *immediately*.

For the Newspaper cut a lot. Of a dancer do either the arms or the legs or the back. Do the shoes—the hands—of the hairdresser—the badly cut coiffure . . . , bare feet in dance, action, etc., etc.

Do every kind of worn object placed, accompanied in such a way that they have the life of the man or the woman; corsets which have just been taken off, for example—and which keep the form of the body, etc., etc.

Series on instruments and instrumentalists, their shapes, twisting of the hands and arms and neck of the violinist, for example, puffing out and hollowing of the cheeks of bassoons, oboes, etc.

Do a series in aquatint on *mourning* (different blacks), black veils of deep mourning (floating on the face), black gloves, carriages in mourning, carriage of the Funeral Company, carriages like Venetian gondolas.

On smoke, smoke of smokers, pipes, cigarettes, cigars, smoke of locomotives, of high chimneys, factories, steamboats, etc. Destruction of smoke under the bridges. Steam.

On the evening. Infinite subjects. In the cafés, different values of the glass-shades reflected in the mirrors.

On the bakery, the bread: series on journeymen bakers, seen in the cellar itself or through the air vents from the street. Colors of pink flour —lovely curves of pie, still lifes on the different breads, large, oval, fluted, round, etc. Experiment, in color, on the yellows, pinks, grey-whites of breads. Perspective views of rows of breads. Charming layout of bakeries. Cakes, the wheat, the mills, the flour, the sacks, the market-porters.

No one has ever done monuments or houses from below, from beneath, up close as one sees them going by in the streets.[54]

Degas Viewed by Paul Valéry

From the beginning of his life in Paris, when he arrived there from Montpellier in 1892, the French poet Paul Valéry (1871–1945) came to know not merely the circle of Symbolist poets and painters and members of the Nabi group like Vuillard and Bonnard, but also, through Henri Rouart, Berthe Morisot, and the circle that gathered in their houses, the surviving Impressionist painters: Degas, Monet, and Renoir. In actuality, Degas was the only Impressionist artist intellectual enough in his approach to appeal to the hypercerebral writer. The study devoted to Degas

[54] Edgar Degas, Notebook CIX (1878–1884), B.N. 327 d rés., 9, formerly F, in Boggs, *Burlington*, pp. 245–246.

*in Degas, Dance, Drawing, did not appear until 1936, many years after
his actual contact with the painter; in many cases, as Valéry himself is
the first to admit, one feels that the poet is simply allowing his thoughts
to pursue a series of "variations on the theme of Degas." Still at times,
the real Degas emerges: witty, highly cultivated, yet armed, like so many
sensitive people, with a "continual, splenetic touchiness," "blunt to a
degree of brutality," as quick to wound with cutting sarcasm as to be
offended by it himself.*

Drawing is Not the Same as Form

Degas liked talking about painting, but could ill bear anyone else
doing so. From writers he would not suffer it at all. He made it his busi-
ness to silence them. For their benefit he always had ready a certain
aphorism of Proudhon's, which I cannot recall, about the "literary
gentry." . . .

Since I was not writing at all, and since he repeated the aphorism
too often, I was not intimidated. On the contrary I enjoyed the ease with
which I could put him in a rage. I would say: "But look here, just what
do you mean by *Drawing?*"

He would reply with his celebrated axiom: "Drawing is not the
same as form, it is a way of seeing form."

This is where the storm would break out.

"Can't follow," I would mumble, in a tone rather suggesting that
the pronouncement seemed to me empty or meaningless.

At once he would start shouting. I would hear him thundering that
I knew nothing about it, that it was no business of mine. . . .

Both of us had *reason* on our side. Degas' statement can mean what
you will, and it was true enough that I had no right to question it.

I had quite a good idea of what he meant. He meant to distinguish
what he called the *mise en place,* or the conventional representation of
objects, from what he called the "drawing," or the alteration which this
exact representation—for example, that of a camera lucida—undergoes
from a particular artist's way of seeing and working.

It is because of this *personal bias* in the task of representing things
by pencil strokes and shadings that *art* becomes possible.

The camera lucida, which I take as the best means of defining *mise
en place,* would enable us to begin work at any point, dispensing us from
so much as taking a view of the whole, from any effort to find the rela-
tionships between lines or surfaces, and so from transforming the thing
seen into the thing *experienced*—that is, into a *personal act.*

Certainly there are draftsmen, of undeniable merit, whose work has
the precision, the evenness, and the veracity of the camera lucida. The
same coldness too; and the nearer they are to perfection in their practice,
the less distinguishable is the work of one such craftsman from another.

Quite the contrary is the case with the real artist. His value resides in certain *inequalities,* all with the same tendency or meaning, uniting to reveal—with regard to a figure, a scene, a landscape—an *aptitude, will,* and *necessity* that are entirely *personal:* a personal power to transpose and recreate. Things in themselves reveal nothing of all this: and it is never of the same kind in two different individuals.

What Degas called a "way of seeing" must consequently bear a wide enough interpretation to include *way of being, power, knowledge,* and *will.* . . .

He would often repeat a saying which I believe he had borrowed from Zola, and Zola from Bacon, as a definition of Art: *Homo additus naturae.*[55] All that remains is to find a meaning for each of these terms. . . .[56]

Berthe Morisot's Recollections of Degas

Here is some of Degas' table talk at Berthe Morisot's, as recorded by her in a notebook.[57]

Degas declared that the study of nature is meaningless, since the art of painting is a question of conventions, and that it was by far the best thing to learn drawing from Holbein; that Edouard [58] himself, though he made a boast of slavishly copying nature, was in fact the most mannered painter in the world, never making a brush stroke without first thinking of the masters—for example, he never showed the finger-nails, because Frans Hals left them out.

[It seems to me that Degas is in error here. Hals shows the finger-nails, including Descartes'. (P. V.)]

(At dinner, with Mallarmé:) [59] Art is falsehood! And he goes on to explain how a man is an artist only at certain moments, by an effort of will. Objects have the same appearance for everybody. . . .

Degas says "orange gives color, green neutralizes, violet gives shading." [60]

55 "Man is the enemy of nature."

56 Paul Valéry, "Degas, Dance, Drawing," in *Degas, Manet, Morisot,* trans. David Paul (New York: Bollingen Foundation, 1960), pp. 81–83. (*Degas Danse Dessin* was originally published in 1935.) Reprinted by permission of the publisher.

57 Berthe Morisot (1841–1895), a talented member of the Impressionist group, was closely linked with Manet and later became his sister-in-law when she married his brother, Eugène Manet, in 1874, the year in which she participated in the first Impressionist Exhibition. In 1900, Valéry married Berthe Morisot's niece, Jeannie Gobillard, whose guardian had been the poet, Stéphane Mallarmé.

58 "Edouard" refers to Edouard Manet, who was, of course, Berthe Morisot's brother-in-law, as well as a close friend of Degas.

59 Stéphane Mallarmé (1842–1898), French poet and a leader of the Symbolist movement, friend of Manet, Degas, and Berthe Morisot, as well as of many other advanced painters and writers.

60 Berthe Morisot in Paul Valéry, *Degas, Manet, Morisot,* pp. 83–84.

A Letter to James Tissot

James Jacques Joseph Tissot (1836–1902), fashionable painter and graphic artist, had studied under Lamothe, Flandrin, and Ingres, and had subsequently become a good friend of Degas, who painted his portrait, now at the Metropolitan Museum in New York, in 1868. In this letter, Degas urges his friend to exhibit at what was to be known as the first Impressionist Exhibition, which took place in Nadar's studio in the Boulevard des Capucines. The eye trouble Degas refers to became more and more serious with time; at first a blind spot which blocked off his vision at any point directly regarded, the difficulty later became more generalized, contributing, in the opinion of many critics, to the artist's adoption of the pastel medium and the greater degree of coloristic abstraction, the larger scale, and the suppression of detail characteristic of his style after the eighties.

Manet, as Degas scornfully points out, refused to participate in this revolutionary undertaking, or in any other of the Impressionist Exhibitions for that matter, preferring to take part in the regular Salons.

FRIDAY, 1874

Look here, my dear Tissot, no hesitations, no escape. You positively must exhibit at the Boulevard. It will do you good, you (for it is a means of showing yourself in Paris from which people said you were running away) and us too. Manet seems determined to keep aloof, he may well regret it. Yesterday I saw the arrangement of the premises, the hangings, and the effect in daylight. It is as good as anywhere. And now Henner [61] (elected to the second rank of the jury) wants to exhibit with us. I am getting really worked up and am running the thing with energy and, I think, a certain success. The newspapers are beginning to allow more than just the bare advertisement and though not yet daring to devote a whole column to it, seem anxious to be a little more expansive.

The realist movement no longer needs to fight with the others; it already *is,* it *exists,* it must show itself as *something distinct,* there must be a *salon of realists.*

Manet does not understand that. I definitely think he is more vain than intelligent. . . .

So forget the money side for a moment. Exhibit. Be of your country and with your friends.[62]

The affair, I promise you, is progressing better and has a bigger reception than I ever thought possible.

[61] Jean-Jacques Henner (1829–1905), extremely successful painter of history, portraits, and genre, winner of numerous medals, and elected to the Legion of Honor in 1873.

[62] Tissot, an active member of the Paris Commune in 1870, had been forced to leave France in 1871, taking refuge in London, from which he had recently returned.

My eyes are very bad. The occulist wanted me to have a fortnight's complete rest. He has allowed me to work just a little until I send in my pictures. I do so with much difficulty and the greatest sadness.

Ever your,

DEGAS

I have not yet written to Legros.[63] Try and see him and stir up his enthusiasm for the matter. We are counting firmly on him. He has only another sixty francs to deposit. The bulk of the money is all but collected.

The general feeling is that it is a good, fair thing, done simply, almost boldly.

It is quite possible that we wipe the floor with it as they say. But the beauty of it will be ours.

Hurry up and send.[64]

Two Sonnets by Degas

As Paul Valéry pointed out, no animal is closer to a première danseuse, *the star of the corps de ballet, than a purebred horse. The horse and the ballet dancer furnished Degas with his themes in literary efforts as well as in art; some twenty sonnets bear witness to his achievement in this poetic genre, which, demanding enormous self-discipline, "above all . . . compels the mind to accept* form *and* content *as being of equal importance." This charming little story, recounted by Valéry about Degas and Mallarmé illustrates this truth: once at Berthe Morisot's, after having struggled over the composition of a sonnet without success, Degas complained that he had wasted his whole day over the poem without making a bit of progress. "All the same," he lamented, "it isn't that I'm short on ideas . . . I'm full of them, I have too many. . . ." And Mallarmé, in his usual quiet way, replied: "But Degas, you don't make poetry with ideas, you make it with words."*

LITTLE DANCER

Dance, wingéd child, in your stage built glade.
Dance be your life, dance be your charm.
In its sinuous line, let your slender arm
Gracefully balance your glide and your weight.

[63] Alphonse Legros (1837–1911), French painter and etcher, friend of Fantin-Latour and Whistler, who finally established himself in London, where he made a great success, above all, as a graphic artist.
[64] Edgar Germain Hilaire Degas, *Letters*, ed. Marcel Guérin, trans. Marguerite Kay (Oxford: Bruno Cassirer [1948]), pp. 38–40. Reprinted by permission of the publisher.

Taglioni awake! Come Arcady's queen!
Nymphs, graces, descend from your far off height;
With a smile at my choice, imbue with your light
That creature so new, so gallant of mien.

If Montmartre gave the forebears, the spirit so wise,
Roxelane the nose and China the eyes,
Hearken, oh Ariel, give this young fay

The lightness, by day and by night, of your feet
And see, for my sake, in her golden palais,
She remembers her race, her descent from the street.[65]

PURE–BRED

You can hear him coming, his pace checked by the bit,
His breath strong and sound. Ever since dawn
The groom has been putting him through his paces
And the brave colt, galloping, cuts through the dew.

Blood-strength, like the burgeoning day drawn up from
The East, gives our novice runner,
Precocious, impervious to ceaseless work,
The right to command crossbreeds.

Nonchalant and diffident, with slow-seeming step,
He returns home for oats. He is ready.
Now, all at once, the gambler grabs him.

And for the various games where he's used for gain
He's forced onto the field for his debut as a thief,
All nervously naked in his dress of silk.[66]

AUGUSTE RODIN: 1840–1917

Art and Nature

The gigantic, ebullient figure of Auguste Rodin towers over the sculpture of the 19th century. Starting out with the eloquently modeled Man with the Broken Nose, *rejected from the 1864 Salon because of its lack of moral elevation and fragmentary condition, Rodin went on during his long lifetime to create an* oeuvre *marked—despite its obvious debt to Donatello, French Gothic Sculpture, and Michelangelo—by extremely personal formal and expressive qualities, though at times marred by excessive symbolism or too overt emotion. Allied to the Impressionists both in his opposition to academicism and pre-existing formula—that is, in the basic realism of his approach to his subjects—his* Age of Bronze *(1876) was*

[65] Edgar Degas in Guérin, *Letters,* p. 264.
[66] Edgar Degas, "Pur Sang," *Huit Sonnets d'Edgar Degas,* ed. Jean Nepveu Degas (Paris: La Jeune Parque, New York: Wittenborn and Company [1946]), p. 25. (Trans. Linda Nochlin.) Reprinted by permission of George Wittenborn, Inc.

accused of having been cast from life!—and in his concern with the evasive entity of light as the primary formative element in art, Rodin nevertheless differs from the Impressionists in his emphasis upon the expressive qualities of his works: the lumps and hollows of their surfaces, the restless, flickering lights and shadows which play across their serrations are not merely descriptive, but at all times conveyors of a message of human suffering, eroticism, or compassion. Even when, in his carving, he leaves a portion of the stone material unfinished, it is not so much to remind one of the limits *imposed by the medium (as was the case for Michelangelo) but rather for its literary or symbolic significance.*

Despite lack of recognition and financial difficulties in his early days, Rodin went on to create a series of major masterpieces, works such as the John the Baptist *(1878),* The Burghers of Calais *(1884–1886),* La Pensée *(1886), and the* Balzac *(1890s), as well as the monumental, all-inclusive and ever-unfinished* Gate of Hell *(1880–1917), which, in his old age, led to extraordinary worldly success. He was visited by royalty, in constant demand as a portraitist by the wealthy and famous of all nations, and elected president of the International Society of Painters, Sculptors, and Engravers in 1903; public adulation reached near deification in an admiring coterie. Thus, the words of the master were taken down almost verbatim by a number of biographers, the best of whom, Judith Cladel, began her work in 1902, the very year in which Rodin began his correspondence with Rainer Maria Rilke (1875–1926), the German poet who later wrote such a penetrating account of the master's work. (See below, pp. 74 to 76.)*

To comprehend nature it is of importance that we never substitute ourselves for it. The corrections that a man imposes upon himself are a mass of mistakes. The tiger has claws and teeth and uses them skilfully; man at times shows himself inferior. Possessing intelligence, too often he strives to turn to that. Animals respect everything and touch nothing. The dog loves his master, and has no thought of criticizing him. The average man does not care that his daughter should be beautiful. He has in his mind certain ideas of manner and instruction, and the beauty of his daughter does not enter into the program that he has made. But the daughter herself feels the influence of nature, and displays her modest and triumphant movements, which this blind one does not see, but which fascinate the artist.

The artist who tells us of his ideal commits the same error that this average man commits. His ideal is false. In the name of this ideal he pretends to rectify his model, retouching a profound organism which admirably combined laws regulate. Through his so-called corrections he destroys the ensemble; he composes a mosaic instead of creating a work of art; the faults of his model do not exist. If we correct that which we call a fault, we simply present something in the place of that which nature has pre-

sented. We destroy the equilibrium; the rectified part is always that which is necessary to the harmony of the whole. There is nothing paradoxical here, because a law that is all-powerful keeps the harmony of opposites. That is the law of life. Everything, therefore, is good, but we discover this only when our thought acquires power; that is to say, when it attaches itself indissolubly to nature, for then it becomes part of a great whole, a part of united and complex forces. Otherwise it is a miserable, debased, detached part contending with a whole that is formed of innumerable units.

Nature, therefore, is the only guide that it is necessary to follow. She gives us the truth of an impression because she gives us that of its forms, and if we copy this with sincerity, she points out the means of uniting these forms and expressing them.

Sincerity, conscience—these are the true bases of thought in the work of an artist; but whenever the artist attains to a certain facility of expression, too often he is wont to replace conscience with skill. The reign of skill is the ruin of art. It is organized falsehood. Sincerity with one fault, indeed with many faults, still preserves its integrity. The facility that believes that it has no faults has them all. The primitives, who ignored the laws of perspective, nevertheless created great works of art because they brought to them absolute sincerity. Look at this Persian miniature, the admirable reverence of this illuminator for the form of these plants and animals, and the attitudes of these persons which he has forced himself to render just as he saw them. How eagerly has he painted that, this man who loved it all! Do you tell me that his work is bad because he is ignorant of the laws of perspective? And the great French primitives and the Roman architects and sculptors! Has it not been repeatedly said that their style is a barbaric style? On the contrary, it has a formidable beauty. It breathes the sacred awe of those who have been impressed by the great works of nature herself. It offers us the strongest proof that these men had made themselves part of life and also a part of its mystery.

To express life it is necessary to desire to express it. The art of statuary is made up of conscience, precision, and will. If I had not had tenacity of purpose, I should not have produced my work. If I had ceased to make my researches, the book of nature would have been for me a dead letter, or at least it would have withheld from me its meaning. Now, on the contrary, it is a book that is constantly renewed, and I go to it, knowing well that I have only spelled out certain pages. In art to admit only that which one comprehends leads to impotence. Nature remains full of unknown forces.

As for me, I have certainly lost some time through the fault of my period. I should have been able to learn much more than I have grasped with so much slowness and circumlocution; but I should not have tasted

less happiness through that highest form of loss; that is, work. And when my hour shall come, I shall dwell in nature, and shall regret nothing.[67]

On Art and Artists

One of Rodin's deepest convictions, most overtly expressed in such figures as "She Who Was Once the Helmet-Maker's Beautiful Wife" *(1885), with its shriveled breasts, twisted limbs, and awkward pose mingling resignation and defiance, yet constantly manifested in less obvious ways in works like the marvelously expressive series of heads of the Japanese dancer Hanako (1908–1911) or the gross yet awesome* Large Head of Iris *(1890–1891), was the idea that there was no such thing as an innately ugly or unsuitable subject for art, but, on the contrary, that the beauty or ugliness of an art work resided in its making, and in the authenticity of the artist's confrontation of nature.*

This view, as well as many other opinions and ideas of the aging artist on a large variety of subjects—movement, themes, antique art—was expressed to Rodin's Boswell, the young littérateur Paul Gsell, in a series of revealing conversations on art, which the latter published in 1911.

On Ugliness in Art

The vulgar readily imagine that what they consider ugly in existence is not fit subject for the artist. They would like to forbid us to represent what displeases and offends them in nature.

It is a great error on their part.

What is commonly called *ugliness* in nature can in art become full of great beauty.

In the domain of fact we call *ugly* whatever is deformed, whatever is unhealthy, whatever suggests the ideas of disease, of debility, or of suffering, whatever is contrary to regularity, which is the sign and condition of health and strength: a hunch-back is *ugly,* one who is bandy-legged is *ugly,* poverty in rags is *ugly.*

Ugly also are the soul and the conduct of the immoral man, of the vicious and criminal man, of the abnormal man who is harmful to society; *ugly* the soul of the parricide, of the traitor, of the unscrupulously ambitious.

And it is right that beings and objects from which he can expect only evil should be called by such an odious epithet. But let a great artist or a great writer make use of one or the other of these *uglinesses,* instantly it is transfigured: with a touch of his fairy wand he has turned it into beauty; it is alchemy; it is enchantment! . . .

[67] Auguste Rodin in Judith Cladel, *Rodin: The Man and his Art, with Leaves from his Note-Book,* trans. S. K. Star (New York: The Century Co., 1918), pp. 215–218.

. . . To the great artist, everything in nature has character; for the unswerving directness of his observation searches out the hidden meaning of all things. And that which is considered ugly in nature often presents more *character* than that which is termed beautiful, because in the contractions of a sickly countenance, in the lines of a vicious face, in all deformity, in all decay, the inner truth shines forth more clearly than in features that are regular and healthy.

And as it is solely the power of *character* which makes for beauty in art, it often happens that the uglier a being is in nature, the more beautiful it becomes in art.

There is nothing ugly in art except that which is without character, that is to say, that which offers no outer or inner truth.

Whatever is false, whatever is artificial, whatever seeks to be pretty rather than expressive, whatever is capricious and affected, whatever smiles without motive, bends or struts without cause, is mannered without reason; all that is without soul and without truth; all that is only a *parade* of beauty and grace; all, in short, that lies, is *ugliness* in art. . . .

On Modeling

I will tell you a great secret. Do you know how the impression of actual life, which we have just felt before that Venus,[68] is produced?

By the *science of modeling*.

These words seem banal to you, but you will soon gauge their importance.

The *science of modeling* was taught me by one Constant, who worked in the atelier where I made my debut as a sculptor. One day, watching me model a capital ornamented with foliage—"Rodin," he said to me, "you are going about that in the wrong way. All your leaves are seen flat. That is why they do not look real. Make some with the tips pointed at you, so that, in seeing them, one has the sensation of death." I followed his advice and I was astounded at the result that I obtained. "Always remember what I am about to tell you," went on Constant. "Henceforth, when you carve, never see the form in length, but always in thickness. Never consider a surface except as the extremity of a volume, as the point, more or less large, which it directs toward you. In that way you will acquire the *science of modeling*."

This principle was astonishingly fruitful to me. I applied it to the execution of figures. Instead of imagining the different parts of a body as surfaces more or less flat, I represented them as projectures [projections] of interior volumes. I forced myself to express in each swelling of the torso or of the limbs the efflorescence of a muscle or of a bone which lay deep beneath the skin. And so the truth of my figures, instead of being

[68] The Venus referred to in this excerpt from a conversation with Paul Gsell was a small antique copy of the *Medici Venus* that Rodin kept in his studio.

merely superficial, seems to blossom from within to the outside, like life itself. . . .

On Movement

Note, first, that *movement is the transition from one attitude to another.*

This simple statement, which has the air of a truism, is, to tell the truth, the key to the mystery.

You have certainly read in Ovid how Daphne was transformed into a bay tree and Procne into a swallow. This charming writer shows us the body of the one taking on its covering of leaves and bark and the members of the other clothing themselves in feathers, so that in each of them one still sees the woman which will cease to be and the tree or bird which she will become. You remember, too, how in Dante's *Inferno* a serpent, coiling itself about the body of one of the damned, changes into man as the man becomes reptile. The great poet describes this scene so ingeniously that in each of these two beings one follows the struggle between two natures which progressively invade and supplant each other.

It is, in short, a metamorphosis of this kind that the painter or the sculptor effects in giving movement to his personages. He represents the transition from one pose to another—he indicates how insensibly the first glides into the second. In his work we still see a part of what was and we discover a part of what is to be. An example will enlighten you better.

You mentioned just now the statue of Marshal Ney by Rude. . . .[69] Well—when you next pass that statue, look at it still more closely. You will then notice this: the legs of the statue and the hand which holds the sheath of the saber are placed in the attitude that they had when he drew—the left leg is drawn back so that the saber may be easily grasped by the right hand, which has just drawn it; and as for the left hand, it is arrested in the air as if still offering the sheath.

Now examine the body. It must have been slightly bent toward the left at the moment when it performed the act which I have described, but here it is erect, here is the chest thrown out, here is the head turning toward the soldiers as it roars out the order to attack; here, finally is the right arm raised and brandishing the saber.

So there you have a confirmation of what I have just said; the movement in this statue is only the change from a first attitude—that which the Marshal had as he drew his saber—into a second, that which he had as he rushes, arm aloft, upon the enemy.

In that is all the secret of movement as interpreted by art. The sculptor compels, so to speak, the spectator to follow the development of

[69] François Rude (1784–1855), French sculptor best known for his *Departure of the Volunteers* on the east façade of the Arc de Triomphe. The bronze statue of Marshal Ney stands at the Place de l'Observatoire in Paris.

an act in an individual. In the example that we have chosen, the eyes are forced to travel upward from the lower limbs to the raised arm, and, as in so doing they find the different parts of the figure represented at successive instants, they have the illusion of beholding the movement performed. . . .

Theme, Thought, and Form in Art

To sum it up . . . you must not attribute too much importance to the themes that you interpret. Without doubt, they have their value and help to charm the public; but the principal care of the artist should be to form living muscles. The rest matters little. . . . You must not think that my last words contradict what I said before.

If I say that a sculptor can confine himself to representing palpitating flesh, without preoccupying himself with subject, this does not mean that I exclude thought from his work; if I desire that he need not seek symbols, this does not signify that I am a partisan of an art deprived of spiritual significance.

But, to speak truly, all is idea, all is symbol. So the form and the attitude of a human being reveal the emotions of its soul. The body always expresses the spirit whose envelope it is. And for him who can see, the nude offers the richest meaning. In the majestic rhythm of the outline, a great sculptor, a Phidias, recognizes the serene harmony shed upon all nature by the divine wisdom; a simple torso, calm, balanced, radiant with strength and grace, can make him think of the all-powerful mind which governs the world.[70]

Rainer Maria Rilke: On Rodin

Rodin himself felt that the relatively brief essay of Rainer Maria Rilke (1875–1926) was the supreme interpretation of his work. The young German poet began his correspondence with the aging sculptor in 1902, and served as Rodin's secretary from 1905 to 1906, although he had had access to the artist's work and thoughts before that time, writing his first study of Rodin in 1903. At a time when the sculptor's representation of partial or fragmentary figures—such as the armless Walking Man, *the headless* Study of a Seated Woman, Flying Figure, *and* Iris, *or the legless* Torso of Adèle—*was considered perverse, destructive, or even sadistic, Rilke's sympathy with and insight into the distinction between that which is* fragmentary *and that which is merely* incomplete *is a bold one; it is, of course, reminiscent of Baudelaire's similarly audacious differentiation between a painting that is* complete *and a work that is* finished, *in his* Salon of 1845. *The whole question of finish and completeness, the*

70 Auguste Rodin, *On Art and Artists*, introd. Alfred Werner, trans. from French of Paul Gsell by Mrs. Romilly Fedden (New York: Philosophical Library, 1957), pp. 58–60, 62–64, 75–77, 84–87, 176–177. Reprinted by permission of the publisher.

sketch and the final work, the totality and the fragment, was of course a crucial one throughout the second half of the 19th century. It was precisely this aspect of Rodin's art—the partial figure or the parts of the body exhibited as independent entities—that most appealed to the avant-garde sculptors of the future, like Maillol, Matisse, Lehmbruck, Brancusi, the Cubist sculptors, and Giacometti.

The Fragment

. . . Completeness is conveyed in all the armless statues of Rodin: nothing necessary is lacking. One stands before them as before something whole. The feeling of incompleteness does not rise from the mere aspect of a thing, but from the assumption of a narrow-minded pedantry, which says that arms are a necessary part of the body and that a body without arms cannot be perfect. It was not long since that rebellion arose against the cutting off of trees from the edge of pictures by the Impressionists. Custom rapidly accepted this impression. With regard to the painter, at least, came the understanding and the belief that an artistic whole need not necessarily coincide with the complete thing, that new values, proportions, and balances may originate within the pictures. In the art of sculpture, also, it is left to the artist to make out of many things one thing, and from the smallest part of a thing an entirety.

There are among the works of Rodin hands, single small hands which, without belonging to a body, are alive. Hands that rise, irritated and in wrath; hands whose five bristling fingers seem to bark like the five jaws of a dog of Hell. Hands that walk, sleeping hands, and hands that are awakening; criminal hands, tainted with hereditary disease; and hands that are tired and will do no more, and have lain down in some corner like sick animals that know no one can help them. But hands are a complicated organism, a delta into which many divergent streams of life rush together in order to pour themselves into the great storm of action. There is a history of hands; they have their own culture, their particular beauty; one concedes to them the right of their own development, their own needs, feelings, caprices, and tendernesses. Rodin, knowing through the education which he has given himself that the entire body consists of scenes of life, of a life that may become in every detail individual and great, has the power to give to any part of this vibrating surface the independence of a whole. As the human body is to Rodin an entirety only as long as a common action stirs all its parts and forces, so on the other hand portions of different bodies that cling to one another from an inner necessity merge into one organism. A hand laid on another's shoulder or thigh does not any more belong to the body from which it came—from this body and from the object which it touches or seizes something new originates, a new thing that has no name and belongs to no one.

This comprehension is the foundation of the grouping of figures by Rodin; from it springs that coherence of the figures, that concentration of the forms, that quality of clinging together. He does not proceed to work from figures that embrace one another. He has no models which he arranges and places together; he starts with the points of the strongest contact as being the culminating points of the work. There where something new arises, he begins and devotes all the capacity of his chisel to the mysterious phenomenon that accompanies the growth of a new thing. He works, as it were, by the light of the flame that flashes out from these points of contact, and sees only those parts of the body that are thus illuminated. . . .

The Function of Atmosphere

To Rodin the participation of the atmosphere in the composition has always been of greatest importance. He has adapted all his figures, surface after surface, to their particular space and environment; this gives them the greatness and independence, the marvelous completeness and life which distinguishes them from all other works. When interpreting nature he found, as he intensified an expression, that, at the same time, he enhanced the relationship of the atmosphere to his work to such a degree that the surrounding air seemed to give more life, more passion, as it were, to the embraced surfaces. A similar effect may be observed in some of the animals on the cathedrals to which the air relates itself in strange fashion; it seems to become calm or storm according to whether it sweeps over emphasized or level surfaces. When Rodin concentrates the surfaces of his works into culminating points, when he uplifts to greater height the exalted or gives more depth to a cavity, he creates an effect like that which atmosphere produces on monuments that have been exposed to it for centuries. The atmosphere has traced deeper lines upon these monuments, has shadowed them with veils of dust, has seasoned them with rain and frost, with sun and storm, and has thus endowed them with endurance so that they may remain imperishable through many slowly passing dusks and dawns.[71]

MEDARDO ROSSO: 1858–1928

About Impressionism in Sculpture

The Italian sculptor Medardo Rosso attempted to achieve the same immediacy of visual impact and sense of spontaneity in wax, clay, plas-

[71] Rainer Maria Rilke, *Rodin,* trans. Jessie Lemont and Hans Trausil (New York: The Fine Editions Press, 1945), pp. 29–31, 67–68. Originally published in Berlin in 1903 and Leipzig, 1913.

ter, and bronze as the French Impressionist painters had with pigment and canvas. Like Rodin, whose bold freedom of form he ultimately surpassed, Rosso tried to go beyond the self-imposed limitations for sculpture set by the classicists and at the same time to achieve for the realm of three-dimensional art those qualities dependent upon the personal touch of the artist which called for the rejection of mechanical methods of execution, such as "pointing"—the making of a plaster or clay model with points at proper intervals and the transfer of these points to the stone block itself, so as to reproduce the model accurately in stone—then practiced by all the major sculptors. Like the Impressionists, Rosso was preoccupied with the problems of light and the reciprocal interplay of subject and environment within a specific context of illumination. After a period of study and work in Milan, during which he was strongly influenced by Baudelaire's ideas about sculpture (see p. 78 and n. 73 below), Rosso made his first trip to Paris in 1884, where he probably came into contact with Impressionist work and met Rodin; he returned to Paris in 1889 for a prolonged stay, this time until 1897. During this period he was encouraged by the interest of Rodin (who expressed a "wild admiration" for the younger sculptor and whom Rosso later accused of imitation) and by the support of the advanced collector and friend of Degas and the Impressionists, Henri Rouart.

In his experimental attitude toward his medium, and in his attempt to conceive of sculpture as a totality viewed from a single viewpoint rather than as an isolated object to be walked around, Rosso made a significant contribution to the generally uninspired sculpture of the 19th century. His achievements were highly praised early in the 20th century by the young Italian Futurists, who shared and exaggerated Rosso's disdain for the past and his insistence upon the dynamic merging of subject and setting, the subjectivity of perception and the objectivity of external reality—ideas such as those expressed by Rosso in the interview printed below.

How many "great masters" would be unknown and would have produced nothing if the Ancients had not preceded them! And, in another realm of ideas, if the Egyptians had not learned about the falseness of holes, of empty spaces, wouldn't the Romans and Greeks have forgotten that unity, and wouldn't their works seem trivial next to the others? You see that I have the greatest respect for the antique masters, who didn't have time to make themselves into second-hand dealers of art, leaders of a School, and who disdained the title of "cher maître." [72] And yet they had the right to be treated as "masters," those who achieved personal works of art and did not live off imitation.

[72] Untranslatable term of respect used by the French for a great artist or teacher.

This has nothing to do with the question that has been raised; but when one sees governments meddling with matters of art, and through authoritarian financial pressures turning what is disdainfully called "the public" away from an artist, then it is not astonishing that the latter is placed on the index.

It is true, however, that Rodin, president of the Salon jury, proud of my friendship, wished to give a token of recognition and sympathy to my work by resigning from the award-giving jury that wanted to exclude me.

But, let us return to the question. I must benefit from this inquiry by pointing out the conception of art that sculptors cannot make known because of this kind of inquisition which is directed against them by the administration.

I believe that a work of art can be executed only by the person who conceived it; it is the very first goal to be achieved. In doing this, the hack-workers would be eliminated, as well as an administration by which so many artists say they are not employed at the same time as they work for it as studio assistants, finishing the feet or hands of a piece of sculpture by copying them from a model which the master had covered with wet rags and plaster to produce the softness and folds of the garment.

In his severe criticism of sculpture, could Baudelaire—the friend of Daumier, just as Dante was the friend of Giotto—have been wrong? [73] Was he not right to treat sculpture as an inferior art when he saw sculptors make a being into a material entity in space, while in actuality, every object is part of a totality and this totality is dominated by a tonality which extends into infinity just as light does?

What is important for me in art is to make people forget matter. The sculptor must, through a summary of the impressions he receives, communicate everything that has touched his own feelings, so that, looking at his work, one can feel completely the emotion that he felt when he was observing nature.

It is certain that to attain this goal, Baudelaire would not have found either low or high relief satisfactory. Without indicating a formula, he would simply have said to the artist: "Make me live." And the poet would have been amazed if it were possible to produce several effects at the same time. He would have been astonished to see a plasterboard placed behind statues to hold them up and to give them a background and some pictorial qualities. Indeed, it is important first of all, that in looking at an artist's translation of a subject, it is possible to reconstitute what is absent from it. There are no limits in nature; there can be none in a work of art. In this way, the atmosphere that surrounds

[73] Baudelaire had written a brief essay on sculpture, entitled "Why is Sculpture Boring?" in his *Salon* of 1846, and a longer article, anticipating several of Rosso's ideas, in his *Salon* of 1859.

the figure, the color that animates it, the perspective that fixes it in space can all be obtained.

When I make a portrait, I cannot limit it to the lines of the head, for that head belongs to a body, it exists in a setting which influences it, it is part of a totality that I cannot suppress. The impression you produce upon me is not the same if I catch sight of you alone in a garden or if I see you in the midst of a group of other people, in a living room or on the street.

This alone matters. Therefore, one should not ask whether the impression I want to communicate changes according to whether the spectator stands nearby or far away, above or below the figure. The first sensation one experiences is very different from the one experienced when the eyes, tired from observation, are resting.

If, after the first moment, the tonality which seemed to be in the background moves forward and then once again backward, the spectator in this way has a very clear perception of the movement of life itself. When the eyes are resting, he [the spectator] can experience the impressions felt by the artist, all those which determined the form that the spectator has before him. He thus experiences a feeling of perspective that is completely different from the one that he receives from the perspective taught in the academies.

That is why I think that it is impossible to see a horse with four legs at once, or a man like a doll, isolated in space. I also feel that this horse and this man belong to a totality from which they cannot be separated, to a setting which the artist must take into account. Finally, I maintain that two effects cannot be grasped at the same time, and that only handicraftsmen are capable of achieving this inconceivable tour de force. But he who has technical skill is not the one who reveals it most.

One does not walk around a statue any more than one walks around a painting, because one does not walk around a figure to receive an impression from it. Nothing is material in space.

If it is conceived of in this way, art is indivisible. There is not the realm of painting on the one hand and that of sculpture on the other. What one has to strive for above all is to achieve a work of art which, no matter what the technique, through the life and humanity that it contains, communicates to the spectator everything that the grandiose spectacle of a powerful and healthy nature would evoke in him.[74]

[74] Medardo Rosso, in Edmond Claris, "Medardo Rosso" (Interview), *De l'impressionisme en sculpture* (Paris: Editions Nouvelle Revue Française, 1902), pp. 49–55.

After Impressionism:

Cézanne

and the Neo-Impressionists

PAUL CÉZANNE: 1839–1906

Cézanne's Letters

Paul Cézanne is generally accepted as the first modern painter. In his transformation of a personal destiny into the content of art, in his acceptance of loneliness as the basic condition of modern man, in his expression of this condition through the inviolable remoteness of the objects of his paintings, and, above all, in his assertion of the pictorial world as a paradigm rather than a simulacrum of nature—an independent world of permanent being in which the significance of the depicted entities lies in their relationships to each other rather than to any external reality—in all these respects Cézanne brought to its culmination the revolutionary efforts of the avant-garde of the 19th century and set forth the problems of the 20th.

The painter was born in Aix-en-Provence of a comfortable middle-class family. Cézanne's domineering father opposed his son's artistic career and insisted that the latter study law, until he was finally granted permission, in 1861, to join his childhood friend Emile Zola in Paris and pursue painting.

Cézanne's correspondence, while awkward from the viewpoint of literary style—involuted in sentence structure and even ungrammatical at times—provides an invaluable insight into the career and preoccupations of the artist during all periods of his life. The very difficulty he had in expressing himself in words seems, at times, analogous to his struggle to "realize" in his painting, and adds an element of pathos and sincerity to the written expression.

Excerpt from a Letter to Joseph Huot, 1861

At this time, the young Cézanne, full of youthful enthusiasm, often torn with inner violence, uncouth in manners and appearance, was working at the Atelier Suisse, a free academy, where one could, for a modest fee, work from the model without any supervision. In this letter to his boyhood friend, Joseph Huot (1840–1898), later to become chief architect in Marseilles, Cézanne describes his impressions of the Salon in verse, a form of expression habitual for him during these early years.

I thought that by leaving Aix I should leave behind the boredom that pursues me. Actually I have done nothing but change my abode and the boredom has followed me. I have left my parents behind and my friends and some of my habits, that is all. And yet to think that I roam about almost the whole day. I have seen, it is naïve to say this, the Louvre and the Luxembourg and Versailles. You know them, these boring

things housed in these admirable monuments; it is astounding, startling, overwhelming. . . . Do not think that I am becoming Parisian. . . .

I have also seen the Salon. For a young heart, for a child born for art who says what he thinks, I believe that that is what is really best, because there all tastes, all styles meet and clash. I could give you some beautiful descriptions here and send you to sleep. Be grateful to me for sparing you.

> I saw by Yvon a brilliant battle;
> Pils in his drawing of a moving scene [1]
> Traces the memory in his stirring picture,
> And the portraits of those who lead us on a leash;
> Large, small, medium, short, beautiful or of a worse kind.
> Here there is a river; there the sun burns,
> The rising of Phoebus, the setting of the moon,
> Sparkling daylight, gloomy twilight.

(Here I am at the end of my rhymes, so I should do well to stop for it would be a bold enterprise on my part to want to give you an idea, even the most meager one, of the chic of this exhibition.) There are also some magnificent Meissoniers. I have seen nearly everything and I am intending to return again. That is worthwhile for me. . . .[2]

A Letter to Emile Zola, 1866

The friendship between Emile Zola (1840–1902) and Paul Cézanne, originating during their schooldays in Aix-en-Provence, was a long and enduring one. As the writer later remembered it: "Opposites by nature, we became united forever, attracted to each other by secret affinities. . . ." When forced to separate by Zola's departure for Paris in 1858, they kept in touch with each other through a correspondence in which they shared their hopes, moods, ambitions, and sentimental experiences. When Cézanne arrived in Paris in 1861, it was Zola who showed the city to his friend, and both of them shared an enthusiasm for Manet when they first saw his work at the Salon des Refusés of 1863; it was no doubt Cézanne who initiated Zola into his appreciation of the nuances and delicate relationships of Manet's work. By 1866 a group of friends met at Zola's every Thursday evening for heated discussions about artistic and literary matters, a group including Baille, Numa Coste, Pissarro, and Solari, as well as Cézanne and Zola. In the same year Zola defended his painter friends in a vitriolic serial review of the Salon which appeared in L'Evénement *under the name of "Claude" (see pp. 96 to 97). There is no*

[1] Isidore Alexandre Augustin Pils (1813–1875) and Adolphe Yvon (1817–1893) were both extremely popular, successful painters of contemporary military subjects.

[2] Paul Cézanne, Excerpt from a letter from Paris of June 4, 1861, in John Rewald, ed., *Paul Cézanne's Letters*, trans. Marguerite Kay (London: Bruno Cassirer, 1941), pp. 58–59. Reprinted by permission of the publisher.

doubt that many of the opinions so boldly expressed in this article were the fruit of Zola's discussions with Cézanne. Their friendship and mutual support continued with, it is true, a certain decline in Zola's appreciation of his friend's genius and a certain sensitivity on the part of Cézanne to the writer's lack of enthusiasm, until 1886, when Cézanne was deeply hurt by Zola's fictional transformation of him into Claude Lantier, the artist of "abortive genius" who was the hero of his novel L'Oeuvre. After this time, the two friends never saw each other again. In the following excerpt from a letter of about October 19, 1866, from Aix, one receives an impression of the easy intimacy existing between the two friends at the time, as well as an insight into Cézanne's efforts in art.

. . . But you know all pictures painted inside, in the studio, will never be as good as the things done outside. When out-of-door scenes are represented, the contrasts between the figures and the ground are astounding and the landscape is magnificent. I see some superb things and I shall have to make up my mind only to do things out-of-doors.

I have already spoken to you about a picture I want to attempt; it will represent Marion and Valabrègue[3] setting out to look for a motif (the landscape motif of course). The sketch which Guillemet[4] considers good and which I did after nature makes everything else seem bad.[5] I feel sure that all the pictures by the old masters representing things out-of-doors have only been done hesitatingly, for they do not seem to me to have the true and above all original aspect lent by nature. Père Gibert of the museum invited me to visit the Musée Bourguignon. I went there with Baille,[6] Marion, Valabrègue. I thought everything was bad. It is very consoling. I am fairly bored, work alone fills me out a little, I am less despondent when someone is there. I see no one but Valabrègue, Marion, and now Guillemet.

[Here follows a sketch after the portrait of his sister.]

This gives you some slight idea of the morsel I am offering to you! My sister Rose[7] is in the center, seated, holding a little book that she is reading. Her doll is on a chair, she is in an armchair. Background black, head light, headdress blue, blue pinafore, frock dark yellow, a bit of still life to the left: a bowl and children's toys.

[3] Antoine Fortuné Marion (1846–1900), like Antoine Valabrègue, was a boyhood friend of Cézanne and Zola. Valabrègue, whose portrait Cézanne painted several times, became an art critic in Paris.

[4] Antoine Guillemet (1841–1918), a pupil of Daubigny and Corot, was a friend of Zola, Cézanne, and Pissarro.

[5] According to John Rewald (*Letters, n.a,* p. 75), only the sketch of this picture is known.

[6] Baptiste Baille (1841–1918), a boyhood friend of Cézanne and Zola, who later became a professor at the Ecole Polytechnique.

[7] Rose Cézanne, born in 1854, was the artist's youngest sister.

Remember me to Gabrielle, also to Solari and Baille who must be in Paris with his *frater*.[8]

I take it that now the trials of the altercation with Villemessant [9] are over you will feel better, and I hope that your work is not too much for you. I learned with pleasure of your introduction into the great paper. If you see Pissarro give him all sorts of messages from me.

But I repeat that I have a little attack of the blues, but for no reason. As you know I do not know what it comes from; it comes back every evening when the sun sets and it rains. It depresses me.

I think I shall send you a sausage one of these days, but my mother must go and buy it, otherwise I shall be cheated. It would be very . . . annoying.

Just imagine that I hardly read any more. I do not know whether you will be of my opinion, and I shall not change for that, but I am beginning to see that art for art's sake is a mighty humbug; but this is *entre nous.*

Sketch of my future picture out-of-doors.

P.S.—It is now four days that I have had the letter in my pocket and I feel the urge to send it to you; Good-bye, my dear fellow,

PAUL CÉZANNE [10]

Excerpt from a Letter to Camille Pissarro, 1876

Camille Pissarro (1830–1903) was the Impressionist painter with whom Cézanne had the closest relationship, having met him at the Atelier Suisse as early as 1861. In 1871 Cézanne, with his mistress and their child, came to live with Pissarro at Pontoise, and then later took a house in the nearby village of Auvers-sur-Oise, where he remained until 1874. It was at Pissarro's side during these years that Cézanne first confronted the motif directly, facing nature without imposing his own emotions or doctrines upon her, often confronting the same scenes from the same viewpoint. While Cézanne never imitated the older master, his apprenticeship with Pissarro helped him immensely in finding his own path toward the truth, a fact of which Cézanne himself was well aware, and for which he manifested an enduring gratitude. Late in life he listed himself in an exhibition catalogue as a pupil of Pissarro, and in 1905 he re-

[8] Gabrielle-Eléonore-Alexandrine Meley, whom Zola met in about 1863–1864 at Cézanne's house, was to become Zola's wife in 1870. The sculptor Philippe Solari (1840–1906) was a boyhood friend of Cézanne and Zola; he created portrait busts of both of them.

[9] Villemessant was director of the journal *L'Evénement,* in which Zola had published his inflammatory series of articles on the Salon in May, 1866. Due to the violence of public reaction, Zola had been obliged to discontinue the series.

[10] Paul Cézanne, Excerpt from an undated letter (probably about October 19, 1866) from Aix, in Rewald, ed., *Letters,* pp. 74–76.

ferred to his former master as "the humble and colossal Pissarro." (See below, p. 95.)

L'ESTAQUE, 2ND JULY, 1876

MY DEAR PISSARRO,

I am forced to reply to the charm of your magic crayon with an iron point (that is, with a metal pen). If I dared I should say that your letter bears the marks of sadness. Pictorial business does not go well; I am much afraid that morally you are rather gloomily influenced by this, but I am convinced that it is only a passing thing.[11]

How much I should like not always to talk of impossible things and yet I always make plans which are impossible to realize. I should imagine that the country in which I am would suit you marvelously well. —There are some fine troubles but I think they are purely accidental. This year it rains two days out of seven each week. Which is astounding in the South. —Such a thing has never been known.

I must tell you that your letter surprised me at Estaque on the sea shore. I am no longer at Aix, which I left a month ago. I have started two little motifs with a view of the sea; they are for Monsieur Chocquet [12] who spoke to me about them. —It is like a playing card—red roofs over the blue sea. If the weather is favorable I may perhaps carry them through to the end. Up to the present I have done nothing. —But motifs could be found which would require three or four months' work, for the vegetation does not change here. The olive and pine trees are the ones which always preserve their foliage. The sun is so terrific here that it seems to me as if the objects were silhouetted not only in black and white, but in blue, red, brown, and violet. I may be mistaken, but this seems to me to be the opposite of modeling. . . .[13]

Letter to Joachim Gasquet and to a Young Friend, 1896

Joachim Gasquet (1873–1921) was a writer and poet, a fellow Provençal and the son of one of Cézanne's schoolmates. Symbolist, royalist, regionalist, and chauvinist, the young Gasquet became a friend of Cézanne in 1896, writing several effusive and flowery articles about the artist in succeeding years, in which his mediocre, verbose, overcharged prose reduces the painter to the level of a regional artist of the Midi. Still worse is his biography of Cézanne, published in 1921, in which he

11 Cézanne is here referring to the second Impressionist exhibition which took place at the picture dealer Durand-Ruel's gallery. Cézanne himself did not participate in this exhibition.

12 Victor Chocquet was a customs officer and an enthusiastic collector, beginning with Delacroix and then turning to younger painters like Renoir and Cézanne, whom he came to know in 1876. Cézanne painted Chocquet's portrait several times.

13 Paul Cézanne, Excerpt of a letter from L'Estaque, July 2, 1876, in Rewald, ed., *Letters*, pp. 102–103.

purports to convey the actual words of the master in a series of three long dialogues with the artist: before the motif, in the Louvre, and in the studio. Gasquet visibly distorts both the content and the manner of expression of Cézanne's thoughts beyond recognition, transforming his hero into a kind of symbolist Provençal superman and even, it would seem, distorting the letters written to him by the artist and reproduced by the poet many years later from memory—an inevitable conclusion from the fact that, as John Rewald points out, they are written in a style very unlike Cézanne's.

Of particular interest in this letter is Cézanne's use of the word "realization," a term of central importance in the artist's conception of his goal, and one which he himself employs frequently in a variety of contexts. As Kurt Badt summarizes it in a chapter entitled "The Problem of 'Realization,'" in his study of Cézanne: "The whole of what Cézanne aimed to accomplish through his artistic endeavours is contained in the term réalisation. . . ." [14]

To Joachim Gasquet and to a Young Friend

. . . I cannot say that I envy you your youth, that is impossible—but your vigor, your inexhaustible vitality.

. . . I am at the end of my strength. I should have more sense and understand that at my age illusions are hardly permissible and that they will always cause my undoing.

. . . At the present time I am still searching for the expression of those confused sensations that we bring with us at birth. If I die everything will be over; but what does it matter!

. . . Perhaps I was born too early. I was more the painter of your generation than of mine. . . . You are young, you have vitality, you will stamp your art with an impulse that only those possessed of true feeling can give it. For my part I am getting old, I shall not have time to express myself. . . . Let us work. . . .

. . . The study of the model and its realization is sometimes very slow in coming.[15]

Two Letters to Charles Camoin

Charles Camoin (1879– ?), a young painter introduced to Cé-zanne by the art dealer Ambroise Vollard, was doing his military service at Aix. A friendship rapidly sprang up between Cézanne and his younger colleague, who later exhibited with the Indépendants *and in the* Salon d'Automne.

[14] Kurt Badt, *The Art of Cézanne,* trans. Sheila Ann Ogilvie (London: Faber and Faber, 1965), p. 222.
[15] Paul Cézanne, Fragments of letters, probably of 1896, to Joachim Gasquet and to a young friend, in Rewald, ed., *Letters,* p. 203.

The first letter was written as a reply to one in which Camoin had expressed his regret that Cézanne had not been included in Baudelaire's poem "Les Phares" ["The Beacons"], in which the poet had praised Rubens, Leonardo, Rembrandt, Michelangelo, Puget, Watteau, Goya, and Delacroix—hence Cézanne's expression of gratitude near the end. The excerpt from the letter of 1904 contains some pertinent advice to the young artist.

AIX, 3RD FEBRUARY, 1902

DEAR MONSIEUR CAMOIN,

I only received your last letter on Saturday; I addressed my reply to Avignon. Today the 3rd, I found your letter of the 2nd in my letter box coming from Paris. Larguier [16] was ill last week and kept at the infirmary which explains the delay in sending me your letter.

Since you are now in Paris and the masters of the Louvre are attracting you, make, if you feel like it, some studies after the great decorative masters Veronese and Rubens, just as you would do after nature—a thing I was only able to do incompletely myself. But you do well to study above all after nature. From what I have been able to see of you you will get on quickly. I am happy to hear that you appreciate Vollard,[17] who is sincere and at the same time serious. I congratulate you on being with madame your mother, who in moments of sadness and discouragement for you will be the surest point of moral support and the most vital source from which you can draw fresh courage to work at your art; for this is what you must strive to do, not slackly without backbone, but steadily and quietly which will not fail to give you exceptional insight, very useful to guide you firmly in life. —Thank you for the very brotherly way in which you regard my efforts to express myself lucidly in painting.

Hoping that I shall one day have the pleasure of seeing you again I send you my warmest greetings.

Your old colleague

PAUL CÉZANNE.[18]

AIX, 9TH DECEMBER, 1904

Studying the model and realizing it is sometimes very slow in coming for the artist.

Whoever the master is whom you prefer this must only be a direc-

[16] Léo Larguier was a poet who later wrote about Cézanne in his memoirs.
[17] Ambroise Vollard (1867–1939), a bold and opinionated art dealer, who was the first to arrange a one-man show of Cézanne's works in 1895. Cézanne painted his famous portrait of Vollard in 1899, demanding one hundred sittings of his subject. The dealer published his recollections of Cézanne in 1914.
[18] Paul Cézanne, Letter to Charles Camoin from Aix, February 3, 1902, in Rewald, ed., *Letters*, pp. 219–220.

tive for you. Otherwise you will never be anything but an imitator. With any feeling for nature whatever, and some fortunate gifts—and you have some—you should be able to dissociate yourself; advice, the methods of another must not make you change your own manner of feeling. Should you at the moment be under the influence of one who is older than you, believe me as soon as you begin to feel yourself, your own emotions will finally emerge and conquer their place in the sun—*get the upper hand, confidence*—what you must strive to attain is a good method of *construction*. Drawing is merely the outline of what you see.

Michelangelo is a constructor, and Raphael an *artist* who, great as he is, is always limited by the model. —When he tries to be thoughtful he falls below the *niveau* of his great rival.

Very sincerely yours,

P. CÉZANNE.[19]

Letter to Louis Aurenche

Louis Aurenche was one of the youthful colleagues introduced to Cézanne in 1896 by Joachim Gasquet. With these young admirers, the usually timid and withdrawn painter emerged from his habitual reserve, at times joining them in the cafés at Aix, or at others receiving them in his own home. Yet despite the old painter's satisfaction in these new friendships, and his manifest efforts to convey to them as frankly and modestly as possible a sense of the efforts involved in the creation of his art, Cézanne could be irritable and cold, seemingly for no reason, or could withdraw from human contact as quickly as he had established it. Aurenche has recounted his impressions of the artist, whom he first met at the Gasquets' in Aix in 1900, in "Souvenirs de jeunesse sur Paul Cézanne," written in 1959, in which he describes the artist's initial timidity, silence, and stiffness and his later openness and good faith, as well as the excellent quality of the food, drink, and hospitality offered by the artist at his home on the Rue Boulegon.

AIX, 25TH JANUARY, 1904

MY DEAR MONSIEUR AURENCHE,

Thank you very much for the good wishes you and your family sent me for the New Year.

Please accept mine in your turn for you and all at home.

In your letter you speak of my realization in art. I think that every day I am attaining it more, although with some difficulty. For if the strong experience of nature—and assuredly I have it—is the necessary basis for all conception of art on which rests the grandeur and beauty of

[19] Paul Cézanne, Excerpt of a letter to Charles Camoin, Aix, December 9, 1904, in Rewald, ed., *Letters*, pp. 241–242.

all future work, the knowledge of the means of expressing our emotion is no less essential, and is only to be acquired through very long experience.

The approbation of others is a stimulus of which, however, one must sometimes be wary. The feeling of one's own strength renders one modest.

I am happy at the success of our friend Larguier. Gasquet lives entirely in the country, I have not seen him for a long time.

I send you, dear Monsieur Aurenche, my very warmest greetings.

PAUL CÉZANNE.[20]

Letters to Emile Bernard

The painter and critic Emile Bernard (1868–1941) had been a leading figure in the symbolist circle centering about Gauguin at Pont-Aven in Brittany in the late eighties and early nineties, at which time he had first become acquainted with the art of Cézanne and had written his first appreciation of it. (See below, pp. 98 to 102.) He did not meet the artist until 1904, when, on a visit to Aix, he was graciously received by Cézanne and even invited to work in a room in the latter's studio. During this period the two visited the museum, painted side by side, and took long walks together. Their long discussions—no doubt stimulated by Emile Bernard's ceaseless and not altogether disinterested questioning of the old master, whose opinions he wanted to support his own theories of art —were continued in a rather lengthy correspondence. It is no doubt due to Bernard's indefatigable zeal in plying Cézanne with questions about his artistic theories that these letters are far more abstract and systematic than the rest of his correspondence. Yet even if they are not completely spontaneous expressions of Cézanne's ideas—and one can at times sense in their tone the artist's annoyance at being "pumped"—these letters nevertheless remain an important source of information and the closest approximation to any coherent body of theoretical writing by the master that we have.

AIX EN PROVENCE, 15TH APRIL, 1904

DEAR MONSIEUR BERNARD,

. . . May I repeat what I told you here: treat nature by the cylinder, the sphere, the cone, everything in proper perspective so that each side of an object or a plane is directed toward a central point. Lines parallel to the horizon give breadth—that is, a section of nature or, if you prefer, of the spectacle that the Pater Omnipotens Æterna Deus spreads out

[20] Paul Cézanne, Letter to Louis Aurenche, Aix, January 25, 1904, in Rewald, ed., *Letters*, p. 232.

before our eyes. Lines perpendicular to this horizon give depth. But nature for us men is more depth than surface, whence the need of introducing into our light vibrations, represented by reds and yellows, a sufficient amount of blue to give the impression of air.

I must tell you that I had another look at the study you made in the lower floor of the studio; it is good. You should, I think, only continue in this way. You have the understanding of what must be done and you will soon turn your back on the Gauguins and the Van Goghs!

Please thank Madame Bernard for the kind thoughts that she has reserved for the undersigned, a kiss from *père Goriot* for the children, all my best regards for your dear family.[21]

AIX, 12TH MAY, 1904

MY DEAR BERNARD,

My absorption in my work and my advanced age will explain sufficiently my delay in answering your letter.

Moreover, in your last letter you discourse on such widely divergent topics, though all are connected with art, that I cannot follow you in all your phases.

I have already told you that I like Redon's talent enormously, and from my heart I agree with his feeling for and admiration of Delacroix. I do not know if my indifferent health will allow me ever to realize my dream of painting his apotheosis.[22]

I am progressing very slowly, for nature reveals herself to me in very complex forms; and the progress needed is incessant. One must see one's model correctly and experience it in the right way; and furthermore express oneself forcibly and with distinction.

Taste is the best judge. It is rare. Art only addresses itself to an excessively small number of individuals.

The artist must scorn all judgment that is not based on an intelligent observation of character. He must beware of the literary spirit which so often causes painting to deviate from its true path—the concrete study of nature—to lose itself all too long in intangible speculations.

The Louvre is a good book to consult but it must only be an intermediary. The real and immense study that must be taken up is the manifold picture of nature.

Thank you for sending me the book; I am waiting so as to be able to read it with a clear head.

You can, if you think it right, send Vollard what he asked you for.

21 Paul Cézanne, Excerpt from a letter to Emile Bernard, Aix-en-Provence, April 15, 1904, in Rewald, ed., *Letters,* pp. 233–234.

22 Cézanne, who greatly admired Delacroix, made several sketches for a projected apotheosis of the romantic painter.

Please give my kind regards to Madame Bernard, and a kiss from *père Goriot* for Antoine and Irene.

Sincerely yours,

P. Cézanne [23]

AIX, 25TH JULY, 1904

MY DEAR BERNARD,

I received the "Revue Occidentale" and can only thank you for what you wrote about me.[24]

I am sorry that we cannot be together now, for I do not want to be right in theory but in nature. Ingres, in spite of his "estyle" (Aixian pronunciation) and his admirers, is only a very little painter. You know the greatest painters better than I do; the Venetians and the Spaniards.

To achieve progress nature alone counts, and the eye is trained through contact with her. It becomes concentric by looking and working. I mean to say that in an orange, an apple, a bowl, a head, there is a culminating point; and this point is always—in spite of the tremendous effect of light and shade and colorful sensations—the closest to our eye; the edges of the objects recede to a center on our horizon. With a small temperament one can be very much of a painter. One can do good things without being very much of a harmonist or a colorist. It is sufficient to have a sense of art—and this sense is doubtless the horror of the bourgeois. Therefore institutions, pensions, honors can only be made for cretins, rogues, and rascals. Do not be an art critic, but paint—therein lies salvation.

A warm handclasp from your old comrade.

P. Cézanne [25]

AIX, 23RD DECEMBER, 1904

MY DEAR BERNARD,

I received your kind letter dated from Naples. I shall not dwell here on aesthetic problems. Yes, I approve of your admiration for the strongest of all the Venetians; we are celebrating Tintoretto. Your desire to find a moral, an intellectual point of support in the works, which assuredly we shall never surpass, makes you continually on the *qui vive,*

[23] Paul Cézanne, Letter to Emile Bernard, Aix, May 12, 1904, in Rewald, ed., *Letters,* pp. 235–236.

[24] This article was Bernard's first account of his visit to Cézanne, written during the early spring of 1904, while the former was still in Aix. According to Theodore Reff ("Cézanne and Poussin," *Journal of the Warburg and Courtauld Institutes,* XXIII [1960], 153), this was the least biased of all Bernard's accounts of Cézanne and the only one approved by the artist himself.

[25] Paul Cézanne, Letter to Emile Bernard, Aix, July 25, 1904, in Rewald, ed., *Letters,* pp. 239–240.

searching incessantly for the way that you dimly apprehend, which will lead you surely to the recognition in front of nature, of what your means of expression are; and the day you will have found them, be convinced that you will find also without effort and in front of nature, the means employed by the four or five great ones of Venice.

This is true without possible doubt—I am very positive: an optical impression is produced on our organs of sight which makes us classify as *light,* half-tone or quarter-tone the surfaces represented by color sensations. (So that light does not exist for the painter.) As long as we are forced to proceed from black to white, the first of these abstractions being like a point of support for the eye as much as for the mind, we are confused, we do not succeed in mastering ourselves, in *possessing ourselves.* During this period (I am necessarily repeating myself a little) we turn toward the admirable works that have been handed down to us throughout the ages, where we find comfort, a support such as a plank is for the bather. —Everything you tell me in your letter is very true. . . .

PAUL CÉZANNE [26]

[AIX], 1905, FRIDAY

MY DEAR BERNARD,

I am replying briefly to some of the paragraphs of your last letter. As you write, I think I really have made some slight progress in the last studies that you saw at my house. It is, however, very painful to have to register that the improvement produced in the comprehension of nature from the point of view of the form of the picture and the development of the means of expression should be accompanied by old age and a weakening of the body.

If the official Salons remain so inferior it is because they only employ more or less widely known methods of production. It would be better to bring more personal feeling, observation, and character.

The Louvre is the book in which we learn to read. We must not, however, be satisfied with retaining the beautiful formulas of our illustrious predecessors. Let us go forth to study beautiful nature, let us try to free our minds from them, let us strive to express ourselves according to our personal temperaments. Time and reflection, moreover, modify little by little our vision, and at last comprehension comes to us.

It is impossible in this rainy weather to practice out of doors these theories which are yet so right. But perseverance leads us to understand interiors like everything else. It is only the old duffers who clog our intelligence, which needs spurring on.

[26] Paul Cézanne, Excerpt from a letter to Emile Bernard, Aix, December 23, 1904, in Rewald, ed., *Letters,* pp. 242–243.

Very sincerely yours and my regards to Madame Bernard and love to the children.

<div align="right">P. Cézanne</div>

You will understand me better when we see each other again; study modifies our vision to such a degree that the humble and colossal Pissarro finds himself justified in his anarchist theories.

Draw; but it is the reflection which *envelops;* light, through the general reflection, is the envelope.

Sincerely yours,

<div align="right">P.C.[27]</div>

<div align="right">Aix, 23rd October, 1905</div>

My dear Bernard,

Your letters are precious to me for a double reason, because their arrival lifts me out of the monotony which is caused by the incessant and constant search for the sole and unique aim and this produces, in moments of physical fatigue, a kind of intellectual exhaustion; secondly I am able to describe to you again, rather too much I am afraid, the obstinacy with which I pursue the realization of that part of nature, which, coming into our line of vision, gives the picture. Now the theme to develop is that—whatever our temperament or power in the presence of nature may be—we must render the image of what we see, forgetting everything that existed before us. Which, I believe, must permit the artist to give his entire personality whether great or small.

Now, being old, nearly seventy years, the sensations of color, which give light, are the reason for the abstractions which prevent me from either covering my canvas or continuing the delimitation of the objects when their points of contact are fine and delicate; from which it results that my image or picture is incomplete. On the other hand the planes are placed one on top of the other from whence neo-impressionism emerged, which outlines the contours with a black stroke, a failing that must be fought at all costs. Well, nature when consulted gives us the means of attaining this end. . . .[28]

A Letter to His Son Paul

In this touching letter to his son Paul, written in the month before his death, Cézanne expresses his rather unflattering opinion of Emile Bernard and his second-hand "philosophical" inspiration, and stresses once more the simple theme which he has stated so often in his letters

[27] Paul Cézanne, Letter to Emile Bernard, Aix, Friday, 1905, in Rewald, ed., *Letters,* pp. 249–251.

[28] Paul Cézanne, Excerpt from a letter to Emile Bernard, Aix, October 23, 1905, in Rewald, ed., *Letters,* pp. 251–252.

and which is so vividly and forcefully embodied in his own painting:
that nature must be the guiding principle of art and that the artist can
develop only through continuous contact with her.

AIX, 13TH SEPTEMBER, 1906

MY DEAR PAUL,

I am sending you a letter that I have just received from Emilio
Bernardinos, one of the most distinguished aesthetes. I am sorry not to
have him in my power so as to infuse into him the idea which is so sane,
so comforting, and the only correct one of the development of art
through contact with nature. I can scarcely read his letter, but I think
he is right, though the good man simply turns his back in practice on
what he expounds in his writings; his drawings are merely old-fashioned
rubbish which result from his dreams of art, based not on the emotion of
nature but on what he has been able to see in the museums, and more
still on a philosophic mind which comes from the too great knowledge
he has of the masters he admires. You must tell me if I am mistaken.
—On the other hand, I cannot help regretting the annoying accident that
happened to him. —You will understand that I cannot go to Paris this
year. —I wrote to you that I drive to the river every day.

Owing to fatigue and constipation I had to give up going to the
studio. This morning I went for a little walk, I came back about ten or
eleven o'clock, had lunch, and at half-past three left, as I told you above,
for the shores of the Arc.

My research interests me greatly. Perhaps I could have converted
Bernard. Obviously one must succeed in feeling for oneself and in ex-
pressing oneself sufficiently. But I repeat the same thing over and over
again, but my life arranged in this way allows me to isolate myself from
the lower spheres of life.

I embrace you and your mother with all my heart,
Your old father,

PAUL CÉZANNE.

One of the strong ones is Baudelaire, his "Art Romantique" is
magnificent, and he makes no mistake in the artists he admires. If you
want to send an answer to his [Bernard's] letter let me have it and I will
copy it. —Do not mislay the aforementioned letter.[29]

Zola's Dedication of "Mon Salon" to Cézanne (1866)

When in 1866, a particularly conservative jury, frightened by the
violence of the public reaction to Manet's Olympia *in the Salon of 1865,*

[29] Paul Cézanne, Letter to his son, Aix, September 13, 1906, in Rewald, ed.,
Letters, pp. 263–265.

refused almost in toto *the offerings of Cézanne and his friends to the Salon of that year, Cézanne wrote a stern letter of protest to M. de Nieu-werkerke, Director of Fine Arts, demanding another Salon des Refusés. Shortly afterward Zola leaped to the defense of his friends and, at the same time, opened fire upon the Salon and the Jury, which he proceeded to demolish in a series of reviews for* L'Evénement *signed "Claude," the third of which was devoted to Edouard Manet. When these articles were reprinted in the Spring of 1866, in the form of a pamphlet entitled* Mon Salon, *Zola prefaced it with a long dedication to Cézanne, who doubtless, in the course of their many discussions about art, had done much to help formulate the ideas which Zola developed in his writing. The warmth and intimacy of Zola's tone is indicative of the close relationship between the two young men at the time.*

I experience deep joy, my friend, in having a tête-à-tête with you. You cannot imagine how much I have suffered from this quarrel which I have just had with the herd, with the unknown crowd; I felt so misunderstood, I felt such hatred around me, that discouragement often made me drop my pen. Today I can avail myself of the intimate pleasure of one of the good talks we have had together for the past ten years. It is for you alone that I write these few pages; I know you will read them with your heart, and that tomorrow you will love me more affectionately.

Imagine that we are alone together in some remote place, far from any struggle, and that we are talking like old friends who know each other's very soul and understand each other at a mere glance.

For ten years we have been speaking of art and literature. We have lived together—do you remember?—and often daybreak caught us still conversing, searching the past, questioning the present, trying to find the truth and to create for ourselves an infallible and complete religion. We shuffled stacks of terrible ideas, we examined and rejected all systems, and after such arduous labor we told ourselves that outside of powerful and individual life there only exist lies and stupidity.

Happy are they who have memories! I envisage your role in my life as that of the pale young man of whom Musset speaks.[30] You are my whole youth; I find you mixed up with all my joys, with all my sufferings. Our minds, in brotherhood, have developed side by side. Today, at the beginning, we have faith in ourselves because we have penetrated our hearts and flesh.

We used to live in our shadow, isolated, unsociable, enjoying our thoughts. We felt lost in the midst of the complacent and superficial crowd. In all things we sought men, in every dawn, in every painting or poem we wanted to find an individual emphasis. We asserted that the

[30] Alfred de Musset (1810–1857), brilliant romantic poet and playwright.

masters, the geniuses, are creators, each of whom had made a world of his own, and we rejected the disciples, the impotent, those whose trade it is to steal here and there a few scraps of originality.

Did you know that we were revolutionaries without being aware of it? I have just been able to say aloud what we told each other for ten years. The noise of the quarrel reached you, did it not? And you have witnessed the fine welcome accorded our dear thoughts. Ah! the poor lads who lived healthily in the middle of Provence, in the sun, and who clung to such folly and such bad faith!

For—you probably did not know this—I am a man of bad faith. The public has already ordered several dozen straitjackets to take me to Charenton.[31] I only praise my relatives and my friends, I am a fool and evil man, I am a scandalmonger.

This inspires pity, my friend, and it is very sad. Will it always be the same story? Will we always have to talk like the others or be still? Do you remember our long conversations? We said that the least new truth could not be revealed without provoking anger and protests. And now I, in turn, am being jeered at and insulted.

It is a good experience, my friend. For nothing in the world would I wish to destroy these pages; they are not much in themselves but they have been, so to speak, my touchstone of public opinion. We now know how unpopular our dear thoughts are.

Yet, I am pleased to present my ideas a second time. I believe in them, I know that in a few years everyone will agree with me. I am not afraid that they will be thrown in my face later on.

<div align="right">EMILE ZOLA</div>

PARIS, MAY 20, 1866 [32]

Emile Bernard on Paul Cézanne

Emile Bernard, at the time a member of Gauguin's circle at Pont-Aven, was impressively articulate in formulating aesthetic theories and programs, and in supplying a rich and sometimes rather hazy background of historical, literary, philosophical, or poetic justification for his art and that of his fellow symbolists, couched in the elliptical, condensed, and often wilfully ambiguous prose style characteristic of the group.

Bernard's earliest article on Cézanne—and he was to write a great deal more about him later in his life—was the brief biography, reprinted below, which appeared in the series Hommes d'Aujourd'hui *in 1891, il-*

31 Famous madhouse near Charenton-le-Pont.
32 Emile Zola, Dedication to *Mon Salon* (1866), in John Rewald, *Paul Cézanne: A Biography,* trans. Margaret H. Liebman (New York: Simon and Schuster, 1948), pp. 56–57. Reprinted by permission of the author.

lustrated with an etched portrait of Cézanne by Pissarro. It is interesting
partly because it reveals how mysterious and intriguing a figure Cézanne
was beginning to be, and, at the same time, how misunderstood he was
even by his admirers; Bernard's viewpoint is obviously "symbolist": he
reads into Cézanne's style an archaic naïveté and decorative refinement
hardly consonant with the actual appearance of the artist's work. Many
of Bernard's later articles about Cézanne, especially those purportedly
reporting "conversations" with the artist—such as the one which appeared
in the 1921 Mercure de France, containing the famous statement (at-
tributed to Cézanne) about "doing Poussin over again entirely from
nature"—are actually extremely suspect as far as their relation to Cé-
zanne's actual thought and manner of expression are concerned, reflect-
ing much more Bernard's own changing taste and stylistic evolution to-
ward a conservative, academic position. Most of his articles and memoirs
about Cézanne were reprinted in Souvenirs sur Paul Cézanne, Paris, 1925.

> ". . . For the play, I remember, pleased
> not the million; 'twas caviare to the
> general: but it was . . . an excellent
> play . . ."
>
> (HAMLET)

In Provence: A romantic adolescence, with verses, declamatory
walks with Zola, his school friend; Hugo, Musset amidst the foliage on
the banks of the Arc; an enthusiastic arrival in Paris, conversations by
night before the great city—that one dreams of conquering—beneath the
stars. Then a bit of misery from an unsympathetic though well-to-do
family; a marriage; blows from the public and impotent artists; the
paroxysm of theories (his most brilliant period) and finally, retirement
and the absolute.

But how many imaginary triumphs, surprising works of art to cre-
ate, vain hopes! !

The friends: Pissarro, Guillaumin,[33] Monet, Zola, Bail [34] have made
their way, have had their share of glory, have known the joy of a justifi-
cation. Unknown, or rather, unrecognized, he [Cézanne] has loved art to
the point of giving up being made into a notorious creature by friend-
ships and coteries. Without disdain, but completely, he has given up an-
nouncing his attempts. . . . Therefore, what a surprise for us, last year

[33] Armand Guillaumin (1841–1927), perhaps least well known of the Impression-
ists, specializing in scenes of the Seine, and later painting landscapes on the outskirts
of Paris; he, like Cézanne and Pissarro, frequented the Atelier Suisse.

[34] Louis Le Bail (1866– ?), painter influenced by Pissarro and Cézanne, with
whom he established a close relationship for a time, and who later exhibited at the
Salon des Indépendants and at the Salon d'Automne.

[were] his contributions to the Brussels Exhibition of the XX: [35] He was no more understood than twenty years ago; not even the honor of a discussion! He was mentioned, and nothing more.

But what pages: those nude women, in a strange, indistinct setting, more suggestive than any others, with their elegances, of XVIth century Dianas; that southern landscape with new solidities.

Style, Tone. —A painter above all—although he is a thinker and a serious one—he opens for art that surprising door: painting for its own sake.

At fourteen Rue Clauzel, at Tanguy's,[36] in a dark, narrow shop, childish landscapes: red houses with spindly trees, primitive hedges, still lifes: apples rounded as though with a compass, triangular pears, fruit stands all askew, napkins violently folded; portraits. The whole thing: bottle green, brick red, ocher yellow, washerwoman's blue.

Harsh, crude, acid, these incredible canvases; they seem to defy all criticism, to be made to stir up battles . . . and some, however, of a charming childishness awaken the precise idea of a talented shepherd boy—like Giotto—who plays around with colors.

At Schuffenecker's: [37] a white cup against the blue-green, flower-striped background of a wallpaper; nearby, a glass in the shape of an urn, an unfolded napkin, some apples propping up a lemon. Two land-scapes: pines along a main road bordered by villas and grasses; red houses seen amidst groups of trees.

At Doctor Gachet's,[38] at Auvers: landscapes of a firm Corot; solemn still lifes, powerful sketches; then, at MM. Choquet's [sic], Pissarro's, Zola's, Rouart's, Murer's: [39] female nudes, bits of tables covered with

35 The XX (Les Vingt), avant-garde group established in Brussels in 1884, with the purpose of promoting new and original forms of art, and consisting of twenty young Belgian artists. The XX organized yearly exhibitions to which twenty guests, mainly foreign artists and representatives of new movements in painting, were invited. Among their guest exhibitors in the years after 1884 were such figures as Whistler, Monet, Renoir, Rodin, Redon, Seurat, Pissarro, and Berthe Morisot, as well as Cézanne. The group's secretary, Octave Maus, in collaboration with Verhaeren, the Belgian poet, and Edmond Picart, edited the journal *L'Art moderne*.

36 Julien Tanguy, the so-called Père Tanguy, humble dealer in artists' supplies and paintings, who collected and admired the works of Cézanne, Pissarro, Gauguin, van Gogh, Seurat, and Signac, and whose portrait was several times painted by van Gogh.

37 Emile Schuffenecker (1851–1934), painter and architect, friend of Pissarro, Seurat, and above all, of Gauguin, who painted his famous portrait of the Schuffenecker family in about 1889.

38 Dr. Paul Gachet, medical man and collector of avant-garde art, who was himself an enthusiastic engraver. Cézanne lived near him in Auvers in 1873, and Vincent van Gogh, who depicted Gachet several times, went to live with the doctor after his release from the asylum of Saint-Rémy in 1890.

39 Eugène Murer, pastry-cook, restaurant owner, and collector of Impressionist and Post-Impressionist painting. Both Renoir and Pissarro painted portraits of Murer and of his wife Marie as well.

fruit; severe portraits. I remember one such work (his wife) which is worthy of Holbein: [40] against a blue-green background where some clothing is hanging, the delicate head with vacant eyes and sensual mouth stands out, leaning against a crimson-red armchair in a black and green striped shirt, pensive, the model poses; but in that pose, life is latent.

Essentially hieratic and of a purity of line known only to the pure, primitive masters, this canvas seems to me like one of the greatest attempts of modern art in the direction of classical beauty.

There are three distinct styles:
The arrival in Paris
The light period
The solemn period

The last manner is scarcely more than a return to the first, but by way of the nascent color theories and some very personal and unexpected insights into style. In no way, however, are the first works inferior to the last in interest. They seize hold of one with their precocious power; they seize one, despite frequent reminiscences of Delacroix, Manet, Courbet, Corot, Daumier.

The light period was his most unsuccessful; it was, moreover, one of constraint. He had met Monet who dreamed of nothing but sun and light and he succumbed in his turn to the charms of great brightness; but he recovered little by little his calm and his ponderation, and he returned more complete and more knowing to his point of departure.

With a solid pigment handled in strokes slowly brushed from right to left, the works of the latest style affirm the efforts of a new art, strange, unknown. Balanced lights glide mysteriously into *transparently solid* penumbras; an architectural gravity presides in the ordering of the lines; at times areas of impasto give rise to sculpture.

The Temptation of Saint Anthony (belonging to M. Murer) [41] seems to me a true example of the type sought after by the painter as well as the most complex.

Romantic in conception, the canvas, at the most twenty by fifteen centimeters in size, shows us the legendary saint collapsing, while a red devil, perched on his head, frantically shows him a nude girl escorted by tiny cupids; the ground is strewn with pale roses upon which the apparition treads. A blue sky stretches its oriflamme behind a tree which bends over this scene.

Here there is no positive shadow; an equal lightness bathes every-

[40] Probably the portrait listed by Lionello Venturi (*Cézanne: son art—son oeuvre* [Paris: Paul Rosenberg, 1936], I) as Cat. No. 229 and ascribed to the period 1872–1877.
[41] Venturi, No. 241, ascribed to 1873–1877.

thing; makes everything iridescent, blanched by the years and beautiful with that mysterious indecision that time stamps upon art.

This is one of the works most powerful in color. It goes without saying that its drawing is as naïve as possible, that only an ancestral popular image could give one an idea of it.

Uniquely pictorial, at first glance, this canvas would easily be taken for what is vulgarly called a "lousy daub" *[croûte grossière];* for it actually seems nothing but a chalky hodgepodge of colors: such would it appear at least to unpracticed eyes (exoteric). But if we tarry there in order to calculate its qualities, the tone, the grace, and the *indefinable,* which suggests the intellect of an artist more than a fantastic representation painted or described in an ordinary manner, we admit that [in this work] there exists that power of originality and of technique always sought after and so rarely encountered in the works shown to us by the generation presently known, and this makes me think of that opinion which Paul Gauguin once expressed in my presence about Paul Cézanne: There is nothing that looks as much like a daub as a masterpiece. An opinion which I, for my part, find in this case, cruelly true.

Paul Cézanne was born in Aix en Provence. He is fifty years old.

EMILE BERNARD.[42]

Gustave Geffroy on Paul Cézanne

Gustave Geffroy (1855–1926), friend and biographer of Monet, published his first article on Cézanne in Le Journal *of 1894. The painter then wrote him a letter of thanks which was followed by the publication of the chapter on Cézanne in Volume III of Geffroy's* La Vie artistique, *which also appeared in 1894; the critic finally met Cézanne, shortly afterward, at Monet's home in Giverny, in the company of Rodin, Clemenceau, and Mirbeau. The painter subsequently asked Geffroy to sit for a portrait, upon which he worked for about three months, and then brusquely abandoned in despair. In 1895, after Ambroise Vollard had organized the first one-man show of Cézanne's works, Geffroy wrote still another article on the painter, and by now, while the general public was hardly sympathetic to his work, certainly Cézanne's artistic personality was more generally accessible. Yet Cézanne, far from seeming to appreciate Geffroy's sympathetic if not very profound understanding of his art and his efforts on his behalf, actually seems to have broken off relations with him at this point, referring to him as "that vulgar Geffroy," and letting it be known that he held against the critic his having directed public attention upon himself, thereby destroying his cherished privacy.*

[42] Emile Bernard, "Paul Cézanne," *Les Hommes d'Aujourd'hui,* VIII, No. 387 [1891], n.p.

In addition, part of Cézanne's apparent ingratitude may have been due to Geffroy's left-wing, anti-religious viewpoint, particularly offensive at a time when Cézanne himself had returned to the Church. Yet no matter what the reasons, Cézanne's relations with Geffroy followed the general pattern of all his intimate friendships: an initial period of warmth and openness lasting for only a short time, then coldness and irritability followed by unexplained silence and withdrawal. As John Rewald has suggested, it is probable that at the bottom of all Cézanne's broken friendships lay the artist's futile attempt to establish a perfect and lasting communion with a fellow human being; when this failed to materialize, he suffered a profound annoyance at this further confirmation of his own experience of solitude as the essential condition of existence.[43]

For a long time Paul Cézanne has had a singular artistic destiny. He could be defined as a personage at once unknown and celebrated, having but rare contacts with the public and considered as an influence among the uneasy and experimental spirits of painting, known only by certain ones, living in an unsociable isolation, reappearing, disappearing brusquely to the eyes of his intimate friends. From all the ill known facts of his biography, from his quasi-secret production, from the scarcity of his canvases which do not seem to be submitted to any of the accepted laws of advertising, a kind of peculiar renown has come to him; already remote, a mystery enveloped his being and his work. Those who are in search of the unexpected, who love to discover things not yet seen, used to talk about Cézanne's canvases with knowing airs, supplied information as though they were giving out passwords. Those who were just arriving, impassioned and earnest in the region—new to them—of modern art, the fields under cultivation where from day to day are to be seen shoots blossoming and growing, all the shoots, the wheat and the tares—these latter asked their elders about this phantom-like Cézanne, who lived in this way on the margin of life, without bothering any longer with a role or supporting players. What did his canvases look like? Where were they to be seen? It was replied that there was a portrait at Emile Zola's, two trees at Théodore Duret's, four apples at Paul Alexis', or else that the preceding week a canvas had been seen at Père Tanguy's, the artists' supply dealer on the Rue Clauzel, but that one had to hurry up to find it, for there were always, in the case of the Cézannes, art lovers swift to pounce upon this widely spaced prey. There was talk also of extensive collections, of various canvases in considerable numbers: it would have been necessary, in order to become acquainted with them, to penetrate into the household of M. Choquet [sic] in Paris, or M. Murer in Rouen, or Dr. Gachet at Auvers, near Pontoise.

[43] John Rewald, *Cézanne, Geffroy et Gasquet, suivi de Souvenirs sur Cézanne de Louis Aurenche et de Lettres inédites* (Paris: Quatre Chemins-Editart, 1959), p. 19.

Actually, the encounters with the paintings of Cézanne were rare in everyday life, since the artist quickly enough gave up putting himself forward and took part only in the first exhibition of the independent group in 1874. So one only caught a glimpse, here and there, of a landscape or a still life, a canvas often unfinished, with parts solid and beautiful, and one kept one's opinion in suspense.

Since then, in artistic circles, Cézanne's reputation has confirmed itself further, has visibly grown. Cézanne has become a kind of precursor to whom the symbolists have referred, and it is quite certain, to stick to the facts, that there is a direct relation, a clearly established continuity, between the painting of Cézanne and that of Gauguin, Emile Bernard, etc. And likewise, with the art of Vincent van Gogh. From this point of view alone, Paul Cézanne deserves that his name be put into the place that is his. It is certain that, in the independent or impressionist group, he revealed, in comparison with his companions, a special talent, an original nature, and there was a bifurcation developing from his work, a branch-road begun by him and continued by others. Whether this new road continues, ends up in magnificent spaces, or loses itself in bogs and swamps is not what is under investigation today. It is the secret of the future. Whatever happens, Cézanne will have been there as a signpost, and that is the point that must not be forgotten. The history of art is made with a laying out of broad paths and of ramifications, and Cézanne has at any rate had control over one of these latter.

It would be a different matter to state that there is an extremely marked intellectual bond between Cézanne and his successors, and that Cézanne has had the same theoretical and synthetic preoccupations as the symbolic artists. Today, if one really cares to, it is easy to create for oneself an idea of the series of efforts and of the total effect of Cézanne's work. In a few days, I had the opportunity of seeing about twenty characteristic paintings, through which the personality of the artist could be summarized as correctly as possible. However, the impression experienced with a growing strength, and which remains dominant, is that Cézanne does not approach nature with a program of art, with the despotic intention of submitting this nature to a law that he has conceived, of subjecting it to an ideal formula which is within himself. He is not, however, completely without program, law, and ideal, but they do not come to him from art, they come to him from the intensity of his curiosity, from his desire to possess the things that he sees and admires. He is a man who looks about him, near him, who experiences an intoxication from the spectacle displayed, and who would like to transfer the sensation of this intoxication onto the restricted space of a canvas. He goes to work and he seeks out the means for achieving this transposition as truthfully as possible.

This desire for truth, visible in all the canvases of Cézanne, is attested to by all those who have been his contemporaries, his friends.

First of all, by Emile Zola, in the dedication of *My Salon,* a pamphlet of 1866. Let us refer back to the terms of that dedication, revealing the most tender intimacy of feeling: *"To my friend Paul Cézanne. I experience deep joy, my friend, in having a tête-à-tête with you."* The writer continues, recalls the ten years of affection, of conversations, and if he happens to approach the question of shaken-up ideas, of systems examined, his conclusion is that Cézanne, like himself, has rejected everything, only believes in the powerful and individual life. Here we have a first, and an excellent, testimony. Zola and Cézanne, both born in Aix-en-Provence, running about the countryside together, taking their classes together, both coming to Paris with the same ambition, shared their thoughts and their dreams, and the writer expressed, with his ideas, the ideas of the painter.

Then there are the testimonials, equally clear, of those who were the comrades, the painting friends of Cézanne, those who were in the fields with him, Renoir, Monet, Pissarro, the witnesses of his labor, those who saw him, like themselves, persisting in the search for the true, in its realization through art.

Ceaselessly, as in the days of his adolescence, his youth, when he would go off for weeks to paint in the anfractuosities of hills and the glades of the woods, ceaselessly Cézanne went off for the conquest of what he saw so beautiful: the earth richly decked out with greenery, the roads softly turning, the trees, lively and strong, the stones covered with mosses, the houses intimately united with the earth, the sky bright and deep. He loved this and he loved nothing but this, to the point of forgetting everything that was not this, of remaining for hours and hours, days and days, before the same spectacle, determined to penetrate within it, to understand it, to express it—an obstinate creature, a seeker, diligent, in the manner of the shepherds who discovered in the solitude of the fields, the beginning of art, of astronomy, of poetry.

It is not with a hasty piece of work, with a superficial preparation that he would cover those canvases greeted at the exhibitions and in the sales by facile mockery. Where many visitors, badly inspired art lovers, were capable of seeing nothing but some sort of scribbles, the work of mere chance, there was, on the contrary, sustained effort, a desire to approach the truth as closely as possible. Any canvas of Cézanne, simple and calm in appearance, is the result of desperate struggles, of a fever of work and of a patience of six months. It was an unforgettable sight, Renoir tells me, to see Cézanne installed at his easel, painting, looking at the countryside: he was truly alone in the world, intense, concentrated, attentive, respectful. He would come back the next day, and every day, he would accumu-

late his efforts, and at times would even go away in desperation, return
without his canvas which he left abandoned on a rock or on the grass, at
the mercy of the wind, the rain, the sun, absorbed by the earth, the painted
landscape received back by surrounding nature.

One would not realize it, although the works of Cézanne state it
openly, manifest the tension toward the real—that patience, that length of
time, that nature of an upright artist, that conscience satisfied with such
difficulty. It is obvious that the painter is frequently incomplete, that he
has been unable to conquer the difficulty, that the obstacle to realization
is revealed to all eyes. It is a little bit, apart from the technique, like the
touching efforts of the primitives. There are absences of atmosphere, of
the fluidity through which the planes must be separated and the farthest
depths be placed at their proper distance. The forms become awkward at
times, the objects are blended together, the proportions are not always
established with sufficient rigor.

But these remarks cannot be made before each canvas of Cézanne.
He has laid out and completely materialized infinitely expressive pages.
In these he unfolds animated skies, white and blue, he erects, within a
limpid atmosphere, his dear hill of Sainte-Victoire, the straight trees
which surround his Provençal home of the Jas de Bouffan, a hillock of
colored and golden foliage, in the countryside near Aix, a weighty inlet
of the sea in a rocky bay where the landscape is crushed beneath an at-
mosphere of heat.

The arbitrary distribution of light and shade which might otherwise
be surprising is no longer noticeable. One is in the presence of a unified
painting which seems all of a piece and which is executed over a long
period of time, in thin layers, which has ended up by becoming compact,
dense, velvety. The earth is solid, the carpet of grass is thick, of that green
with bluish nuances which belongs so much to Cézanne, that he distributes
in precise strokes in the mass of leafage, that he spreads out in large,
grassy stretches on the ground, that he mingles with the mossy softness of
tree trunks and rocks. His painting then takes on the muted beauty of
tapestry, arrays itself in a strong, harmonious weft. Or else, as in the
Bathers, coagulated and luminous, it assumes the aspect of a piece of
richly decorated faïence.

I know another work by Cézanne, a portrait of a *Gardener* which
belongs to Paul Alexis, a too large canvas, the clothing empty, but the
head solid, well supported by the hand, burning eyes that really *look.*
And finally, there are the famous apples that the painter has loved to
paint and that he has painted so well. The backgrounds sometimes come
forward, but the tablecloths, the napkins, are so pliant, the whites so
nuanced, and the fruits are such naïvely beautiful things! Green, red,
yellow, in little twopenny heaps, placed on dishes or poured from full
baskets, the apples have the roundness, the firmness, the lively colors of

nature that harmonize with each other. They are healthy, speak of rusticity, they suggest the good smell of fruit.

No matter what subject he takes up, there is true sincerity in Cézanne, the sometimes charming, sometimes painful sign of a will that either satisfies itself or fails completely. Often as well, an ingenuous grandeur, as in the *Gardener,* where the incorrect figures have such a proud look; that bather, for example, who rests a foot on a hillock, and who takes on, with his sad face, his long, muscular limbs, a sort of Michelangelesque appearance, certainly unsought for.

That Cézanne has not realized with the strength that he wanted the dream that invades him before the splendor of nature, that is certain, and that is his life and the life of many others. But it is also certain that his idea has revealed itself, and that the assemblage of his paintings would affirm a profound sensitivity, a rare unity of existence. Surely this man has lived and lives a beautiful interior novel, and the demon of art dwells within him.[44]

NEO-IMPRESSIONISM

Félix Fénéon: 1861–1944

Félix Fénéon was the earliest and most enthusiastic spokesman for the Neo-Impressionist movement. Upon his arrival in Paris at the age of twenty-nine, he became involved in the avant-garde literary and artistic movements of his day, helping to found the influential Revue Indépendante *in 1884. Impressed by Seurat's* Une Baignade *as early as 1884, he did not give voice to his admiration until two years later, with the appearance of the painter's* La Grande Jatte, *and his meeting with the artist himself. Subsequently he became a close friend and defender of both Signac and Pissarro as well, publishing in the review* La Vogue *a series of articles on the movement based on careful discussions with the painters themselves. Not only was Fénéon a brilliant and forceful polemicist for the Neo-Impressionist group, but he undertook to establish relations between these artists and the Symbolist poets and writers who were his colleagues, thereby not only giving Seurat, Signac, Pissarro, and the other Neo-Impressionists a chance to discuss similar aesthetic problems with their literary counterparts, but also providing the group of painters with admirable literary spokesmen and popularizers.*

Impressive in appearance, with his aquiline nose and pointed beard, Fénéon was represented holding a cyclamen in a "symbolic" portrait by Signac which demonstrated the compositional and coloristic theories of

[44] Gustave Geffroy, "Paul Cézanne," *La Vie artistique* (Paris: Dentu, 1894), III, 249–260.

the Neo-Impressionists and which was entitled Against the Enamel of a Background Rhythmic with Beats and Angles, Tones and Colors, Portrait of M. Félix Fénéon *in 1890.*

The Impressionists in 1886 (Eighth Impressionist Exhibition)

This article, which first appeared in the Symbolist publication La Vogue *in June, 1886, and later in the same year, with additional material and minor changes, in the form of a book entitled* Les Impressionistes en 1886, *can really be considered the "Neo-Impressionist Manifesto." It was, in fact, this brochure that popularized the term "néo-impressionisme" itself, henceforth used to designate the art of Seurat and his followers. It is clear that at this point Seurat and his group saw themselves simply as reformers of casual, informal, instinctive Impressionism by means of the more rigorous disciplines of modern science, rather than as the creators of a completely new and opposing style.*

From the beginning, the Impressionist painters, with that concern for the truth which made them limit themselves to the interpretation of modern life directly observed and landscape directly painted, have seen objects conjointly related to one another, without chromatic autonomy, participating in the luminous qualities of their neighbors; traditional painting considered them [these objects] as ideally isolated and lighted them with a poor and artificial daylight.

These color reactions, these sudden perceptions of complementaries, this Japanese vision, could not be expressed by means of shadowy sauces concocted on the palette: these painters thus made separate notations, letting the colors arise, vibrate in abrupt contacts, and recompose themselves at a distance; they enveloped their subjects with light and air, modeling them in the luminous tones, sometimes even daring to sacrifice all modeling; sunlight was at last captured on their canvases.

They thus proceeded by the decomposition of colors; but this decomposition was carried out in an arbitrary manner: such and such a streak of impasto happened to throw the sensation of red across a landscape; such and such brilliant reds were hatched with greens. Messieurs Georges Seurat, Camille and Lucien Pissarro, Dubois-Pillet, and Paul Signac divide the tone in a conscious and scientific manner. This evolution dates from 1884, 1885, 1886.

If you consider a few square inches of uniform tone in Monsieur Seurat's *Grande Jatte,* you will find on each inch of its surface, in a whirling host of tiny spots, all the elements which make up the tone. Take this grass plot in the shadow: most of the strokes render the local value of the grass; others, orange tinted and thinly scattered, express the scarcely felt action of the sun; bits of purple introduce the complement to green; a cyanic blue, provoked by the proximity of a plot of grass in the sunlight,

accumulates its siftings toward the line of demarcation, and beyond that point progressively rarefies them. Only two elements come together to produce the grass in the sun: green and orange tinted light, any interaction being impossible under the furious beating of the sun's rays. Black being a non-light, the black dog is colored by the reactions of the grass; its dominant color is therefore deep purple; but it is also attacked by the dark blue arising from neighboring spaces of light. The monkey on a leash is dotted with yellow, its personal characteristic, and flecked with purple and ultramarine. The whole thing: obviously merely a crude description, in words; but, within the frame, complexly and delicately measured out.

These colors, isolated on the canvas, recombine on the retina: we have, therefore, not a mixture of material colors (pigments), but a mixture of differently colored rays of light. Need we recall that even when the colors are the same, mixed pigments and mixed rays of light do not necessarily produce the same results? It is also generally understood that the luminosity of optical mixtures is always superior to that of material mixture, as the many equations worked out by M. Rood show.[45] For a violet-carmine and a Prussian blue, from which a gray-blue results:

$$\underbrace{\text{50 carmine} + \text{50 blue}}_{\text{mixture of pigments}} = \underbrace{\text{47 carmine} + \text{49 blue} + \text{4 black}}_{\text{mixture of rays of light}}$$

for a carmine and green:

$$\text{50 carmine} + \text{50 green} = \text{50 carmine} + \text{24 green} + \text{26 black}$$

We can understand why the Impressionists, in striving to express extreme luminosities—as did Delacroix before them—wish to substitute optical mixture for mixing on the palette. Monsieur Seurat is the first to present a complete and systematic paradigm of this new technique. His immense canvas, *La Grande Jatte,* whatever part of it you examine, unrolls, a monotonous and patient tapestry: here in truth the accidents of the brush are futile, trickery is impossible: there is no place for bravura—let the hand be numb, but let the eye be agile, perspicacious, cunning. Whether it be on an ostrich plume, a bunch of straw, a wave, or a rock, the handling of the brush remains the same. And if it is possible to uphold the advantages of "virtuoso painting," scumbled and rubbed, for rough grasses, moving branches, fluffy fur, in any case "la peinture au point" [literally "well-done (cooked) painting"] imposes itself for the execution of smooth surfaces, and, above all, of the nude, to which it has still not been applied.

[45] In *Modern Chromatics (Students' Text-Book of Color),* published in 1879, a book that was to be extremely influential upon Seurat and his group, the American physicist, Ogden N. Rood, a professor at Columbia University had explained the important difference between mixing *pigment* (subtractive mixture) and mixing *light* (additive mixture), demonstrating the latter by means of Maxwell's Discs, and insisting upon its superior luminosity.

The subject [of the *Grande Jatte*]: beneath a canicular sky, at four o'clock, the island, boats flowing by at its side, stirring with a dominical and fortuitous population enjoying the fresh air among the trees; and these forty-odd people are caught in a hieratic and summarizing drawing style, rigorously handled, either from the back or full-face or in profile, some seated at right angles, others stretched out horizontally, others standing rigidly; as though by a modernizing Puvis.[46]

The atmosphere is transparent and singularly vibrant; the surface seems to flicker. Perhaps this sensation, which is also experienced in front of other such paintings in the room, can be explained by the theory of Dove: [47] the retina, expecting distinct groups of light rays to act upon it, perceives in very rapid alternation both the disassociated colored elements and their resultant color.[48]

Neo-Impressionism

In this important article, written for the Belgian avant-garde publication L'Art moderne *on the occasion of the third exhibition of the Society of Independent Artists in 1887, Fénéon attempts a more precise and complete formulation of Neo-Impressionist aims and achievements, especially those embodied in the works of the group's leader, Seurat, and emphasizes the role played by the simultaneous contrast of color in the latter's* Grande Jatte. *Couched in a strange style, "representative of the quaint syntax and unusual vocabulary in favor with the Symbolists,"* [49] *this article accentuated the difference between the original Impressionists and the newer group.*

I

. . . One thinks back to the first Impressionist exhibitions. Confronted by definitive canvases and fearsome scribbles, the constitutionally stupid public was flabbergasted. That a color should give rise to its complementary—ultramarine to yellow, red to blue-green—seemed demented to it, and even though the soberest physicists had assured its members in a scholarly tone of voice that the ultimate effect of darkening any of the colors of the spectrum was actually to add greater and greater quantities of violet light to them, the public still rebelled against violet tinges in the shadows of a painted landscape. Accustomed to the bituminous

[46] Pierre Puvis de Chavannes (1824–1898), painter of poetic and idealized allegories, best known for his murals, and greatly admired by the Symbolists.

[47] Heinrich-Wilhelm Dove (1803–1879), German physicist and meteorologist, whose "theory of luster," probably transmitted through Rood's writing, was influential upon Seurat.

[48] Félix Fénéon, "Les Impressionistes en 1886 (VIIIᵉ Exposition Impressioniste)," in Henri Dorra and John Rewald, *Seurat* (Paris: Les Beaux-Arts, 1959), pp. xi–xiii, trans. L. Nochlin. Reprinted by permission of the publisher; and John Rewald, *Post-Impressionism from van Gogh to Gauguin* (New York: Museum of Modern Art, 1956), p. 98. Reprinted by permission of the Museum of Modern Art, New York.

[49] Rewald, *Post-Impressionism*, p. 98.

sauces cooked up by the master-cooks of the schools and academies, light colored painting turned its stomach. . . .

As far as technique was concerned, still nothing was precise: the impressionist works presented themselves with an air of improvisation. The technique was summary, brutal, and hit-or-miss.

II

Since 1884–1885, Impressionism has come into possession of this rigorous technique. M. Georges Seurat was its instigator.

The innovation of M. Seurat, already implicitly contained in certain works of M. Camille Pissarro, is based on the scientific division of the tone. In this way: instead of triturating the pigment on the palette in order to come as close as possible to the tint of the surface to be represented, the painter places directly on the canvas brushstrokes setting out the local color—that is to say, the color that the surface in question would take on in white light (obviously the color of the object seen from close up). This color, which he has not achromatized on the palette he achromatizes on the canvas, by virtue of the laws of simultaneous contrast, by the intervention of other series of brushstrokes, corresponding to:

1. The portion of colored light which is reflected, without change, on the surface—this will generally be a solar orange;

2. The weak portion of colored light which penetrates farther than the surface and which is reflected after having been modified by a partial absorption;

3. The reflections projected by neighboring bodies;

4. The surrounding complementary colors. Strokes which are not executed with a slashing brush, but by the application of tiny coloring-spots.

Here are some of the advantages of working in this way:

I. These strokes unite on the retina, in an optical mixture. Now, the light intensity of an optical mixture is much greater than that of a pigment mixture. This is what modern physics means when it says that every mixture on the palette is a step toward black.

II. Since the numerical proportions of the coloring-drops can vary infinitely within a very small area, the most delicate nuances of modeling, the most subtle devaluations of tints can be translated.

III. This spotting of the canvas demands no manual skill, but only—only!—an artistic and experienced vision.

III

The spectacle of the sky, of water, of greenery varies from instant to instant, according to the original Impressionists. To seize one of these fugitive appearances on the canvas was their goal. Thus the necessity arose of capturing a landscape in a single sitting, and a propensity for making nature grimace to prove that the moment was indeed unique and would never be seen again.

To synthesize the landscape in a definitive aspect which perpetuates the sensation [it produces]—this is what the Neo-Impressionists try to do. (Furthermore, their manner of working is not suited to hastiness and requires painting in the studio.)

In their scenes with figures, there is the same aversion to the accidental and transitory. Thus the critics in love with anecdote whine: they are depicting dummies, not men. These critics are not tired of the Bulgarian's portraits, which seem to ask: guess what I am thinking! It doesn't bother them at all to see on their wall a gentleman whose waggishness is eternalized in a wicked wink, or some flash of lightning *en route* for years.

The same critics, always perspicacious, compare the Neo-Impressionist paintings to tapestry, to mosaic, and condemn [them]. If it were true, this argument would be of meager value, but it is illusory; step back a bit, and all these varicolored spots melt into undulating, luminous masses; the brushwork vanishes, so to speak; the eye is no longer solicited by anything but the essence of the painting.

Is it necessary to mention that this uniform and almost abstract execution leaves the originality of the artist intact, and even helps it? Actually, it is idiotic to confuse Camille Pissarro, Dubois-Pillet,[50] Signac, and Seurat. Each of them imperiously betrays his disparity—if it be only through his unique interpretation of the emotional sense of colors or by the degree of sensitivity of his optic nerves to such and such a stimulus —but never through the use of facile gimmicks.

Among the throng of mechanical copyists of externals, these four or five artists produce the very effect of life; this is because to them objective reality is simply a theme for the creation of a superior, sublimated reality in which their personality is transformed.[51]

Georges Seurat: 1859–1891

Letter to Maurice Beaubourg, 1890

Despite his tragically brief career, Georges Seurat was the leader of the Neo-Impressionist movement and one of the major figures in 19th-century art. After a period of study at the Ecole des Beaux-Arts under the academician Heinrich Lehmann, and independent examination of the old masters, he was soon drawn to the most fertile area of experimentation and discovery of his time: Impressionism. His first major work, Une Baignade *(1883–1884), rejected from the official Salon and accepted by the newly founded* Groupe des Artistes Indépendants, *bears witness not only to Seurat's dual source of inspiration in traditional composition and Impressionist optical mixture of color and broken brushwork,*

50 Albert Dubois-Pillet (1845–1890), artist associated with the Indépendants, whose works are extremely rare.

51 Félix Fénéon, "Le Néo-Impressionisme" (Correspondance particulière de *L'Art moderne*), *L'Art moderne* (May 1, 1887), pp. 138–139.

but points ahead to his later achievements, such as those embodied in La Grande Jatte *(1886) and* Les Poseuses *(1886–1887).*

In effect, in the years between 1884 and 1886, Seurat attempted to impose a more law-governed, permanent, and objective universality upon Impressionism's "romantic," instinctive, intuitive approach to painting, by turning to contemporary scientific studies of perception, light, and color for support and instruction. During this phase of "chromo-luminarism," as he and some of his supporters preferred to call it, Seurat's major preoccupation was that of finding an equivalent for the luminosity of nature by means of a color technique based on additive rather than subtractive mixture, an attempt owing much to the scientific formulations and experiments of Chevreul, Rood, and Sutter. In latter years, from about 1886 to 1891, he became increasingly concerned with achieving a Symbolist "correspondence" for given emotional states by means of line and composition as well as color and value, but achieved once more, not through mere intuition, but by means of a set of established, universally verifiable principles, so that different combinations of the different pictorial elements would predictably give rise to definite emotional reactions. In this attempt the influence of the brilliant and many-sided Charles Henry—mathematician, chemist, physicist, psychologist, aesthetician, and art critic—is clearly discernible.

Seurat's ideas on painting were given verbal formulation only rather late in his career: first in a statement appearing at the end of a brief biography written by Jules Christophe in Les Hommes d'Aujourd'hui *in 1890, and second, and most importantly, in the letter to Maurice Beaubourg of August 28, 1890 (not published until after the artist's death), in which Seurat drew upon both traditional theories of art and modern scientific discoveries—not only those of physics and psychology, but upon his friend Charles Henry's "experimental aesthetics"—in the formulation of his own theoretical position, most concretely embodied in such late works as* Le Chahut *(1889–1890) and* Le Cirque *(his last major work), both of which contain strong elements of "dynamogeny," a term used by Henry to describe gaiety of compositional and coloristic effect.*

AESTHETIC

Art is Harmony. Harmony is the analogy of contrary and of similar elements of *tone,* of *color,* and of *line,* considered according to their dominants and under the influence of light, in gay, calm, or sad combinations.

The contraries are:

For *tone,* a more $\begin{cases} \text{luminous} \\ \text{lighter} \end{cases}$ shade against the darker.

For *color,* the complementaries, i.e., a certain red opposed to its complementary, etc. (red-green; orange-blue; yellow-violet).

For *line,* those forming a right angle.

Gaiety of *tone* is given by the luminous dominant; of *color,* by the warm dominant; of *line,* by lines above the horizontal.

Calm of *tone* is given by an equivalence of light and dark; of *color,* by an equivalence of warm and cold; and of *line,* by horizontals.

Sadness of *tone* is given by the dominance of dark; of *color,* by the dominance of cold colors; and of *line,* by downward directions.

TECHNIQUE

Taking for granted the phenomena of the duration of a light impression on the retina: a synthesis follows as a result. The means of expression is the optical mixture of tones and colors (both of local color and of the illuminating color—sun, oil lamp, gas lamp, etc.), i.e., of the lights and their reactions (shadows) according to the laws of *contrast, gradation,* and *irradiation.*

The frame is in the harmony opposed to that of the tones, colors, and lines of the picture: [52]

Reflections on Painting: Seurat's Transcription of a Passage from Chevreul's "De la loi du contraste simultané des couleurs"

While the scientist Chevreul proposed a system of general laws of color harmony and contrast, his book, published in 1839, had already long been out of date when Seurat studied and transcribed a portion of it about fifty years later, although at this time it was still considered an important contribution to color theory by artists and aestheticians. The importance which Seurat attached to Chevreul's work is made manifest both in his careful copying of this excerpt and in his early color tech-

[52] Georges Seurat, Letter to Maurice Beaubourg, August 28, [1890], translated in Rewald, *Post-Impressionism,* p. 142.

nique itself; later Chevreul's theories were supplanted by the more ad-
vanced scientific color conceptions of Rood and Henry—especially those
concerning the differences between additive and subtractive mixture—
based on the experiments of Helmholtz and Maxwell.

Michel-Eugène Chevreul (1786–1889) was a chemist and director of
the dyeworks of the Gobelin Tapestry works from 1824 on, who, in his
theoretical studies of color and their application to painting, exerted a
major influence on 19th-century painters from Delacroix to the Neo-
Impressionists.

1

Put a color upon a canvas, it not only colors with that color the
part of the canvas to which that color has been applied, but it also colors
the surrounding space with the complementary.

2

White placed beside a color heightens its tone; it is as if we took
away from the color the white light that enfeebled its intensity.

3

Black placed beside a color weakens and in some cases impoverishes
its tone. Influence on certain yellows. It is actually adding to black the
complementary of the contiguous color.

4

Put grey beside a color, the latter is rendered more brilliant, and
at the same time it tints this grey with its complementary. From this
principle it results that in many cases where grey is near to a pure color
in the model, the painter, if he wishes to imitate this grey which appears
to him tinted with the complementary of the pure color, need not use a
colored grey, as the effect will be produced in the imitation by the juxta-
position of the color with the grey contiguous to it. Besides, the im-
portance of this principle cannot be doubted when we consider that all
the modifications which a monochrome object may present, excepting
those which result from the reflections of colored lights emanating from
neighboring objects, arise from the different relations of position be-
tween the parts of the object and the eye of the spectator; so that it is
strictly true to say that to reproduce by painting all these modifications
it suffices to have a color exactly identical to that of the model, with black
and white. In fact, with white you produce all the modifications due to
the weakening of the color by light, and with black, those which are due
to the height of its tone. Finally, if the color of the model in certain
parts gives rise to the manifestation of its complementary, because these
parts do not return to the eye enough color and white light to neutralize
this manifestation, the modification of which I speak may be imitated by
the employment of a normal grey tone, properly surrounded with the
color of the object.

If the preceding proposition is true, I realize that in many cases it is necessary to employ with the color of the object the colors which are nearest it—that is to say, the modifications of the color. For example, in imitating a rose, we can employ red shaded with a little yellow and with a little blue, or in other terms, shaded with orange and violet, but the greenish shadows that we perceive in certain parts arise from the juxta-position of red and normal grey.

5

To put a dark color near a different but lighter color is to heighten the tone of the first and to lower that of the second, independently of the modification resulting from the mixture of the complementaries.

An important consequence of this principle is that the first effect may neutralize the second or even oppose it. For example: a light blue placed beside a yellow tinges it orange and consequently heightens its tone; while there are some blues so dark relatively to the yellow that they weaken it so much as not only to hide the orange tint, but even to cause sensitive eyes to notice that the yellow is rather green than orange, a very natural result if we consider that the paler the yellow, the greener it tends to appear.

6

Put beside each other two flat tints of different tones of the same color and chiaroscuro is produced, because in setting out from the line of juxtaposition, the tint of the band of the highest tone is insensibly enfeebled, while, setting out from the same line, the tint of the band of the lowest tone becomes heightened; thus there is a true gradation of light. The same gradation takes place in all the juxtapositions of distinctly separated colors.[53]

Paul Signac: 1863–1935

From Eugène Delacroix to Neo-Impressionism

Paul Signac, member of and spokesman for the Neo-Impressionist group, remained faithful to its precepts throughout his long career. He had started to paint very early in life, and then discovered new possibili-ties for art in 1884, when he came upon Seurat's Baignade *at the* Indé-pendants *(of which he was one of the founders). He met the young artist himself and persuaded the considerably older Pissarro to join their enter-prise in 1885; Dubois-Pillet, Angrand, Cross, and Lucien Pissarro, Ca-mille's son, were other early disciples of Seurat who showed in the same*

[53] Georges Seurat, Notes transcribed from Michel Chevreul's *De la loi du con-traste simultané des couleurs* (1839), in C. M. De Hauke, *Seurat et son oeuvre* (Paris: Gründ, 1961), I, xxiv. Reprinted by permission of the publisher, Gründ-Paris. The translation of Seurat's transcription of Chevreul is based mainly on *The Laws of Con-trast of Colour: and their application to the Arts . . .* , trans. John Spanton (London: Routledge, Warne and Routledge, 1860), pp. 92–94.

room with him at the second exhibition of the Indépendants *in 1886. Certainly, it was Signac who in 1887 played a major role in Vincent van Gogh's "conversion" to painting with bright, clear colors and broken brushstrokes. By this time, Seurat and his group had established relations with the Symbolist writers and poets—Jean Moréas, Gustave Kahn, Félix Fénéon, Paul Adam, etc.—many of whom became spokesmen for the group. Yet Signac, the Neo-Impressionist most closely associated with Seurat himself, always attracted by new ideas and capable of precise and lively expression of them, remained the chief propagandist and theorist of the movement. As Pissarro once said to him:* "All the weight of Neo-Impressionism rests on your shoulders. . . ."

Signac's major theoretical work, D'Eugène Delacroix au néo-impressionisme, *did not actually appear until 1899, by which time the force of the movement he was defending had long since been spent, and its scientific, progressivist side even openly attacked by neo-traditionalists and* fin de siècle *aestheticians and Symbolists.*

Recent criticism has pointed out several important defects or distortions in Signac's study: it is oversimplified, it neglects many important questions of Neo-Impressionist practice, it omits a great deal of material on Seurat's early career, it reduces the importance of science in his work.[54] Yet, if one considers it as a defense and popularization of the movement rather than as a definitive art-historical work, it still remains an important document of that aesthetic universalism, that attempt to unite and synthesize all human thought and feeling in a symbolic, law-based harmony which animated so many literary and artistic enterprises of the last twenty years of the 19th century. In addition, Signac's study became important for the evolution of the avant-garde art of the new century; all those concerned with color as an expressive or constructive force, freed from mere imitation and description, looked to Signac for support and information. Excerpts of his book had appeared in the German Jugendstil *publication* Pan *as early as 1898, exerting considerable influence upon the future German Expressionists; his work played an equally important role in the birth of Fauvism and upon the subsequent career of Matisse, as well as upon the Italian Futurists and Kandinsky, Delaunay, and such cubists as Gleizes, Metzinger, Lhote, and Kupka.*

I. Documents

1. The belief that the Neo-Impressionists are painters who cover their canvases with multicolored *little dots* is a very widespread error. We will later demonstrate, but right now affirm, that this mediocre method of the *dot* has nothing at all to do with the aesthetics of the

[54] See William Innes Homer, *Seurat and the Science of Painting* (Cambridge, Mass.: The M.I.T. Press, 1964), pp. 1–3.

painters whom we are defending here, nor with the technique of *division* they employ.

The Neo-Impressionist does not *dot,* he *divides.*

Now, to divide is:

To assure oneself of all the benefits of luminosity, of coloring, and of harmony, by:

1. *The optical mixture of solely pure pigments (all the tints of the prism and all their tones);* [55]

2. *The separation of the different elements (local color, color of the lighting, their interactions, etc. . .);*

3. *The equilibration of these elements and their proportions (according to the laws of contrast, of gradation, and of irradiation);*

4. *The choice of a brushstroke commensurate with the dimensions of the painting.*

The method formulated in these four paragraphs will therefore govern color for the Neo-Impressionists, most of whom will employ, in addition, the more mysterious laws that order lines and directions, and assure them harmony and beautiful arrangement.

Thus informed about line and color, the painter will certainly determine the linear and chromatic composition of his painting, of which the dominants of direction, of tone, and of tint will be appropriate to the subject he wishes to treat.

2. Before going further, let us invoke the authority of the pure and elevated genius of Eugène Delacroix: the rules of color, of line, and of composition that we have just set forth and which summarize *division,* were promulgated by the great painter.

We are going to take up again, one by one, all the parts of the aesthetics and the technique of the Neo-Impressionists; then, by comparing them to the lines written on the same questions by Eugène Delacroix in his letters, his articles, and in the three volumes of his *Journal,* we will show that these painters are only following the teaching of the master and continuing his research.

[Signac now proceeds to make this comparison in great detail, and then goes on to consider, in Chapter II, Delacroix's contribution, which is summarized in section 14 of that Chapter.]

II. Delacroix's Contribution

14. For half a century, Delacroix struggled to obtain more brilliance and more light, thus showing the colorists who were to succeed him the path to follow and the goal to achieve. He still leaves them a

[55] Since the words *tone* [*ton*] and *tint* [*teinte*] are generally used for one another, let us make clear that by *tint* we mean the quality of a color, and by *tone* the degree of saturation or of luminosity of a tint. The gradation of one color toward another will create a series of intermediary *tints,* and the gradation of one of these *tints* toward the light or the dark will pass through a succession of tones. [Signac's note.]

great deal to do, but thanks to his contribution and his teaching, their task will be greatly simplified.

He has proved to them all the advantages of an informed working method, of combination, and of logic, which in no way hinder the passion of the painter, but strengthen it.[56]

He handed over to them the secret of the laws determining color: the accord of like ones, the analogy of contrasting ones.

He shows them how inferior a unified and flat method of coloring is to the tint produced by the vibrations of differing combined elements.

He fixes firmly for them the resources of optical mixture, making it possible to create new tints.

He advises them to banish as far as possible somber, dirty, and dull colors.

He teaches them that a tint can be modified and toned down without being dirtied by mixtures on the palette.

He points out to them the moral influence of color, and how it contributes to the effect of the painting; he initiates them into the aesthetic language of tints and tones.

He incites them to dare everything, never to fear that their harmonies may be too highly colored.

The powerful creator is also the great educator: his teaching is as valuable as his work.

[Signac continues in Chapter III with a discussion of the Impressionist contribution to color theory, which he admits was great, although they failed to go far enough, and indeed often outright rejected or ignored scientific "laws."]

III. The Impressionists' Contribution

. . . Impressionism will certainly characterize one of the periods of art, not only because of the masterful achievements of these painters of life, movement, joy, and sunlight, but also because of the considerable influence it had on all contemporary painting, whose color it regenerated.

It is not necessary to write the history of this movement here; only the effective technical contribution of the Impressionists is specified: simplification of the palette (only the colors of the prism), decomposition of the tints into multiple elements. We, however, who have profited from their efforts will now permit ourselves to express to these masters our admiration for their lives free of either concession or weakness, and for their work. . . .

[56] See Baudelaire's similar view of this artist: "Delacroix was passionately in love with passion, and coldly determined to seek the means of expressing it in the most visible way." Charles Baudelaire, "The Life and Work of Eugène Delacroix" (1863), in *The Mirror of Art*, trans. and ed. Jonathan Mayne (Garden City: Doubleday Anchor Books, 1956), p. 311.

9. The absence of method often leads the Impressionist into error in the application of contrast. If the painter is in good shape or the contrast very visibly marked, the sensation, clearly experienced, will find its exact formulation; but in less propitious circumstances, perceived in a vague condition, it [the sensation] will remain unexpressed or will be translated in an imprecise fashion. And we have seen, from time to time, in Impressionist paintings, the shadow of a local color that is not the exact shadow of that tint, but of another more or less analogous one, or even a tint that is not logically modified by the light or shade: a blue, for example, more highly colored in the light than in the shade, a red warmer in the shade than in the light, a light too dulled or a shadow too brilliant.

IV. The Neo-Impressionists' Contribution

. . . If these painters for whom the epithet *chromo-luminarists* would be more appropriate have adopted this name of *Neo-Impressionists,* it was not in order to fawn upon success (the Impressionists were still in the midst of a struggle), but rather to render homage to the effort of precursors and to indicate that beneath the divergency of method, they shared a common goal: *light* and *color.* It is in this sense that the word *Neo-Impressionists* should be understood, for the technique these painters use has nothing to do with that of the Impressionists: just as much as that of their predecessors is one of instinct and instantaneity, to the same degree theirs is one of reflection and permanence.

2. The Neo-Impressionists, like the Impressionists, have only pure colors on their palette. But they completely repudiate any mixture on the palette, except, of course, the mixture of colors adjacent on the chromatic circle. The latter, gradated among themselves and lightened with white, will have the tendency to restore the variety of tints of the solar spectrum and all their tones. An orange mixed with a yellow and a red, a violet gradating toward red and toward blue, a green passing from blue to yellow are, with white, the only elements at their disposition. But, through the optical mixture of these few pure colors, by varying their proportion, they obtain an infinite quantity of tints, from the most intense to the most grey.

Not only do they banish from their palettes all mixture of diminished tints, but they further avoid sullying the purity of their colors by the meeting of contrary elements on their support. Each brushstroke, taken pure from the palette, remains pure on the canvas. . . .

4. It seems that the first preoccupation of a painter before his white canvas should be to decide which curves and which arabesques are going to cut up its surface, which tints and which tones are going to cover it —a very rare concern in a period in which most paintings are like instantaneous photographs or foolish illustrations.

To reproach the Impressionists with having neglected these pre-occupations would be childish, since their intention was manifestly that of capturing the arrangements and harmonies of nature as they presented themselves, without any concern for arrangement or combination. "The Impressionist sits on the bank of a river," as their critic, Théodore Duret, says, "and paints what he has before him." And they have proved that in this way one can do marvelous things.

The Neo-Impressionist, in this respect following the advice of Delacroix, will not begin a canvas before he has determined the layout. Guided by tradition and science, he will harmonize the composition with his conception—that is to say, he will adopt the lines (directions and angles), the chiaroscuro (tones), the colors (tints) to the expression he wishes to make dominant. The dominant of the lines will be horizontal for calm, ascending for joy, and descending for sorrow, with all the intermediary lines to represent all the other sensations in their infinite variety. A play of many colors, not less expressive and variegated, is conjoined with this linear play; to the ascending lines will correspond warm and light tones; with descending lines cold and dark colors will predominate; a more or less perfect equilibrium of warm and cold tints, of pale and intense tones, will add to the calm of horizontal lines.[57] In thus subordinating color and line to the emotion he has felt and wishes to translate, the painter will produce the work of a poet, of a creator. . . .

[Chapter V, entitled "The Divided Touch," deals with the Neo-Impressionists' actual method of applying paint, an essential aspect of their theory.]

V. THE DIVIDED TOUCH

4. *Division* is a complex system of harmony, an aesthetics rather than a technique. The *dot* is only a means.

To divide is to seek the power and harmony of color, through representing colored light by its pure elements and by using the optical mixture of these pure elements, separated and proportioned according to the essential laws of contrast and gradation.

The separation of the elements and optical mixture insure the purity—that is to say, the luminosity and intensity—of tints; gradation enriches their brilliance; contrast, determining the accord of those that are alike and the analogy of those which are contrary, subordinates these powerful but equilibrated elements to the rules of harmony. The basis of *division* is contrast: is not contrast art?

To dot is the mode of expression chosen by the painter who places color on a canvas by means of little dots rather than spreading it out flat. It means to cover a surface with little juxtaposed, multicolored

[57] Compare Seurat's letter to Maurice Beaubourg of August 28, 1890, for a similar statement. See above, pp. 112 to 114.

brushstrokes, pure or dull, trying to imitate, through the optical mixture of these multiplied elements, the variegated tints of nature, without any desire for equilibrium, without any concern for contrast. The *dot* is only a stroke of the brush, a method, and like all methods, has scarcely any importance. The *dot* has only been used, word or working method, by those who, incapable of appreciating the importance and the charm of contrast and of the equilibrium of elements, have seen only the means and not the spirit of *division*. . . .

[Chapter VI consists of a simple chart summarizing the three contributions.]

VI. SUMMARY OF THE THREE CONTRIBUTIONS

So many sentences—but it was necessary to furnish all the proofs, to be convincing about the legitimacy of Neo-Impressionism by establishing its ascendency and its contribution—could they not be summarized in this synoptic table? [58]

	AIM
Delacroix *Impressionism* *Neo-Impressionism*	To give color its greatest possible brilliance.

	MEANS
Delacroix	1. A palette made up of both pure colors and reduced colors. 2. Mixture (of colors) on the palette, and optical mixture. 3. Cross-hatching. 4. Methodical and scientific technique.
Impressionism	1. A palette composed solely of pure colors, approximating those of the solar spectrum. 2. Mixture (of colors) on the palette, and optical mixture. 3. Brushstrokes of comma-like or swept-over form. 4. A technique depending on instinct and the inspiration of the moment.
Neo-Impressionism	1. The same palette as Impressionism. 2. Optical mixture (of colors).

[58] Paul Signac, *D'Eugène Delacroix au néo-impressionisme*, ed. Françoise Cachin (Paris: Hermann, 1964; orig. published 1899), pp. 37–38, 74–75, 83, 86, 91, 92, 94, 106–107, 113. Reprinted by permission of the publisher.

3. Divided brushstrokes.

4. Methodical and scientific technique.

RESULTS

Delacroix

Through the rejection of all flat color tones, and thanks to shading, contrast, and optical mixture, he succeeds in creating from the partially incomplete elements at his disposal a maximum brilliance whose harmony is insured by the systematic application of the laws governing color.

Impressionism

By making up his palette of pure colors only, the Impressionist obtains a much more luminous and intensely colored result than Delacroix; but he reduces its brilliance by a muddy mixture of pigments, and he limits its harmony by an intermittent and irregular application of the laws governing color.

Neo-Impressionism

By the elimination of all muddy mixtures, by the exclusive use of the optical mixture of pure colors, by a methodical divisionism, and a strict observation of the scientific theory of colors, the Neo-Impressionist insures a maximum of luminosity, of color intensity, and of harmony—a result that had never yet been obtained.[59]

Signac and Anarchism

Impressionists and Revolutionaries

Signac, like Pissarro and some of the other members of the Neo-Impressionist circle, including Henri-Edmond Cross, Charles Angrand, Théo van Rysselberghe, and Maximilien Luce, was a staunch partisan of the socialist-anarchist movement in France. The unpublished correspondence of France's leading anarchist-communist, Jean Grave (1854–1939), was conducted almost entirely with artists, particularly the Neo-Impressionists, as Robert and Eugenia Herbert have pointed out.[60]

[59] Paul Signac in Robert Goldwater and Marco Treves, eds., *Artists on Art*, trans. Robert Goldwater, 3rd ed. (New York: Pantheon Books, 1964), pp. 377–378.

[60] Robert L. and Eugenia W. Herbert, "Artists and Anarchism: Unpublished Letters of Pissarro, Signac, and others—I" *The Burlington Magazine*, CII (November, 1960), 473 and 474–482, *passim*. Also see Eugenia W. Herbert, *The Artist and Social Reform: France and Belgium, 1885–1898* (New Haven: Yale University Press, 1961), pp. 184–191 for further information on this subject.

In the excerpts from an article entitled "Impressionistes et Révolutionnaires," signed "an Impressionist Comrade," Signac achieves the difficult feat of equating social and artistic revolution, while at the same time, staunchly maintaining his antagonism to an overtly proselytizing, propagandistic form of art. The article appeared from June 13 to June 19, 1891, in La Révolte, *the most important organ of French anarchism, directed by Jean Grave himself.*

[The Neo-Impressionists] through their picturesque studies of the workers' housing at Saint-Ouen or Montrouge, sordid and sparkling, through the reproduction of the broad and oddly colored appearance of a navvy near a heap of sand, of a blacksmith in the incandescence of a forge, or still better, through the synthetic representation of the pleasures of decadence: balls, kick-choruses, circuses, such as that of the painter Seurat, who had such a lively feeling for the degradation of our era of transition, bear witness to the great social struggle that is now taking place between the workers and capital. . . .

[The paintings of the Neo-Impressionists], resulting from a purely aesthetic emotion produced by the pictorial quality of things and beings, contain that unconscious social quality with which contemporary literature is already marked: some of the novels of writers like Flaubert, the Goncourts, Zola, and their followers, written with a purely literary aim, based on experienced facts, have served the revolutionary cause much more powerfully than all the novels where political preoccupations took precedence over the literary side. . . .

It would thus be an error, into which the best intentioned revolutionaries, like Proudhon,[61] all too often have fallen, systematically to require a precise socialist tendency in works of art, for this tendency will be found much more powerful and eloquent in the pure aesthetes, revolutionaries by temperament, who, moving far off the beaten path, paint what they see, as they feel it, and very often unconsciously give a hard blow of the pick-axe to the old social structure. . . .[62]

Justice and Harmony

The following excerpt from an unpublished and undated manuscript in the Signac Archives, probably from about 1902, was intended as a lecture aimed at workers and their anarchist leaders.

[61] The anarchist philosopher, P.-J. Proudhon, had insisted that art must directly further the cause of social justice.

[62] Paul Signac, "Impressionistes et Révolutionnaires," originally published in *La Révolte*, June 13–19, 1891; republished in part by Robert L. and Eugenia W. Herbert, *Burlington*, p. 480, trans. L. Nochlin. Reprinted by permission of the publisher.

Justice in sociology, harmony in art: the same thing . . .

The anarchist painter is not the one who will create anarchist pictures, but he who, without concern for wealth, without desire for recompense, will fight with all his individuality against official bourgeois conventions by means of a personal contribution. . . .

The subject is nothing, or at least it is only one part of the work of art, no more important than the other elements—color, drawing, composition. . . .

When the eye is educated, the people will see other things besides the subject in pictures.

When the society we dream of exists, when the worker, rid of the exploiters who brutalize him, has the time to think and instruct himself, he will appreciate the varied qualities of the work of art.[63]

Excerpts from Paul Signac's Journal: 1894–1899

Quite as important as the works Signac intended for publication are these personal notes, left with the artist's daughter in several notebooks and only recently edited and published by John Rewald. Less formally organized than his polemical and expository writings, the pages of these journals reveal all of Signac's fiery temperament, his sense of commitment to both artistic and social ideals, his loyalty to Seurat's memory and to Neo-Impressionism, and, at the same time, his openness to other artistic viewpoints and movements, provided only that they be unsullied by hypocrisy or pretentiousness. A whole period—beginning shortly after Seurat's death, when the cause of Neo-Impressionism was still far from being won, and ending at the turn of the century—is revealed here with warmth, honesty, and a combative vigor in the cause of truth, whether it be a question of the Dreyfus Affair or of a pictorial motif.

On Neo-Impressionism

SEPTEMBER 15 [1894]

How unjust people are toward Seurat. To think that they refuse to recognize in him one of the geniuses of the century! The young ones are full of admiration for Laforgue and van Gogh—these also dead (besides, without this . . .)—and for Seurat . . . oblivion, silence. Yet he is a painter other than van Gogh, who [i.e., van Gogh] is interesting only because of his aspect as an insane phenomenon . . . and whose only interesting paintings are those which were done at the time of his sickness,

[63] Paul Signac, From an unpublished, undated MS in the Signac Archives, probably from about 1902, published by Robert L. and Eugenia W. Herbert, *Burlington*, p. 479, trans. L. Nochlin.

in Arles. At the time of Seurat's death,[64] the critics did justice to his talent but found that he did not leave a single work! It seems to me, on the contrary, that he gave everything he could give, and admirably. He would certainly still have produced and progressed greatly, but his task was accomplished. He had passed everything in review and established almost with finality: the black-and-white, the harmonies of line, composition, the contrast and harmony of color . . . and even the frames.[65] What more can one ask of a painter?

The small success of our paintings is easily explainable: what pleasure can people who have no eye find in them, since we are simply in search of beautiful lines and beautiful colors without concern for fashion, anecdote, or literature! Besides, this is the fate reserved for all painters who are really painters. Do people now look at the paintings of Delacroix? And how numerous are the visitors of Saint-Sulpice? [66] He still bores people as much as he did during his lifetime. . . . He is admired out of sheer cussedness, but he is not looked at. Why should the public look at his work, anyway? It would not understand it. Who among the public or the critics has a sufficiently trained eye to enjoy beautiful lines and beautiful colors? I am sure I [could] make a painting in which all the rules of harmony would be reversed and in which I would do everything contrary to what I believe to represent beauty . . . and nobody would see anything wrong about it!—If there are "dots," it will always be a Signac! . . .

DECEMBER 3 [1894]

. . . We are reproached for being too learned. But we know no more about color than what we should have learned in grade school! To think that the girouettes [weather vanes] of papa Chevreul are not adopted in the schools! Why complain about the lack of taste when one does nothing to educate the eye? Yet, to learn to play the piano, one exercises one's fingers. . . . They have eyes and they do not see.

Raffaëlli is so well versed in our technique that he believes it consists solely in placing a red next to a blue in order to obtain a violet, and a yellow beside a blue to make a green.[67] —But no, dear Maître, when I want a green, I use a green, and when I want a violet, I use a

[64] Seurat had died in 1891.
[65] Seurat had developed special contrasting enframements to enhance the brilliance of his color.
[66] Delacroix had painted two of his most brilliantly colored late masterpieces, *Jacob Wrestling with the Angel* and *Heliodorus Driven from the Temple,* in the Chapel of the Holy Angels in *St. Sulpice* (1854–1861), in which the artist had attempted to apply his observations about the interaction of complementary colors.
[67] Jean François Raffaëlli (1850–1924), painter of popular, picturesque genre scenes of the Parisian suburbs and middle-class daily life, treated with superficial brio and freedom of technique.

violet. . . . Division, contrast are not this at all! It is both simpler and more complex—and, especially, more useful.

COLORS OF LIGHTS

morning:	yellow
noon:	yellow white orange yellow
5 P.M.:	orange orange and red
shadow:	violet greyish blue violet blue blue green blue
sunset:	red
shadow:	green
gaslight:	orange and red
shadow:	greenish blue
magnesium light:	white
shadow:	almost black

In the South the much reflected shadow can be almost warm, luminous. . . .

JULY 5 [1895]

Always in search of a freer technique while retaining the advantages of divisionism and contrast. As for the tone on tone, it goes by itself but when two very clashing tints have to be made to harmonize . . . blue and orange, for instance, it is indeed hard. One should, I think place each touch lightly from the start so that the contour of each of these touches should not be well defined but irradiated, blended, divided. There are in my canvases parts treated this way which were satisfactory from the start while from other parts, too much worked upon, I get no result. What I gained from these searches is a greater and greater horror of the "petit point" and a hatred of dryness.

Every evening gathered much written information for my *Sunset*. This method of working, this search for the documentation one needs, discarding everything that is of no use to you, is truly a relief. One feels that one is not wasting one's time at this work which is more intelligent than that of the copyists, and that each stroke of the brush will be useful. This choice that one makes of what is beautiful or ugly before you, daily adds refinement to the taste and gives one greater confidence in oneself.

One no longer feels a slave; one is left to oneself, and this freedom and responsibility are delightful.[68]

On Zola and the Dreyfus Affair

JANUARY 17 [1898]

In the face of the screams of cowardice and infamy aroused by the courageous intervention of Zola in the Dreyfus and Esterhazi affairs, I asked that my name be put on the list of protesters which is being published by "L'Aurore." I am in good company there. All those who think freely, all those who put dignity before interest, sign these lists which are growing daily.

FEBRUARY 23 [1898]

Zola is condemned to one year of prison. It was inevitable. He attacked one of the cogs of society. . . . The stupid, depraved crowd yells for death; the sword and the flag triumph. . . .[69]

On Copying Versus Style

SEPTEMBER 15 [1898]

The good Paillard,[70] the engraver, who is here for two months, passes before my studio carrying his painter's paraphernalia. He stops for a while and we talk. He is in search of a motif and finds nothing. He needs a corner that would "take shape" and one that could be seen from a place where he might work in the shade. Really, when one is free from any idea of copy or imitation—as we, fortunately, are—these little preoccupations seem rather ridiculous. It is quite recent, in fact, this mania of painting from nature. None of the old masters did so. One should document oneself and not copy. And it is only since the number of painters multiplied itself endlessly that this habit has spread. It is no longer art, it is a copy, an easy craft in which, at the end of a few months and with some care, everyone can succeed. What a difference between the one who, while walking, stops by chance at a spot in the shade and "imitates" the motif which he has before him—and the one who, confronting a canvas or a sheet of paper, tries to convey, through beautiful lines and beautiful colors, the emotion which, at a given moment, he has expe-

[68] Paul Signac in John Rewald, ed., "Excerpts from the Unpublished Diary of Paul Signac: I (1894–1895)," *Gazette des Beaux-Arts,* XXXVI (July–September, 1949), 166–174 (translation). Reprinted by permission of the publisher.

[69] The Dreyfus Affair, becoming more than a question of the trial of a single individual or even of anti-Semitism, became a true ideological dividing line, splitting all France into two warring camps for many years: Dreyfusards—Jewish, liberal, progressive, intellectual—versus anti-Dreyfusards—anti-Semites, militarists, reactionaries.

[70] Henri Pierre Paillard (1844–1912), painter of marines and landscapes and creator of woodcuts.

rienced before a beautiful view of nature. What different results these two painters would achieve: the first will have only a mediocre or banal —if not actually bad—arrangement of colors and lines which everyone who will sit down at the same place will be able to obtain, while the arrangement that results from the artist's own determination will almost always be superior, and will, in any case, have the merit of being novel and personal—he will attain a style which the copyist will never be able to reach.[71]

On the Exhibition at Durand-Ruel's in 1899

On March 10, 1889, there opened at Durand-Ruel's gallery an important exhibition, which, at the dawn of the new century, seemed like a final summary of all the major innovations of the last quarter of the old one. Almost all the leading avant-garde figures were represented, grouped according to their affinities: the Nabis—Bonnard, Denis, Ibels, Ranson, Roussel, Sérusier, Vuillard, and others; the Neo-Impressionists —Angrand, Cross, Luce, Petitjean, Signac, and van Rysselberghe; Odilon Redon, whose name appeared in isolation on the publicity poster; members of the so-called Rose-Croix group, of which Emile Bernard was at that time a member; three sculptors; and, honored by separate rooms, Manet and the Impressionists—Renoir, Monet, Pissarro, and Sisley. There was also a room devoted to Corot.

In the pages from his diary devoted to this exhibition, Signac brings vividly to life the richness and variety of the Parisian art world at the turn of the century, never allowing his strong personal feeling to interfere with unprejudiced judgments of the works themselves.

MARCH 15, 1899

All paintings are on Durand's walls—and the general sight of the exhibition seems most satisfactory. Actually, included are nearly all those who for fifteen years have—outside the official Salons—made some new effort.

When [at Durand-Ruel's] you go from our rooms to those where the Manets and the Impressionists are hung, one is quite surprised at the swank and "museum" look of these canvases which, twenty years ago, compared to those of their forerunners, had the same effect. I took out some Sisleys and a Ziem [72] which I placed under our canvases: they no longer had any color left and they appeared like paintings of another

[71] Paul Signac in John Rewald, ed., "Excerpts from the Unpublished Diary of Paul Signac: II (1897–1898)," *Gazette des Beaux-Arts,* XXXIX (April, 1952), 298–304 (translation).

[72] Félix-François Georges Ziem (1821–1911), painter of seascapes and landscapes in oil and watercolor, specializing in luminous skies and sparkling sunsets; influenced at the beginning by Corot.

century. It is therefore logical that we inherit the antagonism they had to bear.

Once more hatred for color bursts out. My paintings, with their soft effect and rather dim harmonies, find some sympathy this year, whereas those of Cross, glowing and colored, as the most dazzling of the Monets one can remember, are completely misunderstood. Durand, who is most complimentary toward Théo [van Rysselberghe] for his portraits and who is now willing to credit me with some talent, contends that Cross is a fraud, and that, besides, under the name of Delacroix, he [Cross] is exhibiting at the Salon some completely black paintings; that his "pointillé" paintings are made only as a joke, and that, in short, he is disgracing our group.[73]

Some of my canvases look worse here than in my studio. . . . The reason for this must be the horrid red drapery on which they are set-off. I also tried that lovely gold frame of Monet's. Around predominantly purple effects like my *Mont Saint-Michel,* this gilding does no harm, although it takes away some of the strength; but around gold and orange tinted tones it kills the entire painting. So, theory and practice go together. . . .[74]

Then the room of the saints! Vuillard who is triumphant there, expressing the joy and tenderness of things! A green plant on a window, a tankard on a table—what wonderful objects for a painter. And Bonnard, whose charm I cannot sense, in spite of all the good that is told me about him by Vuillard, who says that the smallest panel by his friend gives him the same feeling as a fable by La Fontaine. I do see the wittiness of the arrangement, the amusing side of the subject, but—contrary to Vuillard's works—to me this does not seem expressed in plastic terms: to me the shape seems ugly, the color dirty, the arrangement banal.

APRIL 22, 1899

Saw Durand-Ruel's exhibition again. It really is the apotheosis of Impressionism: a Renoir room, a Monet room, a Sisley room, and a Pissarro room.[75]

It is the final triumph for Renoir. The variety of his researches, the diversity of his compositions, in the unity of genius. In that room one can only think of Veronese. And one is surprised at what once shocked the eye in these paintings. It gives me the impression of being a room of the Louvre. The period which I personally prefer is that of the years

[73] Cross's real name was in fact Delacroix but it is not true, of course, that he exhibited academic works at the official Salon under that name. [John Rewald's note.]

[74] Signac then proceeds to describe the entries of each member of the Neo-Impressionist group, including Cross, Angrand, van Rysselberghe, Petitjean, and Luce; next he goes on to a discussion of the room devoted to the Nabis. (See below, pp. 181 to 191.)

[75] There was also a Corot Room. [John Rewald's note.]

1878 to 1882. These *Canotiers* and *Bougivals*—one would think he painted them with flowers.

Monet. Because of the poor colors and the many varnishes used in succession, the bloom of the oldest canvases has disappeared. Certain paintings, such as the seascapes of Varengeville, are dead, the values having changed, the horizon lines switching back and forth, to and away from the foreground. And as in certain of his canvases the composition is void, what is left is nothing to boast about. The once beautiful tenor has no voice left, the virtuoso has been struck by paralysis. His good period is also between 1878 and 1882: the *St. Lazare Gares,* the *Débacles,* the *Vétheuils,* and the *Pourvilles.*

Two canvases of the *Peupliers* are still gorgeously alive and are masterpieces, thanks to the fine arabesque and to the purity of the tints still untarnished by varnish.

A small Sisley room. Also a triumph. The display is perhaps more lavish than that of Monet. There are small landscapes of the Paris region, from the years [around] 1874, which are marvels of coloring. Judging by this retrospective exhibition, it is clearly revealed that he is the first and foremost to have "divided" the touch. And his paintings so treated have aged better than those of Monet.

As for Pissarro, he comes in only as a bad fourth. From year to year one can watch the deterioration, and in his latest canvases he sinks into complete mud. He paints the first subject he happens to see from his window, without looking for composition, and uses just any blend of colors, painting at random, without regard for light or color. There are skies flatter and of uglier shades than Damoye's worst.[76] —For him too, the good period is between 1882 and 1883—Osny and Pontoise—blues, greens, reds, orange tints, juxtaposed in hatchings, becoming soiled perhaps through contact, but creating shades of beautiful optical grey, resulting in a delicate general harmony and a pearly unity. But the *Boulevards,* the *Avenue de l'Opéras,* the latest *Rouens,* these are truly nil, the low negation of all his lifetime searches.

It is interesting that all of them, Monet—the *Cathédrales*—Pissarro, Renoir, and also Sisley gave up, five or six years ago, the sparkling colors, the search for luminosity, which they had fought for all their lives so valiantly and so brilliantly. Could there be reasons other than age and fatigue?

At the same time a small Corot show. The lesson that emerges from it is that the Impressionists were wrong in giving up the search for composition. Corot created pictures; except for Renoir, they made nothing but studies.

[76] Pierre-Emmanuel Damoye (1847–1916), painter of landscapes in the manner of Corot and Daubigny.

Nature and Painting

MAY 10, 1899

At the Velodrome to make notes and sketches for a small painting. I had previously jotted down a small sketch, and the scenery I created from memory proves to be much closer to the subject than that in water color which I bring back from a sitting on the spot. In life, the sky holds the largest part of the general layout; it is a landscape with small trees, too much sky, and where the cycle-racing track has too little importance. In the sketch made from memory the trees against the sky outlined a large arabesque which filled the composition; the multicolored effects which had given me the idea for that painting played a more important role than they actually did; the track drawn from life was too small, the trifling parts of the subject took up too much room. Seeing the real was thus in opposition to what I wanted to do; nevertheless, these sittings have furnished me a few small details which will give a pictorially picturesque note to my painting: the pink spots of the programs, the details of the sloping fortifications, the differences in the foliage—things which I could not have invented. It is always the same lesson; to take from nature some elements of composition, but to handle them to one's liking. He who would have sufficient memory to remember all these impressions would hardly need this direct work from life. Is it so paradoxical to wonder why the painter has to work more from life than the writer or the musician? The latter look to life not for realism, but for subject matter—for sources of emotion, sensations, which they try to interpret and to communicate. But, one would say, the painter depicts natural forms. But don't these forms become rhythms and measurements for him as for the poet or musician?

Personally, except for a quick indication which memory or a camera would often supply just as well, any artist's work must be creative. And isn't the painter just as well able to create at his table or at his easel as under a bridge or on a road? All masters' drawings are rapidly noted bits of information; the magnificent sketch of the legs in *Jacob luttant avec l'Ange* by Delacroix was made in two minutes. In addition to these documents, they either draw or make water colors but in [doing so, they are] creating: *L'Education d'Achille* or the water colors of Turner's *Rivières de France* are compositions. Nearly everything I saw by Turner was made in the studio. All I know by him—drawn from life—are but a few on the spot sketches, notes, or recollections. And his canvases or water colors give the impression of nature just as do the Impressionist canvases of Monet. And Millet . . . and Corot . . .[77]

[77] Paul Signac in John Rewald, ed., "Excerpts from the Unpublished Diary of Paul Signac: III (1898–1899)," *Gazette des Beaux-Arts*, XLII (July–August, 1953), 72–80 (translation).

4

After Impressionism:
Van Gogh, Gauguin,
Symbolists, and Synthetists

VINCENT VAN GOGH: 1853–1890

G.-Albert Aurier: "The Isolated Ones: Vincent van Gogh"

"After having proclaimed the omnipotence of scientific observation and deduction for eighty years with childlike enthusiasm, and after asserting that for its lenses and scalpels there did not exist a single mystery, the nineteenth century at last seems to perceive that its efforts have been in vain, and its boast puerile. Man is still walking in the midst of the same enigmas, in the same formidable unknown, which has become even more obscure and disconcerting since its habitual neglect. A great many scientists and scholars today have come to a halt discouraged. They realize that this experimental science, of which they were so proud, is a thousand times less certain than the most bizarre theogony, the maddest metaphysical reverie, the least acceptable poet's dream, and they have a presentiment that this haughty science which they proudly used to call 'positive' may perhaps be only a science of what is relative, of appearances, of 'shadows' as Plato said, and that they themselves have nothing to put on old Olympus, from which they have removed the deities and unhinged the constellations." [1]

With these words, the Symbolist writer and critic, G.-Albert Aurier (1865–1892), characterized the position of avant-garde art and thought in 1892, when Vincent van Gogh had already been dead for two years. Exaggerated in the antithesis it draws between positivism and poetic mystery, this passage nevertheless sets the stage for the attempts of many young artists and writers to escape from the bonds of naturalistic objectivity into a realm of expressive equivalences, such as that suggested by Baudelaire in his poem "Correspondences."

While never directly associated with either the Synthetist painters gathered about Gauguin in Brittany, nor with the group of Symbolist writers themselves, van Gogh with his art of violently expressive color and form, his attempt to create striking pictorial equivalents for moods and emotions, his mental unbalance, his life of suffering and martyrdom, was obviously an ideal subject for a Symbolist critic like Aurier to study. In the following excerpt from an article which Aurier had published in the newly founded Symbolist journal, Mercure de France, *in January, 1890—the first article, incidentally, ever to appear on van Gogh—the critic completely assimilates the artist to the Symbolist position, stressing in language that has been rightly characterized as "precious, obscure*

[1] G.-Albert Aurier, "Les Peintres symbolistes" (1892), cited in H. R. Rookmaaker, *Synthetist Art Theories: Genesis and Nature of the Ideas on Art of Gauguin and his Circle* (Amsterdam: Swets & Zeitlinger, 1959), p. 1. Reprinted by permission of the publisher and the author.

and verbose," [2] *the painter's anti-naturalism and his rejection of "scien-*
tific" Impressionism, distinctions which van Gogh himself was quick to
disdain. (See below, pp. 152 to 156, for van Gogh's reply to Aurier.)

. . . In the case of Vincent van Gogh, despite the sometimes baffling
strangeness of his works, it is hard for an unprejudiced and knowledge-
able spectator either to deny or question the naïve truthfulness of his art,
the ingenuousness of his vision. Indeed, apart from that indefinable aura
of good faith and the truly-seen which emanates from all his pictures,
the choice of subjects, the constant harmony among the most extreme
colors, the conscientious study of character, the continual search for the
essential sign for each thing—a thousand significant details undeniably
affirm his deep and almost childlike sincerity, his great love for nature
and truth: his *own* truth.

. . . What characterizes his work as a whole is its excess, its excess
of strength, of nervousness, its violence of expression. In his categorical
affirmation of the character of things, in his often daring simplification
of forms, in his insolence in confronting the sun directly, in the vehement
passion of his drawing and color, right down to the smallest details of
his technique, a powerful figure is revealed—masculine, daring, very often
brutal, yet at times ingenuously delicate. This is revealed in the almost
orgiastic exaggerations of everything he has painted; he is a fanatic, an
enemy of bourgeois sobriety and of pettiness, a kind of drunken giant,
better at shaking up mountains than handling delicate nicknacks, a
brain at the boiling point, pouring down its lava unchecked into all the
ravines of art, a terrible, maddened genius, often sublime, sometimes
grotesque, always near the brink of the pathological. Last, and most im-
portant, he is a hyperaesthete with clear symptoms who, with abnormal,
perhaps even painful intensity, perceives the imperceptible and secret
characteristics of line and form, and still more, those colors, lights, and
nuances which are invisible to healthy eyes, the magic iridescence of
shadows. And this is why the realism of this neurotic, as well as his sin-
cerity and his truth, are so different from the realism, the sincerity, and
the truth of those great petty bourgeois of Holland,[3] who were so healthy
physically and well balanced mentally, who were his ancestors and his
masters.

Yet this respect and love for the reality of things is not enough, all
by itself, to explain and characterize the profound, complex, terribly
special art of Vincent van Gogh. No doubt, like all the painters of his
race, he is very much aware of the importance and beauty of the pigment,

2 John Rewald, *Post-Impressionism from van Gogh to Gauguin* (New York: The
Museum of Modern Art, 1956), p. 368.

3 Such 17th-century Dutch masters as Dou, Cuyp, Terborch, and Metsu, whom
Aurier had already contrasted with van Gogh.

but even more often, he only considers this bewitching pigment as a kind of marvelous language destined for the translation of the Idea. He is almost always a symbolist.[4] Not at all a symbolist like the Italian primitives, those mystics who hardly felt it necessary to de-immaterialize their dreams, but rather a symbolist who feels the continual need to clothe his ideas in precise, ponderable, tangible forms, in intensely sensual and material envelopes. Beneath this morphic envelope, beneath this very fleshly flesh, this very material matter, there lies, in almost all his canvases, for those who know how to find it, a thought, an Idea, and this Idea, the essential substratum of the work, is, at the same time, its efficient and final cause. As for the brilliant, radiant symphonies of color and line, no matter what their importance may be for the painter, in his work they are merely simple, expressive *means,* simple *methods* of symbolization. Indeed, if we refused to acknowledge the existence of these idealistic tendencies beneath this naturalistic art, a great deal of the work we are examining would remain completely incomprehensible. How, for example, could we explain the *Sower,* that august and disturbing sower, that yokel with a brutally brilliant forehead, sometimes with a distant resemblance to the artist himself, whose silhouette, gesture, and labor have always obsessed Vincent van Gogh, and whom he painted over and over again, sometimes beneath skies ruddy with the setting sun, sometimes amid the golden dust of smouldering noons—how could we explain the *Sower* without thinking of that fixed idea haunting his brain, of the necessary advent of a man, a messiah, a sower of truth, who would regenerate the decrepitude of our art and perhaps of our imbecilic and industrialist society? And how could we explain that obsessive passion for the solar disk he delights in blazing forth from the conflagration of his skies, and, at the same time, for that other sun, for that vegetable star, the splendid sunflower, which he repeats tirelessly, like a monomania, if we refuse to accept his persistent preoccupation with some vague and glorious heliomythic allegory?

Vincent van Gogh is thus not merely a great painter, enraptured by his art, his palette, and nature; he is also a dreamer, a fanatical believer, a devourer of beautiful Utopias, living on ideas and dreams.

For a long time, he has delighted in imagining a renewal of art, made possible by a shift of the center of civilization: an art of tropical regions, the natives imperiously demanding works corresponding to the new inhabited regions, the painters, finding themselves face-to-face with a hitherto unknown nature, blazing with light, finally admitting the im-

[4] It must be remembered that Aurier was writing this article, the first in a projected series on "The Isolated Ones," for a Symbolist publication, and therefore tends to assimilate van Gogh to his "cause."

potence of the old academic formulae and trying naïvely to search out the candid translation of all these new sensations! Wouldn't he, he the intense and imaginative colorist, grinder of gold and of precious stones, have been the eminently suitable painter of these countries of resplendence, of brilliant sun and blinding colors? . . .

As a result of this conviction of the necessity for beginning completely from the beginning in art, he had for a long time cherished the idea of inventing a very simple, popular, almost childish sort of painting, capable of touching humble folk who don't understand refinements and of being understood by the simplest of the poor in spirit. The *Berceuse,* that enormous, brilliant *image d'Epinal,* which he repeated with curious variations several times, the portrait of the phlegmatic and indescribably joyful *Postmaster,* the *Drawbridge,* so brilliant with raw light, so exquisitely banal, the ingenuous *Young Girl with the Rose,* the *Zouave,* the *Provençal Woman,* all exhibit with the greatest clarity this tendency toward the simplification of art which one finds more or less present in all his work and which seems neither so absurd nor unworthy of esteem in this era of outrageous complication, myopia, and inept analysis.

Are all these theories, these hopes of Vincent van Gogh practicable? Are they not simply vain and beautiful chimeras? Who knows? At any rate, I do not have to deal with this now; in order to come to the end, I must only characterize a little further this unusual mind, so far removed from all banal paths, by saying a few more words about his technique.

The external, material side of his painting correlates absolutely with his artistic temperament. In all his works, the execution is vigorous, exalted, brutal, intensified. His excited, powerful, often awkward and somewhat heavy-handed draughtsmanship exaggerates the character, simplifies, leaps over the detail like a master, a conqueror, and achieves an authoritative synthesis, and sometimes, though not always, great style.

We are already familiar with his color. It is unbelievably dazzling. He is the only painter I know who perceives the coloring of things with such intensity, with such a metallic, gemmy quality! His attempts to capture the coloring of shadows, the influence of one tone upon another, the effects of full sunlight, are most extraordinary. He is not, however, always able to avoid a certain unpleasant harshness, disharmony, dissonance. . . . As for his actual brushwork, his way of coloring the canvas, it is like everything else that has to do with him: fiery, very forceful, and very nervous. He maneuvers his brush with enormous impasto touches of very pure color in curved pathways broken by rectangular strokes . . . in sometimes awkward heaps of shining masonry, and this gives some of his canvases the solid appearance of dazzling walls made of crystal and sun.

This robust and true artist, a real thoroughbred with the brutal hands of a giant, the neuroses of an hysterical woman, and the soul of a mystic, so original and so far removed from the milieu of our pitiful contemporary art, will he know some day—anything is possible!—the joys of rehabilitation, the repentant blandishments of fashion? Perhaps. But whatever happens, even when it becomes fashionable to pay the same prices for his canvases as those of the little infamies of M. Meissonier,[5] I do not think that much sincerity can ever enter into that belated admiration of the public at large. Vincent van Gogh is at once too simple and too subtle for the contemporary bourgeois mind. He will never be completely understood except by his brothers, the real artists . . . and those happy creatures among the simple folk, the lowest social level, who have by chance escaped the well-meaning teaching of public education! [6]

Van Gogh's Letters

". . . The individual adventure always goes back to the one which is the archetype of our times: that is, van Gogh—an essentially solitary and tragic adventure." [7] *Van Gogh's letters, almost as much as his paintings, reveal the nature of that solitary struggle, of which Picasso speaks, and at the same time, like the* Journal *of Delacroix, the predecessor he so admired, they provide an authentic and extraordinarily moving insight into the nature of the whole creative situation in the 19th century. Belying the popular myth of the intuitive, inspired madman, van Gogh's letters reveal an unfaltering and articulate awareness of the daily problems involved in the making of paintings, as well as more searching insights into the profounder reaches of human experience: his relation with his brother Theo; his struggle to achieve his vision in pictorial form; his unshakable faith in nature and art; his insistence that art be whole and completely involving of the self—all of this is revealed in his correspondence, with a simplicity and vividness that arise not from any sort of literary* parti pris, *but from his intense awareness of his destiny as an artist and as a human being.*

Letter to Theo about the "Potato-Eaters"

The climactic and summarizing work of van Gogh's early Nuenen period (1883–1885) is the movingly awkward Potato-Eaters, *created in April and May of 1885. Painted in somber, earth colored impasto, the*

5 Ernest Meissonier (1815–1890), immensely popular French painter of minute, scrupulously detailed historical genre scenes and battle pieces. Van Gogh himself held Meissonier in the highest regard. (See below, pp. 154 to 155.)

6 G.-Albert Aurier, "Les Isolés: Vincent van Gogh," *Mercure de France,* Jan. 1890, in Pierre Cailler, ed., *Van Gogh raconté par lui-même et par ses amis* (Vésenaz-Genève: Pierre Cailler, 1947), pp. 63–70. Reprinted by permission of the publisher.

7 Pablo Picasso in Françoise Gilot and Carlton Lake, *Life with Picasso* (New York: Signet Books, 1965), p. 70.

work is a secular, deeply human version of the religious sacrament celebrated in the Last Supper, with the peasant's potatoes and coffee substituted for the traditional bread and wine. The profoundly moral bias of van Gogh's art, inseparably linked with his struggle to achieve a formal equivalent for his conception of truth, is vividly conveyed by this letter to his brother.

[APRIL 30, 1885]

DEAR THEO,

On your birthday I am sending you my best wishes for good health and serenity. I should have liked to send you the picture of the potato eaters on that day, but though it is getting on well, it is not quite finished yet.

Though the ultimate picture will have been painted in a relatively short time and for the greater part from memory, it has taken a whole winter of painting studies of heads and hands.

And as to those few days in which I have painted it now, it has been a real battle, but one for which I feel great enthusiasm. Although I was repeatedly afraid I should never pull it off. But painting is also "agircréer." [8]

When the weavers weave that cloth, which I think is called Cheviot, or also the peculiar Scottish plaids, then you know their aim is, for the Cheviot, to get special broken colors and grays, and for the multicolored checkered cloth, to make the most vivid colors balance each other so that, instead of the issue being crude, the *effet produit* of the pattern is harmonious at a distance.

A gray woven from red, blue, yellow, dirty white, and black threads, a blue that is *broken* by a green, and orange-red, or yellow, thread, are quite different from *plain colors*—that is to say they are more iridescent, and primary colors become *hard,* cold, and *dead* in comparison. But for the weaver, or rather the designer of the pattern or the combination of colors, it is not always easy to determine his estimation of the number of threads and their direction, no more than it is easy to blend the strokes of the brush into a harmonious whole.

If you could compare the first painted studies I made on my arrival here at Nuenen and the picture I'm now working on, I think you would see that things are getting a little more lively as to color.

I believe that the question of the analysis of colors will preoccupy you too someday, for as a connoisseur and expert, I think one must also have *a fixed opinion,* and possess certain *convictions.*

At least for one's own pleasure, and in order *to substantiate one's*

8 "Action-creation."

opinion, and one must also be able to explain it in a few words to others who sometimes ask a person like you for information when they wish to know something more about art.

I have still something to say about Portier [9]—of course I am not at all indifferent to his private opinion, and I highly appreciate his saying that he did not retract anything of what he had said.

Neither do I mind its appearing that he had not hung those first *studies.* But if I send a picture intended for him if he likes, *he can only get it on condition that he will show it.*

As to the potato eaters, it is a picture that will show well in gold, I am sure of that, but it would show as well on a wall, papered in the deep color of ripe corn.

It simply cannot be seen without such a setting.

It does not show up well against a dark background, and not at all against a dull background. That's because it gives a glimpse of a very gray interior. In reality too it stands in a gold frame, as it were, because the hearth and the glow of the fire on the white wall would be nearer to the spectator, now they are outside the picture, but in reality they throw the whole thing into perspective.

I repeat, it must be shut off by framing it in something of a deep gold or brass color.

If you yourself want to see it as it must be seen, don't forget this, please. This putting it next to a gold tone gives, at the same time, a brightness *to spots where you would not expect it,* and takes away the marbled aspect it gets when unfortunately placed against a dull or black background. The shadows are painted in blue, and a gold color puts life into this.

Yesterday I brought it to a friend of mine in Eindhoven who has taken up painting. After three days or so, I shall go and wash it there with white of an egg, and finish some details.

The man, who himself is trying very hard to learn to paint, and to get a good palette, was very much pleased with it. He had already seen the study after which I had made the lithograph, and said he hadn't thought I could carry both the drawing and the color to such a pitch. As he paints from the model too, he also knows what is in a peasant's head or fist; and about the hands, he said that he himself had now got quite a different notion of how to paint them.

I have tried to emphasize that those people, eating their potatoes in the lamplight, have dug the earth with those very hands they put in the dish, and so it speaks of *manual labor,* and how they have honestly earned their food.

[9] Paris art dealer who lived in the same building as Theo, and to whom the latter had brought some of his brother's paintings.

I have wanted to give the impression of a way of life quite different from that of us civilized people. Therefore I am not at all anxious for everyone to like it or to admire it at once.

All winter long I have had the threads of this tissue in my hands, and have searched for the ultimate pattern; and though it has become a tissue of rough, coarse aspect, nevertheless the threads have been chosen carefully and according to certain rules. And it might prove to be a real *peasant picture. I know it is.* But he who prefers to see the peasants in their Sunday-best may do as he likes. I personally am convinced I get better results by painting them in their roughness than by giving them a conventional charm.

I think a peasant girl is more beautiful than a lady, in her dusty, patched blue skirt and bodice, which get the most delicate hues from weather, wind, and sun. But if she puts on a lady's dress, she loses her peculiar charm. A peasant is more real in his fustian clothes in the fields than when he goes to church on Sunday in a kind of dress coat.

In the same way it would be wrong, I think, to give a peasant picture a certain conventional smoothness. If a peasant picture smells of bacon, smoke, potato steam—all right, that's not unhealthy; if a stable smells of dung—all right, that belongs to a stable; if the field has an odor of ripe corn or potatoes or of guano or manure—that's healthy, especially for city people.

Such pictures may *teach* them something. But to be perfumed is not what a peasant picture needs.

I wonder whether you will find something in it which pleases you? I hope so. I am glad that just now when Mr. Portier has said he is going to take up my work I, for my part, have something more important than just studies. As to Durand-Ruel,[10] though he did not think the drawings worthwhile, do show him this picture; he may sneer at it all right, but show it to him anyway, so that he may see there is some energy in our work. But you will hear: *"Quelle croûte."* [11] You may be sure of that; I am. Yet we must continue to give something *real* and *honest.*

Painting peasant life is a serious thing, and I should reproach myself if I did not try to make pictures which will rouse serious thoughts in those who think seriously about art and about life.

Millet, De Groux,[12] so many others have given an example of character, and of not minding criticisms such as nasty, coarse, dirty, stinking, etc., etc., so it would be a shame to waver.

No, one must paint the peasants as being one of them, as feeling, thinking as they do.

[10] Paris art dealer who specialized in the works of the Impressionists.

[11] Slang term for a bad painting.

[12] Charles de Groux (or Degroux, 1825–1870), Belgian painter of genre scenes in a realistic manner.

Because one cannot help being the way one is.

I often think how the peasants form a world apart, in many respects so much better than the civilized world. Not in every respect, for what do they know about art and many other things?

I still have a few smaller studies, but you will understand that the large one has preoccupied me so much that I have been able to do very little else. As soon as it is quite finished and dry, I shall send you the picture in a box, and add a few smaller ones.

I think it will be well not to wait long before sending it, therefore I shall do so; probably the second lithograph will not be ready then, but I understand that, for instance, Mr. Portier must be somewhat strengthened in his opinion, so that we can firmly count on him as a friend. I sincerely hope this will succeed. I have been so absorbed in the picture that I literally almost forget my moving, which has to be looked to after all.

My cares will not become less, but the lives of all painters of that kind are so full of them that I should not wish to have an easier time of it than they. And seeing that they made their pictures in spite of everything, material difficulties will worry me, it is true, but, in short, they will not crush me or make me slacken.

I think the potato eaters will get finished after all; the last days are almost dangerous for a picture, as you know, because when it isn't quite dry, one cannot work on it with a large brush without a great risk of spoiling it. And the changes must be made quietly and calmly with a small brush. Therefore I have simply taken it to my friend and told him to take care that I do not spoil it in that way and that I come to his house to give those finishing touches. You will see it has originality.

Good-by, I'm sorry it was not ready by today; once more I wish you health and serenity. Believe me, with a handshake,

Ever yours,
VINCENT

Today I am still working on some smaller studies, which are to be sent at the same time.

Did you send that copy of the Salon edition? [13]

Letter to Theo from Arles

In February of 1888, after a two-year stay in Paris, where he had worked in Cormon's studio; had met, through his brother Theo, who was a picture-dealer at the Goupil Galleries (Boussod and Valadon),

[13] Vincent van Gogh, Letter to his brother Theo (404), Nuenen [April 30, 1885], *The Complete Letters of Vincent van Gogh,* ed. V. W. van Gogh and J. van Gogh-Bonger (Greenwich, Conn.: New York Graphic Society [1958]), II, 369–371. Reprinted by permission of the publisher.

*various figures in the Impressionist and Post-Impressionist movements;
had lightened his palette and found a more viable kind of color-orches-
tration and composition, van Gogh moved to Arles in the south of
France, arriving when the orchards were in bloom. Working feverishly,
living on funds provided by Theo, he dreamed of establishing a coopera-
tive society of painters in his new home, but succeeded in convincing no
one to join him but Paul Gauguin, whose visit ended abruptly and tragi-
cally with the first of van Gogh's serious mental crises.*

*This letter, written before the artist's breakdown, reveals not only
his familiarity with the art and literature of his time, but also, in the
very language he uses in his letters to describe the genesis of his art, the
perpetual intermingling of feeling and its pictorial concomitants: color
and composition.*

ARLES [SEPTEMBER, 1888]

MY DEAR THEO,

I spent yesterday with the Belgian,[14] who also has a sister among
the "vingtistes." [15] The weather was not fine, but a very good day for
talking; we went for a walk and all the same saw some very fine things
at the bullfight and outside of town. We talked more seriously about the
idea that if I keep a place in the South, he ought to set up a sort of post
among the coal mines. Then Gauguin and I and he, if the importance of
a picture made it worth the journey, could change places—thus being
sometimes in the North, but in familiar country with a friend in it, and
sometimes in the South.

You will soon see him, this young man with the look of Dante, be-
cause he is going to Paris, and if you put him up—if the room is free—
you will be doing him a good turn; he is very distinguished looking, and
will become so, I think, in his painting.

He likes Delacroix, and we talked a lot about Delacroix yesterday.
He even knew the violent cartoon for the "Bark of Christ." [16]

Well, thanks to him I at last have a first sketch of that picture
which I have dreamed of for so long—the poet. He posed for me. His fine
head with that keen gaze stands out in my portrait against a starry sky
of deep ultramarine; for clothes, a short yellow coat, a collar of un-
bleached linen, and a spotted tie. He gave me two sittings in one day.

Yesterday I had a letter from our sister, who has seen a great deal.
Ah, if she could marry an artist, it wouldn't be such a bad thing for her.

[14] Reference to the Belgian painter Bock, whom van Gogh represented as a poet.
In October, 1888, he writes to Emile Bernard that he has "mercilessly destroyed" this
work (or another version of it?), *Poet against a Starry Sky*. See *Complete Letters*, III, 517.

[15] A group of avant-garde artists and writers who organized exhibitions in Brus-
sels.

[16] A reference to *Christ on the Lake of Gennesaret*.

I have finished *L'Immortel* by Daudet.[17] I rather like the sculptor Védrine's saying, that achieving fame is something like ramming the live end of your cigar into your mouth when you are smoking. But I certainly like *L'Immortel* less, far less than *Tartarin.*

You know, it seems to me that *L'Immortel* is not so fine in color as *Tartarin,* because with its mass of true and subtle observations it reminds me of the dreary pictures by Jean Bérend,[18] which are so dry and cold. Now *Tartarin* is *really great,* with the greatness of a masterpiece, just like *Candide.*

I beg you to keep my studies of this place as well aired as possible, because they are not yet thoroughly dry. If they remain shut up or in the dark, the colors will lose their quality. So the portrait of "The Young Girl," "The Harvest" (a wide landscape with the ruin in the background and the line of the Alps), the "Little Seascape," the "Garden" with the weeping trees and clumps of conifers—it would be a good thing if you could put these on stretchers. I am rather keen on them. You will easily see from the drawing of the little seascape that it is the most thought-out piece.

I am having two oak frames made for my new peasant's head and for my Poet study. Oh, my dear brother, sometimes I know so well what I want. I can very well do without God both in my life and in my painting, but I cannot, ill as I am, do without something which is greater than I, which is my life—the power to create.

And if, frustrated in the physical power, a man tries to create thoughts instead of children, he is still part of humanity.

And in a picture I want to say something comforting, as music is comforting. I want to paint men and women with that something of the eternal which the halo used to symbolize, and which we seek to convey by the actual radiance and vibration of our coloring.

Portraiture so understood does not become like an Ary Scheffer [19] just because there is a blue sky in the background, as in "St. Augustine." For Ary Scheffer is so little of a colorist.

But it would be more in harmony with what Eug. Delacroix attempted and brought off in his "Tasso in Prison," [20] and many other pictures, representing a *real* man. Ah! portraiture, portraiture with the thoughts, the soul of the model in it, that is what I think must come.

[17] Alphonse Daudet (1840–1897), naturalist writer of plays, novels, and short stories, born in Nîmes.

[18] Possibly a reference to the artist Jean Béraud (1849–1936), painter of detailed canvases of modern life, especially known for having introduced the figure of Christ into contemporary scenes.

[19] Ary Scheffer (1795–1858), painter of Dutch origin who worked in France, much appreciated by the bourgeois public for his little romantic genre paintings, as well as for his facile and flattering portraits.

[20] Generally known as *Tasso in the Madhouse.*

The Belgian and I talked a lot yesterday about the advantages and disadvantages of this place. We quite agree about both. And on the great advantage it would be to us if we could *move* now North, now South.

He is going to stay with McKnight [21] again so as to live more cheaply. That, however, has one disadvantage, I think, because living with a slacker makes one slack.

I think you would enjoy meeting him, he is still young. I think he will ask your advice about buying Japanese prints and Daumier lithographs. As to these—the Daumiers—it would be a good thing to get some more of them, because later on there won't be any more available.

The Belgian was saying that he paid eighty francs for board and lodging with McKnight. So what a difference living together makes, since I have to pay forty-five a month for nothing but lodging. I always come back to the same calculation; that with Gauguin I should not spend more than I do alone, and be no worse off. But we must consider that they were very badly housed, not for sleeping, but for the possibility of working at home.

So I am always between two currents of thought, first the material difficulties, turning round and round to make a living; and second, the study of color. I am always in hope of making a discovery there, to express the love of two lovers by a wedding of two complementary colors, their mingling and their opposition, the mysterious vibrations of kindred tones. To express the thought of a brow by the radiance of a light tone against a somber background.

To express hope by some star, the eagerness of a soul by a sunset radiance. Certainly there is no delusive realism in that, but isn't it something that actually exists?

Good-by for now. I'll tell you another time when the Belgian may be leaving, because I'll see him again tomorrow.

With a handshake,

Ever yours,
VINCENT.

The Belgian told me that they have a De Groux at home, the cartoon for the "Bénédicité" in the museum in Brussels.

The execution of the portrait of the Belgian is something like the portrait of Reid [22] which you have.[23]

[21] McKnight or MacKnight: American painter, staying in Arles, whom van Gogh later described as dry and unsympathetic.
[22] *Portrait of Alexander Reid,* an English art dealer, painted during van Gogh's Paris period.
[23] Vincent van Gogh, Letter to his brother Theo (531), Arles [September, 1888], *Complete Letters,* III, 24–26.

Letter to Emile Bernard

Van Gogh had met the young Emile Bernard (1868–1941) at Père Tanguy's in Paris in 1887, and the two men subsequently formed a warm attachment, discussing their ideas on art together and even, for a time, working together in Bernard's studio. Their discussions later continued in their letters, after Bernard had gone to Brittany and van Gogh to Arles, but the correspondence was dropped for a year, until late in 1889, when Bernard sent his friend some photographs of his recent works.

In November, 1889, van Gogh wrote Theo the following disparaging passage about these photographs of Bernard's extremely stylized, abstract, self-conscious religious works, produced in Pont-Aven in close conjunction with Gauguin: ". . . I have been working in the olive groves, because their Christs in the Garden,[24] with nothing really observed, have gotten on my nerves. Of course with me there is no question of doing anything from the Bible—and I have written to Bernard and Gauguin too that I considered that our duty is thinking, not dreaming, so that when looking at their work I was astonished at their letting themselves go like that. For Bernard has sent me photos of his canvases.[25] The trouble with them is that they are a sort of dream or nightmare—that they are erudite enough—you can see that it is someone who is gone on the primitives—but frankly the English Pre-Raphaelites did it much better, and then again Puvis and Delacroix, much more healthily than the Pre-Raphaelites." [26]

A few weeks later, in the following letter to the artist himself, van Gogh lashed out at Bernard's tendencies toward mysticism, archaism, and abstraction, and begged him to return to modern reality and the observation of nature for the themes of his paintings.

[Saint-Rémy, Beginning of December, 1889]

My dear friend Bernard,

Thanks for your letter and especially for the photographs, which give me an idea of your work.

My brother wrote to me about it the other day for that matter, and told me that he liked the harmony of the colors and a certain nobility in many of the figures very much.

Now look here, I am too charmed by the landscape in the "Adoration of the Magi" to venture to criticize, but it is nevertheless too much of an impossibility to imagine a confinement like that, right on the road,

24 Both Bernard and Gauguin had treated this subject, the former perhaps portraying Gauguin as Judas, the latter representing Christ with his own features.

25 These included an *Adoration of the Magi*, an *Annunciation*, and *Christ Carrying the Cross*, as well as the *Christ in the Garden of Olives* already alluded to.

26 Vincent van Gogh, Letter to his brother Theo (615), *Complete Letters*, III, 233.

the mother starting to pray instead of giving suck; then there are those fat ecclesiastical frogs kneeling down as though in a fit of epilepsy, God knows how, and why!

No, I can't think such a thing sound, but personally, *if* I am capable of spiritual ecstasy, I adore Truth, the possible, and therefore I bow down before that study—powerful enough to make a Millet tremble—of peasants carrying home to the farm a calf which has been born in the fields. Now this, my friend, all people have felt from France to America; and after that are you going to revive medieval tapestries for us? Now honestly, is this a sincere conviction? No! you can do better than that, and you know you must seek after the possible, the logical, the true, even if you should have to forget the Parisian things à la Baudelaire a little. How much I prefer Daumier to that gentleman!

An "Annunciation," of what? I see figures of angels—dear me, quite elegant—a terrace with two cypresses which I like very much; there is an enormous amount of air, of brightness in it; but, once this first impression is past, I ask myself whether it is a mystification, and those secondary figures no longer mean anything to me.

But it will be enough if you will just understand that I am yearning to know such things of yours as that picture which Gauguin has, those Breton women strolling in a meadow,[27] so beautifully ordered, so naïvely distinguished in color. And you will trade this for what is—must I say the word?—counterfeit, affected!

Last year you did a picture—according to what Gauguin told me —which I think was something like this: on a grassy foreground a figure of a young girl in a blue or whitish dress, lying stretched out full length; on the second plane the edge of a beech wood, the ground covered with fallen red leaves, the verdigris-colored tree trunks forming a vertical barrier.

I suppose the hair is an accent of a color tone which is necessary as a color complementary to the pale dress, black if the dress is white, orange if it is blue. But what I said to myself was, what a simple subject, and how well he knows how to create elegance with nothing.[28]

Gauguin told me about another subject, nothing but three trees, an effect of orange foliage against a blue sky; but then very clearly designed, and very categorically divided into planes of contrasting and candid colors—bravo![29]

27 *Market in Brittany—Breton Women in the Meadow,* c. 1888, a painting which, according to Bernard, had a great influence upon Gauguin (which the latter was unwilling to admit). Gauguin took the work to Arles with him, and van Gogh made a copy of it.

28 Bernard's painting of his sister lying among the trees, entitled *Madeleine at the Bois d'Amour,* painted at Pont-Aven in 1888.

29 A landscape formerly in the collection of Eugène Bloch. Van Gogh accompanies the description of this work and the painting of Madeleine with sketches.

And when I compare such a thing with that nightmare of a "Christ in the Garden of Olives," good Lord, I mourn over it, and so with the present letter I ask you again, roaring my loudest, and calling you all kinds of names with the full power of my lungs—to be so kind as to become your own self again a little.

The "Christ Carrying His Cross" is appalling. Are those patches of color in it harmonious? I won't forgive you the *spuriousness*—yes, certainly, spuriousness—in the composition.

As you know, once or twice, while Gauguin was in Arles, I gave myself free rein with abstractions, for instance in the "Woman Rocking," in the "Woman Reading a Novel," black in a yellow library; [30] and at the time abstraction seemed to me a charming path. But it is enchanted ground, old man, and one soon finds oneself up against a stone wall.

I won't say that one might not venture on it after a virile lifetime of research, of a hand-to-hand struggle with nature, but I personally don't want to bother my head with such things. I have been slaving away on nature the whole year, hardly thinking of impressionism or of this, that, and the other. And yet, once again I let myself go reaching for stars that are too big—a new failure—and I have had enough of it.

So I am working at present among the olive trees, seeking after the various effects of a gray sky against a yellow soil, with a green-black note in the foliage; another time the soil and the foliage all of a violet hue against a yellow sky; then again a red-ocher soil and a pinkish green sky. Yes, certainly, this interests me far more than the above-mentioned abstractions.

If I have not written you for a long while, it is because, as I had to struggle against my illness, I hardly felt inclined to enter into discussions—and I found danger in these abstractions. If I work on very quietly, the beautiful subjects will come of their own accord; really, above all, the great thing is to gather new vigor in reality, without any preconceived plan or Parisian prejudice. Apart from that, I am very discontented with this year's work; but perhaps it will prove to be a solid foundation for next year. I have let myself be saturated with the air of the little mountains and the orchards; this much gained, I shall wait and see. My ambition is limited to a few clods of earth, sprouting wheat, an olive grove, a cypress—the latter, for instance, by no means easy to do. I ask myself why you, who like the primitives, and study them, do not seem to know Giotto. Gauguin and I saw a tiny panel of his at Montpellier, the death of some good holy woman. [31] The expression of pain and ecstasy in it is so utterly human that however nineteenth-century one

30 *La Berceuse* (Madame Roulin), in five versions, painted from January–March, 1889, and *The Novel-Reader*, November, 1888.

31 Probably a reference to *The Death and Assumption of the Virgin* in the Montpellier Museum, now attributed to the School of Giotto.

may be, one feels as though one were present—so strongly does one share the emotion.

If I saw the pictures themselves, I think it possible that I might be enraptured with the colors all the same; but you also speak of portraits you have done and which you have worked hard on; that's what will be good and where you will have been yourself.

Here is the description of a canvas which is in front of me at the moment. A view of the park of the asylum where I am staying; [32] on the right a gray terrace and a side wall of the house. Some deflowered rose bushes, on the left a stretch of the park—red-ocher—the soil scorched by the sun, covered with fallen pine needles. This edge of the park is planted with large pine trees, whose trunks and branches are red-ocher, the foliage green gloomed over by an admixture of black. These high trees stand out against an evening sky with violet stripes on a yellow ground, which higher up turns into pink, into green. A wall—also red-ocher—shuts off the view, and is topped only by a violet and yellow-ocher hill. Now the nearest tree is an enormous trunk, struck by lightning and sawed off. But one side branch shoots up very high and lets fall an avalanche of dark green pine needles. This somber giant—like a defeated proud man—contrasts, when considered in the nature of a living creature, with the pale smile of a last rose on the fading bush in front of him. Underneath the trees, empty stone benches, sullen box trees; the sky is mirrored—yellow—in a puddle left by the rain. A sunbeam, the last ray of daylight, raises the somber ocher almost to orange. Here and there small black figures wander around among the tree trunks.

You will realize that this combination of red-ocher, of green gloomed over by gray, the black streaks surrounding the contours, produces something of the sensation of anguish, called "noir-rouge," from which certain of my companions in misfortune frequently suffer. Moreover the motif of the great tree struck by lightning, the sickly green-pink smile of the last flower of autumn serve to confirm this impression.

Another canvas shows the sun rising over a field of young wheat; lines fleeting away, furrows rising up high into the picture toward a wall and a row of lilac hills. The field is violet and yellow-green. The white sun is surrounded by a great yellow halo. Here, in contrast to the other canvas, I have tried to express calmness, a great peace. [33]

I am telling you about these two canvases, especially about the first one, to remind you that one can try to give an impression of anguish without aiming straight at the historic Garden of Gethsemane; that it is not necessary to portray the characters of the Sermon on the Mount in order to produce a consoling and gentle motif.

[32] A reference to *The Park of St. Paul's Hospital,* painted in October, 1889. Van Gogh painted another version later in the same year.
[33] Possibly a reference to *The Field Enclosure* of November, 1889.

Oh! undoubtedly it is wise and proper to be moved by the Bible, but modern reality has got such a hold on us that, even when we attempt to reconstruct the ancient days in our thoughts abstractly, the minor events of our lives tear us away from our meditations, and our own adventures thrust us back into our personal sensations—joy, boredom, suffering, anger, or a smile.

The Bible! The Bible! Millet, having been brought up on it from infancy, did nothing but read that book! And yet he never, or hardly ever, painted Biblical pictures. Corot has done a "Mount of Olives," with Christ and the evening star, sublime; in his works one feels Homer, Aeschylus, Sophocles, as well as the Gospel sometimes, yet how discreet it is, and how much all possible modern sensations, common to us all, predominate. But you will say, What of Delacroix? Yes!

Delacroix—but then you would have to study in quite a different way, yes, study history, before putting things in their places like that. So, old fellow, the Biblical pictures are a failure, but there are only a few who make such a mistake, and a mistake it is, but I dare think that the reversal will be magnificent!

Sometimes by erring one finds the right road. Go make up for it by painting your garden just as it is, or whatever you like.[34] In any case it is a good thing to seek for distinction, nobility in the figures; and studies represent a real effort, and consequently something quite different from a waste of time. Being able to divide a canvas into great planes which intermingle, to find lines, forms which make contrasts, that is technique, tricks if you like, cuisine, but it is a sign all the same that you are studying your handicraft more deeply, and that is a good thing.

However hateful painting may be, and however cumbersome in the times we are living in, if anyone who has chosen this handicraft pursues it zealously, he is a man of duty, sound and faithful. Society makes our existence wretchedly difficult at times, hence our impotence and the imperfection of our work. I believe that even Gauguin himself suffers greatly under it too, and cannot develop his powers, although it is in him to do it. I myself am suffering under an absolute lack of models. But on the other hand there are beautiful spots here. I have just done five size 30 canvases, olive trees. And the reason I am staying on here is that my health is improving a great deal. What I am doing is hard, dry, but that is because I am trying to gather new strength by doing some rough work, and I'm afraid abstractions would make me soft.

Have you seen a study of mine with a little reaper, a yellow wheat

34 Compare Bernard's own statement: ". . . one should not paint in front of things but by calling them back into the imagination that had acquired them, which preserved them in the idea." *Souvenirs inédits sur l'artiste peintre Paul Gauguin et ses compagnons,* 1939, cited in Rookmaaker, *Synthetist Art Theories: Notes in Letters,* n.z, p. 35.

field and a yellow sun? It isn't *it* yet; however, I have attacked that devilish problem of the yellows in it again. I am speaking of the one with the heavy impasto, done on the spot, and not of the replica with hatchings, in which the effect is weaker.[35] I still have many things to say to you, but, although I am writing today now that my head has got a bit steadier, I was previously afraid to excite it before being cured. A very cordial handshake in thought, for you as well as Anquetin and my other friends, if you see any of them, and believe me,

<div align="right">Sincerely yours,
Vincent</div>

P.S. I don't need to tell you how sorry I am for your sake, as well as for your father's, that he did not approve of your spending the season with Gauguin. The latter wrote me that your military service has been postponed for a year because of your health. Thanks all the same for your description of the Egyptian house. I should have liked to know too whether it is larger or smaller than a rural cottage in this country—in short, its proportions in relation to the human figure. But it is above all about the coloration that I am asking for information.[36]

Van Gogh's Reply to G.-Albert Aurier

Van Gogh voluntarily entered the St. Paul Asylum at Saint-Rémy, not far from Arles, in the spring of 1889, remaining there through the early winter of 1890. It was at the end of his confinement that he wrote the following letter to G.-Albert Aurier, in response to the latter's article in the Mercure de France. *(See above, pp. 135 to 139.) Van Gogh's innate modesty and his very accurate insight into what he was striving for in his art prevented him from being completely swept away by Aurier's fulsome praise, nor would he allow himself to be assimilated to the Symbolist's partisan and exclusive program of art. In a letter to Theo of February 12, 1890, he confided: "Aurier's article might have encouraged me, if I dared to let myself go, to venture farther away from reality and to make with colors something like a music of tones, such as are some of Monticelli's canvases.[37] But truth is so dear to me, and the search for being truthful too. Well, I think I still prefer being a cobbler to being a musician who works with colors."[38] Thus van Gogh's letter to Aurier,*

35 Probably references to *Cornfields at the Fall of Day,* painted in June, 1889, and *Harvest,* painted in October of the same year.

36 Vincent van Gogh, Letter to Emile Bernard (B21) [Saint-Rémy, beginning of December, 1889], *Complete Letters,* III, 521–525.

37 Adolphe Monticelli (1824–1886), painter of brilliantly colored, dashingly executed figure pieces, portraits, and still lifes. Van Gogh was always a passionate devotee of Monticelli's colorism and his work in general, finding only Delacroix his equal in the orchestration of colors, "something passionate and eternal—the rich color and rich sun of the glorious South. . . ." Letter 477a, *Complete Letters,* II, 547.

38 Cited in Rewald, *Post-Impressionism,* p. 373.

while expressing his gratitude at being singled out for the honor ac-
corded him, is measured in its tone, pointing out similar if not superior
virtues in the works of other artists, and gently chiding the critic for his
unnecessarily "sectarian spirit."

[SAINT-RÉMY, FEBRUARY 12, 1890]

DEAR MR. AURIER,

Many thanks for your article in the *Mercure de France,* which greatly surprised me. I like it very much as a work of art in itself; in my opinion your words produce color; in short, I rediscover my canvases in your article, but better than they are, richer, more full of meaning. However, I feel uneasy in my mind when I reflect that what you say is due to others rather than to myself. For example, Monticelli in particular. Saying as you do: "As far as I know, he is the only painter to perceive the chromatism of things with such intensity, with such a metallic, gem-like luster," be so kind as to go and see a certain bouquet by Monticelli at my brother's—a bouquet in white, forget-me-not blue, and orange— then you will feel what I want to say. But the best, the most amazing Monticellis have long been in Scotland and England. In a museum in the North—the one in Lisle, I believe—there is said to be a very marvel, rich in another way and certainly no less French than Watteau's "Départ pour Cythère." At the moment Mr. Lauzet [39] is engaged in reproducing some thirty works of Monticelli's.

Here you are; as far as I know, there is no colorist who is descended so straightly and directly from Delacroix, and yet I am of the opinion that Monticelli probably had Delacroix's color theories only at second hand; that is to say, that he got them more particularly from Diaz and Ziem.[40] It seems to me that Monticelli's personal artistic temperament is exactly the same as that of the author of the *Decameron*—Boccaccio— a melancholic, somewhat resigned, unhappy man, who saw the wedding party of the world pass by, painting and analyzing the lovers of his time —he, the one who had been left out of things. Oh! he no more imitated Boccaccio than Henri Leys [41] imitated the primitives. You see, what I mean to say is that it seems there are things which have found their way to my name, which you could better say of Monticelli, to whom I owe so much. And further, I owe much to Paul Gauguin, with whom I worked

39 A. M. Lauzet (? –1898), painter and lithographer, who reproduced works of Monticelli and Puvis de Chavannes, among others.
40 Félix François Ziem (1821–1911), popular artist specializing in marine paintings, above all, scenes of Venice, with light-filled skies or brilliant sunsets.
41 Henri Leys (1815–1869), Belgian painter of historical scenes, genre, and frescoes, much influenced by Delacroix, the Dutch Little Masters of the 17th century, and Rembrandt.

in Arles for some months, and whom I already knew in Paris, for that matter.

Gauguin, that curious artist, that alien whose mien and the look in whose eyes vaguely remind one of Rembrandt's "Portrait of a Man" in the Galerie Lacaze—this friend of mine likes to make one feel that a good picture is equivalent to a good deed; not that he says so, but it is difficult to be on intimate terms with him without being aware of a certain moral responsibility. A few days before parting company, when my disease forced me to go into a lunatic asylum, I tried to paint "his empty seat." [42]

It is a study of his armchair of somber reddish-brown wood, the seat of greenish straw, and in the absent one's place a lighted torch and modern novels.

If an opportunity presents itself, be so kind as to have a look at this study, by way of a memento of him; it is done entirely in broken tones of green and red. Then you will perceive that your article would have been fairer, and consequently more powerful, I think, if, when discussing the question of the future of "tropical painting" and of colors, you had done justice to Gauguin and Monticelli before speaking of me. *For the part which is allotted to me, or will be allotted to me, will remain, I assure you, very secondary.*

And then there is another question I want to ask you. Suppose that the two pictures of sunflowers, which are now at the *Vingtistes'* exhibition, have certain qualities of color, and that they also express an idea symbolizing "gratitude." Is this different from so many flower pieces, more skillfully painted, and which are not yet sufficiently appreciated, such as "Hollyhocks," "Yellow Irises" by Father Quost? [43] The magnificent bouquets of peonies which Jeannin [44] produces so abundantly? You see, it seems so difficult to me to make a distinction between impressionism and other things; I do not see the use of so much sectarian spirit as we have seen these last years, *but I am afraid of the preposterousness of it.*

And in conclusion, I declare that I do not understand why *you* should speak of Meissonier's "Infamies." [45] It is possible that I have inherited from the excellent Mauve [46] an absolutely unlimited admiration

[42] *Gauguin's Armchair*, painted in December, 1888. Van Gogh painted his own chair (*Chair and Pipe*) as a companion-piece.

[43] Ernest Quost (1844–1931), French painter of flowers, fruit, still life, and landscape.

[44] Georges Jeannin (1841–1925), painter specializing in flowers and still lifes; president of the Society of Flower-Painters.

[45] See above, p. 139, for Aurier's scathing remarks about this artist.

[46] Anton Mauve (1838–1888), Dutch landscape and animal painter, great admirer of Millet and the Barbizon School, for whom van Gogh, in turn, had great respect.

for Meissonier; Mauve's eulogies on Troyon and Meissonier used to be inexhaustible—a strange pair.

I say this to draw your attention to the extent to which people in foreign countries admire the artists of France, without making the least fuss about what divided them, often enough so damnably. What Mauve repeated so often was something like this: "If one wants to paint colors, one should also be able to draw a chimney corner or an interior as Meissonier does."

In the next batch that I send my brother, I shall include a study of cypresses for you, if you will do me the favor of accepting it in remembrance of your article. I am still working on it at the moment, as I want to put in a little figure. The cypress is so characteristic of the scenery of Provence; you will feel it and say: "Even the color is black." Until now I have not been able to do them as I feel them; the emotions that grip me in front of nature can cause me to lose consciousness, and then follows a fortnight during which I cannot work. Nevertheless, before leaving here I feel sure I shall return to the charge and attack the cypresses. The study I have set aside for you represents a group of them in the corner of a wheat field during a summer mistral. So it is a note of a certain nameless black in the restless gusty blue of the wide sky, and the vermilion of the poppies contrasting with this dark note.

You will see that this constitutes something like the combination of tones in those pretty Scotch tartans of green, blue, red, yellow, black, which at the time seemed so charming to you as well as to me, and which, alas, one hardly sees any more nowadays.

Meanwhile, dear Sir, accept my gratitude for your article. When I go to Paris in the spring, I certainly shall not fail to call on you to thank you in person.

<div align="right">VINCENT VAN GOGH</div>

It will be a year before the study that I am going to send you will be thoroughly dry, also in the thick layers of paint; I think you will do well to lay on a goodly coat of varnish.

In the meantime it will be necessary to wash it a good many times with plenty of water in order to get the oil out. The study is painted with plain Prussian blue, the much-maligned color nevertheless used so often by Delacroix. I believe that as soon as the tones of this Prussian blue are quite dry, you will, by varnishing, get the black, the very black tones, necessary to bring out the various somber greens.

I am not quite sure how this study ought to be framed, but seeing that it makes one think of those nice Scotch materials, I mention that I have observed that a very *simple flat frame* in VIVID ORANGE LEAD would produce the desired effect in conjunction with the blues of the background

and the dark greens of the trees. Without it there would not be enough red in the picture, and the upper part would seem a little cold.[47]

Letter to His Sister Wilhelmina

Van Gogh's love for portraiture was a natural concomitant of his life-long commitment to human value, his belief in the importance of the individual, and his struggle to make contact with himself and others. While in Paris he painted twenty-two portraits in less than two years, and in Arles forty-six within the space of a single year. His subjects are always of his own choosing, often simple people to whom he was personally attached, presented naturally and directly in flat, brilliant color areas from which their individuality emerges with iconic clarity. In the modern portrait, as van Gogh points out in this excerpt from a letter to his youngest sister Wil, feeling and expression are inseparably linked to color itself, rather than to realistic representation. Written during the final period of his life, when he was staying with Dr. Gachet at Auvers-sur-Oise—the portrait of this sympathetic and melancholy friend is one of his most successful—van Gogh's statements, while expressing his own deeply personal outlook, are also closely linked to other advanced Symbolist and Synthetist trends of his time, such as that summarized by Maurice Denis when he states: "It is from the canvas itself, a plane surface coated with colors, that the emotion surges. . . ." (See below, p. 190.)

[AUVERS-SUR-OISE, FIRST HALF OF JUNE, 1890]

My dear sister,

. . . What impassions me most—much, much more than all the rest of my métier—is the portrait, the modern portrait. I seek it in color, and surely I am not the only one to seek it in this direction. *I should like* —mind you, far be it from me to say that I shall be able to do it, although this is what I am aiming at—*I should like* to paint portraits which would appear after a century to the people living then as apparitions. By which I mean that I do not endeavor to achieve this by a photographic resemblance, but by means of our impassioned expressions —that is to say, using our knowledge of and our modern taste for color as a means of arriving at the expression and the intensification of the character. So the portrait of Dr. Gachet shows you a face the color of an overheated brick, and scorched by the sun, with reddish hair and a white cap, surrounded by a rustic scenery with a background of blue hills; his clothes are ultramarine—this brings out the face and makes it paler, notwithstanding the fact that it is brick-colored. His hands, the

47 Vincent van Gogh, Letter to G.-Albert Aurier (626a) [Saint-Rémy, February 12, 1890], *Complete Letters*, III, 256–258.

hands of an obstetrician, are paler than the face. Before him, lying on a red garden table, are yellow novels and a fox-glove flower of a somber purple hue.[48]

My self-portrait is done in nearly the same way; the blue is the blue color of the sky in the late afternoon, and the clothes are a bright lilac.[49] The portrait of the Arlésienne [50] has a drab and lusterless flesh color, the eyes calm and very simple, a black dress, the background pink, and with her elbow she is leaning on a green table with green books. . . .[51]

PAUL GAUGUIN: 1848–1903

Letter to Emile Schuffenecker

Despite the fact that he had given up a profitable career as a banker in 1883, and had twice exhibited with the Impressionists, Paul Gauguin had not yet painted anything particularly revolutionary at the time he wrote the following letter, when living in Copenhagen with his family in 1885. The extremely advanced program enunciated in this letter is, therefore, a prediction of the style of art he and his associates were to evolve in Pont-Aven, Brittany, in the years from 1886 to about 1891, rather than a description of any work he had already produced. Yet as a document, it is startlingly advanced: while the idea that pure color might have a directly expressive, rather than a merely descriptive, function can be traced back to Delacroix and Baudelaire, the similar potentialities of line and form had never been so unequivocally or forcefully stated. In his insistence on the possibility of communicating emotion or subjectively experienced reality directly through abstract, pictorial equivalences, Gauguin has, in this document, formulated the quintessence of Synthetism before the fact, seizing on notions that were current in literature and philosophy, and which were soon to be made actuality within the realm of art, in the works of Seurat and van Gogh, as well as those of himself and his group.

Emile Schuffenecker (1851–1934), to whom this letter is addressed, had been an employee at the same brokerage house, Bertin's, as Gauguin. He had exhibited at the Salons of 1877 and 1880; he was one of the

48 Van Gogh created two versions of this portrait in June, 1890. The yellow novels are two by the Goncourts: *Manette Salomon* and *Germinie Lacerteux.*

49 Perhaps a reference to the last of his self-portraits, and one of the greatest, painted in May, 1890, at Saint-Rémy.

50 Probably a reference to one of the four versions of this subject executed by van Gogh after a drawing by Paul Gauguin in January–February, 1890.

51 Vincent van Gogh, Excerpt of a letter to his sister (W22) [Auvers-sur-Oise, first half of June, 1890], *Complete Letters,* III, 470.

founders of the Salon des Indépendants. "The good Shuff" was always ready to come to Gauguin's aid during the latter's first difficult years as a full-time artist, lending him money and permitting him to live for a time in his home in Paris. Gauguin's portrait of this kindly friend and his family (1889) is a fine example of the painter's ability to convey psychological relationships through bold composition, brilliant areas of flat pigment, and curvilinear outline.

COPENHAGEN, 14 JANUARY, 1885

MY DEAR SCHUFFENECKER,

I have had a letter from Guillaumin; [52] it appears that you wanted to buy one of his exhibited pictures, but that it was already reserved. Why don't you go to him and choose another; I believe you will be glad to have one of his works, while I should be pleased to hear of a sale for this poor but highly talented artist.

As for myself, it seems to me at the moment that I am mad, and yet the more I brood at night in bed, the more I think I am right. For a long time philosophers have reasoned about phenomena which appear to us supernatural, and of which, however, we have the *sensation*. Everything is there, in this word—Raphael and others, people in whom sensation was formulated before the mind started to operate, which enabled them, while pursuing their studies, to keep this feeling intact, and to remain artists. And for me the great artist is synonymous with the greatest intelligence; he is the vehicle of the most delicate, the most invisible emotions of the brain.

Look around at the immense creation of nature and you will find laws, unlike in their aspects and yet alike in their effect, which generate all human emotions. Look at a great spider, a tree trunk in a forest— both arouse strong feeling, without your knowing why. Why is it you shrink from touching a rat, and many similar things; no amount of reasoning can conjure away these feelings. All our five senses reach the brain *directly*, affected by a multiplicity of things, and which no education can destroy. Whence I conclude there are lines that are noble and lines that are false. The straight line reaches to infinity, the curve limits creation, without reckoning the fatality in numbers. Have the figures 3 and 7 been sufficiently discussed? Colors, although less numerous than lines, are still more explicative by virtue of their potent influence on the eye. There are noble sounds, others that are vulgar; peaceful and consoling harmonies, others that provoke by their audacity. You will find in graphology the traits of candid men and those of liars; why should not lines and colors reveal also the more or less grand character

[52] Armand Guillaumin (1849–1927), a member of the Impressionist group, employed by the Department of Bridges and Roads of Paris.

of the artist. Look at Cézanne, the misunderstood, an essentially mystic Eastern nature (he looks like an old man of the Levant). In his methods, he affects a mystery and the heavy tranquility of a dreamer; his colors are grave like the character of orientals; a man of the South, he spends whole days on the mountain top reading Virgil and looking at the sky. So his horizons are lofty, his blues most intense, and with him red has an amazing vibration. Virgil has more than one meaning and can be interpreted as one likes; the literature of his pictures has a parabolic meaning with two conclusions; his backgrounds are equally imaginative and realistic. To sum up: when we look at one of his pictures, we exclaim "Strange." But he is a mystic, even in drawing.

The farther I go into this question—the translation of thought into a medium other than literature—the more I am convinced of my theory—we shall see who is right. If I am wrong, why does not all your Academy, which knows all the methods used by the old masters, paint masterpieces? Because it is impossible to create a nature, an intelligence, a heart. The young Raphael knew all these things intuitively and in his pictures there are harmonies of line which cannot be accounted for; they are the veiled reflections of the innermost recesses of the man's mind. Look at the details—even in the landscape of a Raphael picture, you will find the same emotion as in a head. Purity pervades the whole. A landscape of Carolus-Durand [53] is as raffish as a portrait. (I cannot explain it but I have this feeling.)

Here I am tormented more than ever by art, and neither my money worries nor my quest for business can turn me aside from it. You tell me that I should do well to join your Society of Independents; shall I tell you what would happen? You are a hundred strong; tomorrow you will be two hundred. Artist tradesmen are two-thirds intriguers; in a short time you will be assuming the importance of Gervex [54] and others, and what shall we, the dreamers, the unappreciated, do? You have had a favorable press this year; next year they will stir up all the mud to fling at you, so as to appear respectable.

Go on working, *freely and furiously,* you will make progress and sooner or later your worth will be recognized, if you have any. Above all, don't perspire over a picture. A strong emotion can be translated immediately: dream on it and seek its simplest form.

The equilateral triangle is the most firmly based and the perfect triangle. A long triangle is more elegant. We say lines to the right advance, those to the left retreat. The right hand strikes, the left defends.

[53] Charles Carolus-Durand (1838–1917), painter who made his first sensation in the 1865 Salon as a realist, and later settled down to become an extremely fashionable and conventional portrait painter.

[54] Henri Gervex (1852–1929), realist painter, one of whose best canvases was refused by the 1878 Salon on the grounds of immorality.

A long neck is graceful but heads on shoulders more thoughtful. But I am running away with myself and talking all kinds of rot. Your friend Courtois [55] is more reasonable but his painting is so stupid. Why are willows with hanging branches called weeping? Is it because drooping lines are sad? And is the sycamore sad because it is found in cemeteries; no, it is the color that is sad.

As to business, I am always at the same point, the start; I shall not see the result, if there is one, for six months. Meanwhile, I am penniless, up to the neck in squalor—which is why I console myself in dreaming.

Gradually we shall extricate ourselves; my wife and I give lessons in French: you will laugh, me, lessons in French!

I wish you better luck than ours. Regards to your wife.

P. GAUGUIN.[56]

Letter to Emile Bernard

The young Emile Bernard (1868–1941) had met Gauguin at the Pension Gloanec in Pont-Aven during the summer of 1886 and was much impressed by his work. Bernard himself was inclined to be theoretical, philosophical, and brooding, very much abreast of current ideas in literature and philosophy as well as in painting. By the summer of 1888, when Bernard returned to Brittany, Gauguin became interested in his style; his own was still rather Impressionist in character, whereas Bernard, full of the latest ideas of the literary Symbolists, had, in company with his friend Anquetin, already produced some extremely simplified, flattened, brightly colored, sharply outlined decorative canvases in a manner which one critic had described as "cloisonisme." In addition, Bernard had impressed Gauguin with his articulateness and erudition, supplying the older artist with appealingly high-sounding theories and concepts for his own enterprises, and perhaps stimulating him to go further in the direction he had already chosen—toward greater abstraction, simplification, and anti-naturalism, "the synthesis of form and color derived from the observation of the dominant element only," as Gauguin himself put it.[57] Yet the young Bernard came to admire Gauguin—certainly by far the stronger painter and personality of the two—more and more; by this time, the group centering around Gauguin in Pont-Aven, and later at Le Pouldu, had grown to include not only Bernard, Laval, Anquetin, and

[55] Perhaps a reference to Gustave Courtois (1853–1924), pupil of Gérôme, best known for his portraits.

[56] Paul Gauguin, Letter to Emile Schuffenecker, Copenhagen, January 14, 1885, *Letters to His Wife and Friends,* ed. Maurice Malingue, trans. H. J. Stenning (Cleveland and New York: The World Publishing Company, 1949), pp. 33–35.

[57] Paul Gauguin, Letter to Schuffenecker [Pont-Aven, August 14, 1888], cited by John Rewald, *Post-Impressionism,* p. 196.

Schuffenecker, but also Paul Sérusier, Meyer de Haan, Moret, and de Chamaillard.

In later years Bernard lapsed into discouragement and a kind of facile medieval mysticism, gradually strengthening his ties with Catholicism and, in the years after 1891, breaking off completely with Gauguin, whom he accused of having stolen his ideas, claiming that he alone had been responsible for the new stylistic tendencies which had evolved in Brittany in 1888. Gauguin on his side flatly denied Bernard the slightest shred of originality, forgetting that the Synthetist style had, in fact, arisen from close collaboration between the two men.

In this letter, written from Arles during his short, dramatic stay with van Gogh, Gauguin reveals the nature of the formal and expressive problems discussed by the Pont-Aven group, as well as their admiration for the art of Japan.

ARLES, 1889

MY DEAR BERNARD,

. . . You are discussing the problem of shadows with Laval [58] and want to know whether I give a damn about them. Insofar as they are explanations of light, no. Look at the Japanese, who draw so admirably, and you will see life out-of-doors and in the sun, without shadows; they only use color as a combination of local tints giving the impression of heat, etc. Moreover, I consider Impressionism as a completely new undertaking, completely different from anything mechanical such as photography, etc. It follows that I reject as far as possible anything that gives the illusion of a thing, and since shadows are the *trompe l'oeil* of the sun, I am inclined to eliminate them.

But if a shadow gets into your composition as a necessary form, that is completely different. If, instead of a figure, you put only the shadow of a person, that is an original point of departure, the strangeness of which you have calculated, just like the raven on the head of Pallas, which came to be there instead of a parrot as a result of the choice of the artist, a calculated choice. So, my dear Bernard, use shadows if you find them useful, or don't use them—it's exactly the same thing, as long as you don't consider yourself the slave of shadow. Then it is the shadow which is somehow at your service. . . .

It's funny, Vincent [van Gogh] sees Daumier to be done here, while I on the contrary see colored Puvis [de Chavannes] mixed with

[58] Charles Laval (? –1894), member of the group of young painters gathered about Gauguin at Pont-Aven in the years after 1886, a circle which included Emile Bernard, Anquetin, and others. Gauguin made a voyage to Panama and Martinique with Laval in 1887. Laval participated in the Synthetist Exhibition organized by Gauguin at the Café Volpini in 1889.

Japan. The women here, with their headdresses, are elegant, their beauty is Greek, their shawls falling in folds like the primitives—they are Greek processions. The girl who goes by on the street is as much a lady as anyone, and as virginal in appearance as Juno. At any rate there is a source of *modern style* beauty here. . . .[59]

Notes on Painting

Gauguin probably wrote this extremely important, although incomplete essay in about 1890, since it was written into a sketchbook containing studies of Brittany. At this time Gauguin wrote to Emile Bernard about an article he was preparing attacking art criticism. The text was published in 1910 by Henri Mahaut. The musical analogies that run through this essay had already been stated by both Delacroix and Baudelaire, who had maintained: "if [a painting] is melodious, it already has a meaning. . . ." [60] Thus, Gauguin's insistence upon the power of artistic genius, in painting and music, to seize reality directly by means of non-rational faculties and to convey emotion immediately to the human soul, through the senses, in a single, complete, harmonious unity, is part of a larger, more general current of the nineties, common to poets, writers, painters, and musicians with Symbolist inclinations, and ultimately traceable to the ideas of Arthur Schopenhauer (1788–1860). While it is extremely unlikely that Gauguin was acquainted with the works of the German philosopher, the latter's sharp distinction between the scientific-rational and the artistic-instinctive forms of knowledge and his stress upon the power of art, particularly music, to reveal the inner nature of the world in a language which even the artist or composer himself cannot rationally understand, had already been absorbed into the theory of the French literary Symbolists, with whom Ganguin came into close contact in 1890–1891. In 1891 G.-Albert Aurier, writing in the Symbolist organ Mercure de France, *had made the analogy between music and painting most explicit when he stated that the emotion expressed by an artist could "ultimately be only a pure sensation: a sensation of a particular harmony of lines, of a symphony determined by colors," [61] and in later years, Gauguin was to state: "painting should seek suggestion more than description, as indeed music does." [62]*

[59] Paul Gauguin, Excerpt of a letter to Emile Bernard, Arles, 1889, *Lettres de Paul Gauguin à Emile Bernard* (Geneva: Pierre Cailler, 1954), pp. 63–66. Reprinted by permission of the publisher.

[60] Charles Baudelaire, "Salon de 1846," *Oeuvres complètes* (Paris: Gallimard [Bibliothèque de la Pléiade], 1961), p. 883. In this same section of his 1846 Salon, "On Color," Baudelaire had stated: "In color we find harmony, melody, and counterpoint" (p. 881).

[61] G.-Albert Aurier, Article on the Salons of 1891, *Mercure de France,* III (1891), 37, cited by Rookmaaker, *Synthetist Art Theories: Notes in Letters,* n. dw, p. 69.

[62] Paul Gauguin, Letter to Daniel de Monfreid, 1901, cited in Robert Goldwater, *Paul Gauguin* (New York: Harry N. Abrams, Inc., n.d.), p. 42.

Painting is the most beautiful of all arts. In it, all sensations are condensed, at its aspect everyone may create romance at the will of his imagination, and at a glance have his soul invaded by the most profound memories, no efforts of memory, everything summed up in one moment. Complete art which sums up all the others and completes them. Like music, it acts on the soul through the intermediary of the senses, the harmonious tones corresponding to the harmonies of sounds, but in painting, a unity is obtained which is not possible in music, where the accords follow one another, and the judgment experiences a continuous fatigue if it wants to reunite the end and the beginning. In the main, the ear is an inferior sense to the eye. The hearing can only grasp a single sound at one time, whereas the sight takes in everything and at the same time simplifies at its will.

Like literature, the art of painting tells whatever it wants, with the advantage of letting the reader immediately know the prelude, the direction, and the dénouement. Literature and music ask for an effort of memory to appreciate the whole. This last art is the most incomplete and the least powerful.

You may dream freely when you listen to music as well as when you look at painting. When you read a book you are the slave of the author's mind.

Sight alone produces an instantaneous impulse.

But then, the men of letters alone are art critics, they alone defend themselves against the public. Their preface is always defense of their work, as if a really good work would not defend itself by itself.

These gentlemen flutter about the world like bats which flap their wings in the twilight, so that their dark mass appears to you in every direction; animals disquieted by their fate, and their too heavy bodies which prevent them from rising. Throw them a handkerchief full of sand and they will stupidly make a rush at it.

One must listen to them judging all human works. God has made man after his own image which, obviously, is flattering for man. "This work pleases me and is done exactly the way I should have conceived it." All art criticism is like that. To be in keeping with the public, to seek a work after its image. Yes, gentlemen of letters, you are not capable of criticizing a work of art, even a book. You are already corrupt judges, you had before-hand a ready-made idea, that of the man of letters, and you believe too much in someone else's mind. You do not like blue, since you condemn all blue paintings. If you are a sensitive and melancholy poet, you want all compositions to be in a minor key. Such a one likes graciousness, and he must have everything that way. Another one likes gaiety, and he does not understand a sonata. Intelligence and knowledge are necessary to judge a book. To judge painting and music special sensations in nature are necessary besides intelligence and artistic

science. In short, one has to be a born artist, and few are chosen among all those who are called. Any idea may be formulated, but not so the sensations of the heart. What efforts are needed to master fear, or a moment of enthusiasm! Is not love often instantaneous and nearly always blind? And to say that thinking is called spirit, whereas the instincts, the nerves, and the heart are part of matter. The irony of it!

The vaguest, the most undefinable, the most varied, that is matter. Thinking is a slave of sensations.

Nature is above man.

Literature is human thinking described by words.

With whatever talent you may tell me how Othello comes, with his heart devoured by jealousy, to kill Desdemona, my soul will never be as much impressed as when I have seen Othello with my own eyes entering the room, his forehead presaging the storm. Therefore you need the theater to complement your work.

You may describe a storm with talent, but you will never succeed in conveying to me the sensation of it.

Instrumental music as well as numbers are based on a unit. The entire musical system derives from this principle, and the ear has got used to all the divisions, but you may choose another base and the tones, half-tones, and quarter-tones, follow each other. Out of these you will have varying tones. The eye is less used to these variations than the ear, but then, the divisions are more manifold, and for further complication there are several units.

On an instrument you start from one tone. In painting you start from several. Thus, you begin with black and divide up to white—first unit, the easiest and also the most in use, consequently the best understood. But take as many units as there are colors in the rainbow, add those made up by composite colors, and you will have a rather respectable number of units, truly a Chinese puzzle, so that it is not asounding that the colorist's science has been so little investigated by the painters, and so little understood by the public. On the other hand, what richness of means to attain to an intimate relationship with nature.

They reprove our colors which we put unmixed side by side. In that domain we are perforce victorious, since we are powerfully helped by nature, which does not proceed otherwise.

A green next to a red does not result in a reddish brown like the mixture, but in two vibrating tones. If you put chrome yellow next to this red, you have three tones complementing each other and augmenting the intensity of the first tone: the green.

If, instead of the yellow, you apply blue, you will find three different tones, but vibrating through one another.

If instead of the blue, you apply a violet, the result will again be a single tone, but a composite one, belonging to the reds.

The combinations are unlimited. The mixture of colors results in a dirty tone. One color alone is a crudity and does not exist in nature. They only exist in an apparent rainbow, but how well rich nature took care to show them to you side by side in an arbitrary and unalterable order, as if each color was born out of another!

Now, you have fewer means than nature, and you condemn yourselves of all those which it puts at your disposal. Will you ever have as much light as nature, as much heat as the sun? And you speak of exaggeration, but how can you be exaggerating, since you remain below nature?

Ah! If you mean by exaggerated, any badly balanced work, then you are right in that respect. But I must draw your attention to the fact that, even if your work be timid and pale, it will be considered exaggerated, if there is a mistake of harmony in it.

Is there then a science of harmony? Yes.

And in that respect, the feeling of the colorist is exactly the natural harmony. Like singers, painters sometimes sing out of tune, and their eyes have no harmony.

Later there will be, through studies, an entire method of harmony, unless people omit to study it in the academies and in the majority of the studios. In fact, the study of painting has been divided into two categories. One learns to draw and then to paint, meaning that one colors inside of a ready-made contour, very much as a statue might be painted afterwards.

I admit that, so far I have understood only one thing about this practice, and that is that the color is nothing but an accessory. "Sir, you must draw properly before painting"—this said in a professorial manner; the greatest stupidities are always said that way.

Do you put on your shoes like your gloves? Can you really make me believe that drawing does not derive from color and vice versa? And to prove it, I commit myself to reduce or enlarge one and the same drawing, according to the color which I use to fill it up. Try to draw a head of Rembrandt in exactly the same proportions, and then put on it the colors of Rubens, and you will see what a misshapen thing you will have, and at the same time, the color will have become unharmonious.

For centuries, important amounts of money have been spent on the propagation of drawing, and the number of painters is increasing without progressing in the least. Who are the painters we admire at the present moment? All those who reproved the schools, all those who drew their science from personal observation of nature. Not one. . . . [Here ends the manuscript.] [63]

[63] Paul Gauguin, "Notes on Painting," in John Rewald, *Gauguin* (New York and Paris: Hyperion Press, 1938), pp. 161–163.

A Fable about Art from Gauguin's "Intimate Journals"

"This is not a book," Gauguin reiterates several times in the pages of his Intimate Journals, *those notes in which he sets down in an extremely fresh and spontaneous style his most personal thoughts and feelings about a variety of subjects—art, love, the colonial administration, native customs, more or less scabrous anecdotes. Written during the course of his second stay in the Pacific, in Tahiti and the Marquesas from 1895 to 1903 (although mainly in the last two years of his life), the manuscript was then sent by Gauguin to the critic André Fontainas in Paris, where this unique document remained unpublished until 1910, when it appeared as* Avant et Après.

The vaguely primitive and "folkloristic" flavor of this little fable is completely in accord with Gauguin's artistic preference for the simplicity of "barbaric" rather than "civilized" styles and cultures.

It was in the days of Tamerlane, I think in the year X, before or after Christ. What does it matter? Precision often destroys a dream, takes all the life out of a fable. Over there, in the direction of the rising sun, for which reason that country is called the Levant, some young men with swarthy skins, but whose hair was long, contrary to the custom of the soldier-like crowd, and thus indicated their future profession, found themselves gathered together in a fragrant grove.

They were listening, whether respectfully or not I do not know, to Vehbi-Zunbul Zadi, the painter and giver of precepts. If you are curious to know what this artist could have said in these barbarous times, listen.

Said he: "Always use colors of the same origin. Indigo makes the best base; it turns yellow when it is treated with spirit of nitre and red in vinegar. The druggists always have it. Keep to these three colors; with patience you will then know how to compose all the shades. Let the background of your paper lighten your colors and supply the white, but never leave it absolutely bare. Linen and flesh can only be painted by one who knows the secret of the art. Who tells you that flesh is light vermilion and that linen has grey shadows? Place a white cloth by the side of a cabbage or a bunch of roses and see if it will be tinged with grey.

"Discard black and that mixture of white and black they call grey. Nothing is black and nothing is grey. What seems grey is a composite of pale tints which an experienced eye perceives. The painter has not before him the same task as the mason, that of building a house, compass and rule in hand, according to the plan furnished by the architect. It is well for young men to have a model, but let them draw the curtain over

it while they are painting. It is better to paint from memory, for thus your work will be your own; your sensation, your intelligence, and your soul will triumph over the eye of the amateur. When you want to count the hairs on a donkey, discover how many he has on each ear, and determine the place of each, you go to the stable.

"Who tells you that you ought to seek contrast in colors?

"What is sweeter to an artist than to make perceptible in a bunch of roses the tint of each one? Although two flowers resemble each other, can they ever be leaf by leaf the same?

"Seek for harmony and not contrast, for what accords, not what clashes. It is the eye of ignorance that assigns a fixed and unchangeable color to every object; as I have said to you, beware of this stumbling-block. Practise painting an object in conjunction with, or shadowed by —that is to say, close to or half behind—other objects of similar or different colors. In this way you will please by your variety and your truthfulness—your own. Go from dark to light, from light to dark. The eye seeks to refresh itself through your work; give it food for enjoyment, not dejection. It is only the sign-painter who should copy the work of others. If you reproduce what another has done you are nothing but a maker of patchwork; you blunt your sensibility and immobilize your coloring. Let everything about you breathe the calm and peace of the soul. Also avoid motion in a pose. Each of your figures ought to be in a static position. When Oumra represented the death of Ocraï, he did not raise the saber of the executioner, or give the Khakhan a threatening gesture, or twist the culprit's mother in convulsions. The sultan, seated on his throne, wrinkles his brow in a frown of anger; the executioner, standing, looks at Ocraï as on a victim who inspires him with pity; the mother, leaning against a pillar, reveals her hopeless grief in this giving way of her strength and her body. One can therefore without weariness spend an hour before this scene, so much more tragic in its calm than if, after the first moment had passed, attitudes impossible to maintain had made us smile with an amused scorn.

"Study the silhouette of every object; distinctness of outline is the attribute of the hand that is not enfeebled by any hesitation of the will.

"Why embellish things gratuitously and of set purpose? By this means the true flavor of each person, flower, man, or tree disappears; everything is effaced in the same note of prettiness that nauseates the connoisseur. This does not mean that you must banish the graceful subject, but that it is preferable to render it just as you see it rather than to pour your color and your design into the mold of a theory prepared in advance in your brain." [64]

[64] Paul Gauguin, *The Intimate Journals of Paul Gauguin*, trans. Van Wyck Brooks (London: William Heinemann Ltd., 1952), pp. 30–31 (pp. 68–72 in paperback edition published by the Indiana University Press in 1958). Reprinted by permission of LIVERIGHT, Publishers, N. Y. Copyright © Renewed, 1949 by Van Wyck Brooks.

A Letter to His Wife about "The Spirit of the Dead Watches"

The whole question of the relation between observed reality and iconic equivalence, between the representation of nature and abstract, pictorial invention, an issue so central to Gauguin's art, to Synthetism, and to the art of the late 19th century in general, is raised in this discussion of Manao Tupapau (The Spirit of the Dead Watches), *which Gauguin explains to his wife in a letter dealing with a projected Danish exhibition of his works.*

Gauguin had criticized the Impressionists, because, in his view, "they studied color exclusively as a decorative effect, but without liberty, keeping the shackles of probability. For them, the dream-landscape, created as a totality, does not exist. They look and they see harmoniously, but without any goal. . . . They sought for things at the visible level and not at the mysterious center of thought, and for this reason they fell into scientific reasoning. . . ."[65]

Such statements as these by no means indicate that Gauguin completely rejected nature; he felt, rather like Delacroix, that reality was a point of departure rather than a complete subject for the artist, an element within the total aesthetic structure of line and color which at once intensified and expressed a more manifold, complex, imaginative reality than could be provided by mere physical vision alone.

Naturally, many pictures will be incomprehensible and so you will have something with which to enjoy yourself. I want you to understand them and be in the know and so I am going to explain to you the toughest one, which is, by the way, the one I would like to keep or to sell at a high price—"Manao Tupapau." [66] I did a young nude. In this state the slightest thing is enough to make her indecent. And yet this is the way I want her. Line and movement interest me and so I add a touch of fear to her face. This fright has to be justified if not explained, and this in the very character of the person—a Maori. This race traditionally has a very great fear of the spirit of the dead. In our country, a young girl would be afraid to be surprised in this state. (Here, not at all.) And so I have to explain this fright with the least possible literary means, as it used to be done. And so this is what I am doing. General harmony: dark, sad, frightening, resounding in the eye like a funeral knell. The violet, the dark blue, and the yellow-orange. I am making the linen greenish-yellow: 1) because the linen of this savage is different from ours (beaten tree-bark); 2) because it generates, suggests, artificial light (the Kanaka

[65] Cited by Charles Morice, *Paul Gauguin* (Paris: H. Floury, 1919), pp. 140–141.
[66] *The Spirit of the Dead Watches,* 1892.

woman never sleeps in darkness), and yet I don't want the effect of a lamp (it's ordinary); 3) this yellow links the orange-yellow and the blue and so completes the musical harmony. There are a few flowers in the background, but they must not be real since they are imagined; I make them look like sparks. For the Kanaka, the night phosphorescences are connected with the spirit of the dead; they believe this and are frightened by it. And finally, I am simply making a ghost, a little old woman, because the young girl, being unfamiliar with French séances, cannot help seeing the spirit of the dead linked to the actual dead person— that is, a person like herself. This is a little explanation which will make you clever before the critics when they bombard you with their wicked questions. And finally, it has to be a very simple painting, since the motif is primitive, childlike. . . .[67]

Correspondence between Gauguin and August Strindberg

When, during the winter of 1895, Gauguin asked the Swedish dramatist August Strindberg (1849–1912) to write the catalogue statement for a forthcoming public sale of his works prior to his second departure for the South Seas, the latter, who had been a frequent visitor to the painter's studio, refused. But Gauguin found the playwright's long letter of refusal so interesting that he substituted it, along with his own reply, for the usual preface.

The "Eve" which both men mention in the course of their discussion, refers specifically to one of the paintings, Parau Ne Te Varua Ino *(Words of the Devil), that figured in the sale of February 18, 1895. But the figure of Eve, more generally conceived, haunted the painter's imagination as an image of primitive, unself-conscious sensuality. For example, in the course of an explanation of his art, written after Noa Noa, he says of his Tahitian ideal: "She is very subtle, very knowing in her naïveté, the Tahitian Eve. . . . She is Eve after the Fall, still capable of walking around naked without shame, keeping all her animal beauty as it was on the first day. Motherhood could not deform her, so solid do her flanks remain. . . .*

"Like Eve, her body has remained animal. But her head has progressed with evolution, her thought has developed subtlety, love has imprinted an ironic smile on her lips. . . ."[68] To this type of Eve, "adorable and sad," he sharply opposes the Eve of civilized societies, in his reply to Strindberg.

[67] Paul Gauguin, Excerpt from a letter to his wife, Tahiti, December 8, 1892, *Lettres de Gauguin à sa femme et à ses amis,* ed. Maurice Malingue (Paris: Editions Bernard Grasset, 1946), p. 237. Reprinted by permission of the publisher.

[68] Cited by John Rewald, *Gauguin* (Paris: Editions Hypérion, 1949), pp. 24–25.

[PARIS, FEBRUARY 1, 1895]

MY DEAR GAUGUIN,

You absolutely insist upon having the preface of your catalogue written by me, in memory of the winter 1894–5, when we lived here, behind the Institute, not far from the Panthéon, above all, near the Montparnasse cemetery.

I would have gladly given you the memory to carry off to that island of Oceania, where you are going to seek a setting in harmony with your powerful stature and some space, but I feel myself in an equivocal position right from the start, and I am replying immediately to your request by "I cannot"; or, more brutally, by "I do not want to."

At the same time, I owe you an explanation for my refusal, which does not arise from a lack of willingness to oblige, from a laziness of the pen, although it would have been easy for me to place the blame on the already-celebrated malady of my hands, which, however, still have not been completely crippled by writer's cramp.

Here it is:

I cannot grasp your art and I cannot like it. (I have no hold on your art, this time exclusively Tahitian.) But I know that this confession will neither surprise you nor wound you, for you seem to me mainly strengthened by the hatred of others; your personality delights in the antipathy to which it gives rise, anxious to remain intact. And rightly, perhaps, for from the moment when, approved of and admired, you have partisans, you would be categorized, classified, a name would be given to your art which the young men would make use of in less than five years as a label designating an outworn art that they would do everything to make even more outdated.

I myself have made serious attempts to classify you, to introduce you as a link in the chain, to lead myself to the knowledge of the history of your development—but in vain.

I remember my first stay in Paris in 1876. The city was depressing, for the nation was in mourning for past events and was uneasy about the future; something was brewing.

In the Swedish artists' circles, the name of Zola had not yet been heard, for *The Assommoir* had not yet been published. I was present at the presentations at the Théâtre Français of *Rome Vaincue,* where Mme. Bernhardt, the new star, was crowned a second Rachel;[69] and my young artists had dragged me to Durand-Ruel's to see something completely new in painting. A young painter, then unknown, brought me, and we

69 A reference to the two most famous French tragediennes of the 19th century, Sarah Bernhardt (1844–1923) and Rachel (1820–1858), who had revived the classical drama.

saw absolutely marvelous canvases, signed chiefly Manet and Monet. But as I had other things to do in Paris besides looking at paintings—I was obliged, as secretary of the Stockholm library, to do research on an old Swedish missal at the Bibliothèque Ste.-Geneviève—I looked at this new painting with a calm indifference. But the next day I returned, without really knowing why, and I discovered "something" in these odd manifestations. I saw the swarming of the crowd on a pier, but I did not see the crowd itself; I saw the trajectory of a fast train in a Norman countryside, the movement of wheels in the street, terrible portraits of extremely ugly people who had been unable to pose calmly. Struck by these extraordinary canvases, I sent to a journal of my country a review in which I attempted to translate the sensations I believed the Impressionists had wanted to convey, and my article had a certain success as an incomprehensible item.

When I returned to Paris for the second time, in 1883, Manet was dead, but his spirit lived in a whole school that fought for hegemony with Bastien-Lepage; [70] during my third stay in Paris, in 1885, I saw the Manet exhibition. This movement had then imposed itself; it had produced its effect and now it was classified. At the triennial exhibition, same year, complete anarchy! All styles, all colors, all subjects: historic, mythological, and naturalist. People did not want to hear any more talk about schools or tendencies. Liberty was now the rallying cry. Taine had said that the beautiful was not the pretty and Zola that art was a bit of nature seen through a temperament.

However, in the midst of the last gasps of naturalism, one name was pronounced with admiration by all: that of Puvis de Chavannes. He was there all alone as a contradiction, painting with a believing soul, while lightly taking into consideration his contemporaries' taste for allusion. (They still didn't have the term "symbolism," an extremely unfortunate appellation for such an old thing: allegory.)

It was to Puvis de Chavannes that my thoughts turned last night, when, to the southern sounds of the mandolin and the guitar, I saw on the walls of your studio that confusion of sun-flooded paintings which pursued me this night in my sleep. I saw trees that no botanist would ever discover, animals that Cuvier [71] never suspected the existence of, and men that you alone have been able to create. A sea that might flow from a volcano, a sky in which no god could live. Monsieur (said I in my dream), you have created a new earth and a new heaven, but I am not happy in the midst of your creation; it is too sunny for me—I, who love

[70] Jules Bastien-Lepage (1848–1884), painter of idealized scenes of peasant life, especially those of his native valley of the Meuse.

[71] Georges Cuvier (1769–1832), famous French zoologist and paleontologist, who created the sciences of comparative anatomy and paleontology.

chiaroscuro. And in your paradise there lives an Eve who is not my ideal
—for really, I too have an ideal of womanhood or two!

This morning I went to visit the Luxembourg Museum to cast an
eye on Chavannes, who always came back to my mind. With a deep sym-
pathy, I contemplated the *Poor Fisherman*,[72] so attentively absorbed in
lying in wait for the prey that will earn him the faithful love of his wife
who is gathering flowers, and of his lazy child. That is beautiful! But
right away I run into the fisherman's crown of thorns. However, I hate
Christ and crowns of thorns. Monsieur, I hate them, do you understand!
I want nothing of that pitiable god who accepts the blows. My God,
rather the Vitsliputsli [73] who eats the heart of men in the sun.

No, Gauguin was not brought forth from the side of Chavannes,
nor from that of Manet or of Bastien-Lepage!

Then what is he? He is Gauguin, the savage who hates an encum-
bering civilization, a bit of the Titan who, jealous of the creator, in his
spare moments makes his own little creation, the child who takes apart
his toys to make others from them, he who abjures and who flaunts, pre-
ferring to see the sky red rather than blue with the crowd.

It seems indeed that since I have warmed myself up in writing, I
am beginning to have a certain understanding of Gauguin's art.

A modern author has been accused of not depicting real beings but
of *merely* constructing his characters himself. *Merely!*

Bon Voyage, *Maître;* but do come back to us and especially to me.
Perhaps by then I will have learned to understand your art better, and
this will allow me to write a real preface for a new catalogue in a new
Hôtel Drouot, for I too begin to feel an enormous need to become savage
and to create a new world.

AUGUST STRINDBERG.[74]

[PARIS, 5 FEBRUARY, 1895]

DEAR STRINDBERG,

I received your letter yesterday; your letter which is a preface for
my catalogue. The idea of asking you to write this preface occurred to
me when I saw you the other day in my studio playing the guitar and
singing: your Northern blue eyes studying the pictures hung on the
walls. I felt your revulsion: a clash between your civilization and my

[72] One of Puvis de Chavannes' most influential paintings (1881), which was copied
by Seurat in about 1882 and inspired Gauguin to do two variations of the same theme
in 1896.
[73] Vitsliputsli, Vitzilopuchtli, or Huitzilopochtli: ancient Aztec God of War, to
whom numerous human sacrifices were made.
[74] August Strindberg, Letter to Gauguin [Paris, February 1, 1895], in Catalogue,
*Vente de tableaux et dessins par Paul Gauguin, artiste peintre, Hôtel des Ventes, Salle
7, le lundi 18 février 1895,* pp. 3–6.

barbarism. . . . A civilization from which you are suffering: a barbarism which spells rejuvenation for me.

Studying the Eve of my choice, whom I have painted in forms and harmonies of a different world, she whom you elect to enthrone evokes perhaps melancholy reflections. The Eve of your civilized imagination makes nearly all of us misogynists: the Eve of primitive times who, in my studio, startles you now, may one day smile on you less bitterly. This world I am discovering, which may perhaps never find a Cuvier or a naturalist, is a Paradise the outlines of which I shall have merely sketched out. And between the sketch and the realization of the vision there is a long way to go. What matters! If we have a glimpse of happiness, what is it but a foretaste of *Nirvana?*

The Eve I have painted—and she alone—can remain naturally naked before us. Yours, in this simple state, could not move without a feeling of shame, and too beautiful, perhaps, would provoke misfortune and suffering.

To make clearer my ideas to you, I will not compare the two women themselves, but rather the languages they speak—the Maorie or Touranian language spoken by my Eve and the language spoken by your chosen woman, language with inflections, European language.

Everything is bare and primordial in the languages of Oceania, which contain the essential elements, preserved in their rugged forms, whether isolated or united, without regard for politeness.

Whereas in the inflected languages, the roots, from which—as in all languages—they spring, disappear in daily use which wears away their angles and their contours. They are like a perfected mosaic where one forgets the more or less skilful joining of the stones in admiration for the fine lapidary painting. Only an expert eye can detect the process of construction.

Excuse this long philological digression, which I deem necessary to explain the barbarian drawing which I had to employ to represent a Touranian country and people.

It remains for me, dear Strindberg, to thank you.

When shall we see each other again?

Today, as yesterday, with all my heart,

PAUL GAUGUIN.[75]

A Letter to Daniel de Monfreid

In this excerpt from a letter to his close friend and fellow artist, Georges-Daniel de Monfreid (1856–1929), Gauguin upholds the values

[75] Paul Gauguin, Letter to Strindberg [Paris, February 5, 1895], in Catalogue, *Vente de tableaux . . . 1895*, republished in *Paul Gauguin: Letters to his Wife and Friends*, pp. 197–198.

of suggestion, evocation, and stylization, in opposition to the pedantic naturalism then current in academic sculpture. Gauguin himself followed his own advice in his wood carvings and ceramics, where he looked toward primitive and non-Western sources for inspiration. Yet despite the fact that the painting, drawing, and sculpture executed after his arrival in the South Seas reveal his profound interest in Polynesian (and later, Melanesian) art and artifacts (which he collected and used to decorate his rooms), in his studio were to be found photographs of Greek and Roman reliefs, notably of the Parthenon frieze, as well as those of the sculptures of Barabudur in Java, statues of Buddha, of Egyptian wall painting, and of Manet's Olympia. *In other words, despite his decided opinions, Gauguin was an eclectic, in the modern sense of conceiving of art as a museum without walls; an artist who felt free to range through the widest possible variety of styles and sources to find nourishment for his own unique vision.*

OCTOBER 1897

. . . I see that you are in a productive mood; of sculpture! Admit that it is great fun and very easy or very hard; very easy when you look at *nature,* very hard when you want to express yourself a little mysteriously in parables, *to find forms:* what your friend, the little sculptor from the South, calls "deforming." Always keep in mind the *Persians,* the Cambodians, and a bit of the Egyptians; the big mistake is the Greek, no matter how beautiful it may seem. I am going to give you a little bit of practical help; you can do whatever you want with it: mix lots and lots of fine sand with your clay. This will create useful difficulties for you and then it will prevent you from seeing the surface, from falling into the atrocious affectations of the Beaux-Arts school. A clever thumb-stroke sleekly modeling the meeting of nostril and cheek—that's their ideal. Then, sculpture means bumps but never holes. The *human ear* must have a hole to hear, but that of God, never. He hears and sees, perceives without the aid of the senses, which are only there in order to be tangible to men; everything happens by means of fluid, through the soul. *Suggest that.*[76]

André Fontainas' Review of Gauguin's Works and the Artist's Reply

In January, 1899, an exhibition of Gauguin's works was organized by Daniel de Monfreid at Vollard's consisting mainly of the artist's recent Tahitian paintings, and including the monumental Where Do We

[76] Paul Gauguin, Letter to Georges-Daniel de Monfreid, October, 1897, *Lettres de Gauguin à Daniel de Monfreid* (Paris: Georges Falaize, 1950), p. 113. Reprinted by permission of the publisher, Editions Georges Fall, Paris.

Come From? What Are We? Where Are You Going?, *which Gauguin*
had started to paint as a grand, summarizing, last pictorial testament
before his attempted suicide in 1897. The critic André Fontainas (1865–
1948), although writing his review for the Symbolist publication Mercure
de France, *and obviously sympathetic toward Gauguin's efforts as a*
whole, nevertheless completely failed to grasp the import of the artist's
major work, complaining that the allegorical content lacked a clear
explanation.

Stimulated, perhaps, by the combination of sympathy and mis-
understanding embodied in the review, Gauguin, in a letter of March,
1899, undertook to reply to the critic with a lengthy explanation, not of
the subject of the work in question, but rather of his entire artistic out-
look and intention. The elliptical, evocative style of this letter, as well
as several references and a quotation, are attributable to the influence
of the Symbolist poet Stéphane Mallarmé (1842–1898), who, like Gau-
guin, had insisted upon the musical, suggestive qualities implicit in
words and phrases in much the same way that the painter does for line,
form, *and* color *in his art.*

Excerpt from Fontainas' Review

I do not like M. Paul Gauguin's painting very much. For a long
time I was repelled by it and spoke of it slightingly, perhaps a little
brusquely; I knew almost nothing about it. This time I examined with
care his few recent canvases now on exhibition at Vollard's gallery in the
rue Laffitte; and if my opinion of them has changed very little, at least
I have become aware of a new and growing respect, solid and profound,
for the serious, thoughtful, and sincere work of this painter. I have tried
to understand it; I believe I have grasped some of his motives and im-
pulses, I have caught myself discussing and criticizing them, becoming
enthusiastic over some while disregarding others. Yet even after this care-
ful study I have never been as moved or excited as I have been by certain
other painters. I have sought for the causes of my indifference and believe
I have found them.

I do not criticize M. Gauguin either for his drawing, so often dis-
paraged, or for his exoticism; I should be more apt to praise him for
them if, in truth, there were any need to do so. Indeed, what other anal-
ysis of drawing should one accept than that of Balzac in the *Chef d'oeuvre
inconnu:* "Line is the means by which the effect of light on an object
makes itself manifest. Form is . . . an instrument for the dissemination
of ideas, sensations; it is poetry. The mission of art is not to copy nature,
but to express it." Therefore I acknowledge M. Gauguin's right to ex-
press himself as he sees fit, on condition that he inspires in the mind of
the spectator sensations, ideas, anything at all that will produce a vision
similar to his own. In this respect, I admit, M. Gauguin is irreproachable.

He has created his own drawing even though it may resemble that of van Gogh or Cézanne; his aggressive drawing, new and precise in pattern, has a positive effect; indeed it would be impossible to find fault with it.

The same holds true for his exoticism. Everyone is at liberty to choose either a commonplace or an unusual setting, as he pleases. That in itself is of no importance. The essential—since I cannot see in these pictures an exact representation of scenes in Tahiti or in the Marquesas —is that the art of the painter must convey to us an image, true or false (that does not matter), of a tropic land, luxuriant and primitive, covered with gigantic dense jungle growth, a land of deep waters and violent contrasts of light and air, peopled by a dignified race, modest and unspoiled. That M. Gauguin should have abandoned the too artificial simplicity of Brittany for his oceanic mirages is yet another proof of his complete sincerity. Out there on his enchanted island he is no longer concerned with the absurd mania for playing at the restoration of the great archaic romance of Brittany, so tedious after all. He no longer needs to worry about his reputation among the literary aesthetes; he is alive in the midst of distant seas, and the pictures he sends to his friends from time to time continue to prove to us that he is working.

What impresses the beholder at once is the careful study of arrangement in his canvases, which are primarily decorative. The landscapes that compose their profound, subdued harmony are organized not so much for crude picturesque effect as for the purpose, almost always achieved, of creating warm, brooding wellsprings for the surging emotions. If the violent oppositions of such full and vibrant tones, which do not blend and never merge into one another through intermediate values, first distract and then rivet the attention, it must also be admitted that while they are often glowing, bold, and exultant they sometimes lose their effect by monotonous repetition; by the juxtaposition, irritating in the long run, of a startling red and a vibrant green, identical in value and intensity. And yet it is undoubtedly the landscape that satisfies and ever exalts one in M. Gauguin's painting. He has invented a new and broad method of painting landscapes by synthesis and, in the words that he himself wrote in the *Mercure de France,* by "seeking to express the harmony between human life and that of animals and plants in compositions in which I allowed the deep voice of the earth to play an important part."

At Vollard's, hanging not far from an extremely delicate landscape painted some years ago, in which figures at the water's edge are watching the reflection of the sun sparkling on the waves, there is a purely decorative picture conceived in this manner and, I believe, very characteristic of the artist's personality. In the midst of the somber blues and greens, noble animal and vegetable forms intermingle, composing a pure pattern. Nothing more; a perfect harmony of form and color.

There is also a landscape of varied yellows spread out like a delicate curtain of thin golden rain. Here and there the green of some strange leaf, the repeated detail of bright red berries. A man in a sarong reaches toward the low branches of a tree. All this—the light, the graceful effort of the gesture, the grouping of objects and colors—composes a simple and exquisite picture.

If only M. Gauguin were always like that! Or if he would paint as he does when he shows us ceremonial dancers lingering under the trees amidst thick undergrowth, or nude women bathing surrounded by gorgeous, strangely illuminated vegetation. But too often the people of his dreams, dry, colorless, and rigid, vaguely represent forms poorly conceived by an imagination untrained in metaphysics, of which the meaning is doubtful and the expression is arbitrary. Such canvases leave no impression but that of deplorable error, for abstractions are not communicated through concrete images unless, in the artist's own mind, they have already taken shape in some natural allegory which gives them life. That is the lesson taught by the noble example Puvis de Chavannes gives us through his art. To represent a philosophical ideal he creates harmonious groups of figures whose attitudes convey to us a dream analogous to his own. In the large picture exhibited by M. Gauguin, nothing —not even the two graceful and pensive figures standing so tranquilly and beautifully, or the masterful evocation of a mysterious idol—would reveal to us the meaning of the allegory, if he had not taken the trouble to write high up in a corner of the canvas: "Whence do we come? What are we? Where are we going?"

However, in spite of the outlandishness of these near-savages, to which one becomes accustomed, the interest is diverted from the naked woman crouched in the foreground and again becomes fixed wholly upon the charm of the setting in which the action takes place.

But if I point out the grace of a woman half-reclining on a sort of couch, magnificent and curious, in the open air, I prefer not to dwell on other paintings which show the persistent efforts of an obstinate innovator in all the wilfulness, slightly brutal, of his struggle.

In other respects M. Gauguin is without doubt an unusually gifted painter from whom the opportunity of displaying the vigorous energy of his temperament by the execution of an important decorative composition on the walls of a public edifice has been too long withheld. There we could see exactly what he is capable of doing, and if he would guard against a tendency toward abstraction, I am sure we would see powerful and truly harmonious creations produced by his hand.[77]

77 André Fontainas, Review of Vollard Exhibition, *Mercure de France,* January, 1899, cited in Paul Gauguin, *Letters to Ambroise Vollard and André Fontainas,* ed. John Rewald (San Francisco: Grabhorn Press, 1943), pp. 18–21.

Gauguin's Reply

Un grand sommeil noir
Tombe sur ma vie
Dormez, tout espoir
Dormez, toute envie.

VERLAINE [78]

TAHITI, MARCH 1899

MONSIEUR FONTAINAS,

In the January number of the *Mercure de France* you have two in-teresting articles, "Rembrandt" and "The Vollard Gallery." In the latter you mention me. In spite of your dislike you have tried to make an hon-est study of the art or rather the work of a painter who has no emotional effect upon you. A rare phenomenon among critics.

I have always felt that it was the duty of a painter never to answer criticisms, even hostile ones—especially hostile ones; nor flattering ones either because those are often dictated by friendship.

This time, without departing from my habitual reserve, I have an irresistible desire to write to you, a caprice if you will, and—like all emo-tional people—I am not good at resisting. Since this is merely a personal letter it is not a real answer but simply a chat on art; your article prompts and evokes it.

We painters, we who are condemned to penury, accept the material difficulties of life without complaining, but we suffer from them insofar as they constitute a hindrance to work. How much time we lose in seek-ing our daily bread! The most menial tasks, dilapidated studios, and a thousand other obstacles. All these create despondency, followed by im-potence, rage, violence. Such things do not concern you at all; I mention them only to convince both of us that you have good reason to point out numerous defects, violence, monotony of tone, clashing colors, etc. Yes, all these probably exist, do exist. Sometimes however they are inten-tional. Are not these repetitions of tones, these monotonous color har-monies (in the musical sense) analogous to oriental chants sung in a shrill voice, to the accompaniment of pulsating notes which intensify them by contrast? Beethoven uses them frequently (as I understand it) in the "Sonata Pathétique," for example. Delacroix too with his repeated harmonies of brown and dull violet, a somber cloak suggesting tragedy. You often go to the Louvre; with what I have said in mind, look closely at Cimabue. Think also of the musical role color will henceforth play in modern painting. Color, which is vibration just as music is, is able to attain what is most universal yet at the same time most elusive in nature: its inner force.

Here near my cabin, in complete silence, amid the intoxicating per-

[78] "A huge, dark sleep/ Falls upon my life/ Sleep, all hope/ Sleep, all desire."

fumes of nature, I dream of violent harmonies. A delight enhanced by I know not what sacred horror I divine in the infinite. An aroma of long-vanished joy that I breathe in the present. Animal figures rigid as statues, with something indescribably solemn and religious in the rhythm of their pose, in their strange immobility. In eyes that dream, the troubled surface of an unfathomable enigma.

Night is here. All is at rest. My eyes close in order to see without actually understanding the dream that flees before me in infinite space; and I experience the languorous sensation produced by the mournful procession of my hopes.

In praise of certain pictures that I considered unimportant you exclaim: "If only Gauguin were always like that!" But I don't want to be always like that.

"In the large panel that Gauguin exhibits there is nothing that explains the meaning of the allegory." Yes, there is: my dream is intangible, it comprises no allegory; as Mallarmé said, "It is a musical poem, it needs no libretto." Consequently the essence of a work, unsubstantial and out of reach, consists precisely of "that which is not expressed; it flows by implication from the lines without color or words; it is not a material structure." [79]

Standing before one of my pictures of Tahiti Mallarmé also remarked: "It is amazing that one can put so much mystery in so much brilliance."

To go back to the panel: the idol is there not as a literary symbol but as a statue, yet perhaps less of a statue than the animal figures, less animal also, combining my dream before my cabin with all nature, dominating our primitive soul, the unearthly consolation of our sufferings to the extent that they are vague and incomprehensible before the mystery of our origin and of our future.

And all this sings with sadness in my soul and in my design while I paint and dream at the same time with no tangible allegory within my reach—due perhaps to a lack of literary education.

Awakening with my work finished, I ask myself: "Whence do we come? What are we? Where are we going?" A thought which has no longer anything to do with the canvas, expressed in words quite apart on the wall which surrounds it. Not a title but a signature.

You see, although I understand very well the value of words—abstract and concrete—in the dictionary, I no longer grasp them in paint-

[79] Mallarmé had stated in an essay of about 1886: "I say: a flower! and, out of the oblivion into which my voice relegates all contour, there musically arises something other than the known calyxes, the idea itself, and fragrant, the flower absent from all bouquets." "Crise de vers," *Oeuvres complètes* (Paris: Gallimard [Bibliothèque de la Pléiade], 1945), p. 360. Gauguin paraphrases this statement even more closely in *Noa Noa*, when, in discussing the relationship between the artist and nature, he says: "a flower does not consist only in *what one sees of it*, in its evident, immediate aspect: it is above all in that part *of it that one does not see. . . ."* Paul Gauguin, *Noa Noa* (Paris: Les Editions G. Crès et Cie, 1924), p. 21.

ing. I have tried to interpret my vision in an appropritae décor without recourse to literary means and with all the simplicity the medium permits: a difficult job. You may say that I have failed, but do not reproach me for having tried, nor should you advise me to change my goal, to dally with other ideas already accepted, consecrated. Puvis de Chavannes is the perfect example. Of course Puvis overwhelms me with his talent and experience, which I lack; I admire him as much as you do and more, but for entirely different reasons (and—don't be annoyed—with more understanding). Each of us belongs to his own period.

The government is right not to give me an order for a decoration for a public building which might clash with the ideas of the majority, and it would be even more reprehensible for me to accept it, since I should have no alternative but to cheat or lie to myself.

At my exhibition at Durand-Ruel's [80] a young man who didn't understand my pictures asked Degas to explain them to him. Smiling, he recited a fable by La Fontaine. "You see," he said, "Gauguin is the thin wolf without the collar." [81]

After fifteen years of struggle we are beginning to free ourselves from the influence of the Academy, from all this confusion of formulas apart from which there has been no hope of salvation, honor, or money: drawing, color, composition, sincerity in the presence of nature, and so on. Only yesterday some mathematician (Charles Henry) [82] tried to prove to us that we should use unchangeable light and color.

Now the danger is past. Yes, we are free, and yet I see still another danger flickering on the horizon; I want to discuss it with you. This long and boring letter has been written with only that in view. Criticism of today, when it is serious, intelligent, full of good intentions, tends to impose on us a method of thinking and dreaming which might become another bondage. Preoccupied with what concerns it particularly, its own field, literature, it will lose sight of what concerns us, painting. If that is true, I shall be impertinent enough to quote Mallarmé: "A critic is someone who meddles with something that is none of his business."

In his memory will you permit me to offer you this sketch of him, hastily dashed off, a vague recollection of a beautiful and beloved face, radiant even in the shadows. Not a gift but an appeal for the indulgence I need for my foolishness and violence.

Very cordially,

PAUL GAUGUIN.[83]

[80] In 1893.

[81] That is, he prefers liberty with starvation to servitude with abundance.

[82] Charles Henry, many-sided art theoretician, chemist, physicist, and psychologist, whose ideas strongly influenced Seurat and the Neo-Impressionists.

[83] Paul Gauguin, Letter to André Fontainas, Tahiti, March, 1899, *Letters to Ambroise Vollard and André Fontainas,* pp. 21–24.

THE NABIS

In the early autumn of 1888, Gauguin offered to give an out-of-doors art lesson to a young painter who was passing the summer at Gloanec's boardinghouse at Pont-Aven, taking him for this purpose to the Bois d'Amour.

"How do you see those trees?" the older artist asked.

"Yellow."

"Well then, make them your most beautiful yellow.

"How do you see the earth?"

"Red."

"Use your best red. . . ." [84]

In this way was the young Paul Sérusier (1865–1927) initiated into the mysteries of Synthetism, creating a work in which the direct impression of nature was submitted to intellectual choice, decorative arrangement, and simplification of forms and colors. This little painting, created under Gauguin's direct supervision and later dubbed "The Talisman" by Sérusier himself, was really the concrete stimulus to the founding of the quasi-mystical, hermetic, secret society known as "The Nabis" ("nabi" meaning "prophet" in Hebrew), a name bestowed upon the group by Sérusier, who had a pronounced taste not only for art, but for philosophy and oriental languages as well. This circle of young artists, violently anti-naturalistic, anti-bourgeois, and completely dedicated to the creation of Art with a capital "A"—an art at once intellectual, decorative, and mystical—flourished from about 1888 to 1900. Its members included Sérusier (known to his fellow initiates as "the Nabi with the Fiery Beard"), Maurice Denis (1870–1943), "the Nabi with the Beautiful Icons," Paul Ranson (1864–1909), Georges Lacombe (1868–1916), Ker-Xavier Roussel (1867–1944), Félix Vallotton (1865–1925), Jean Verkade (1868–1946), Edouard Vuillard (1868–1940), and Pierre Bonnard (1867–1947). These young artists, of varying backgrounds and beliefs, formed themselves into a confraternity, vaguely oriental in flavor, with secret passwords (they signed all their letters "E.T.P.M.V.E.M.P.": "En ta paume, mon verbe et ma pensée"), a special vocabulary, weekly meetings at the "Temple" (Paul Ranson's studio), and famous monthly banquets, at which the speaker of the moment had to hold a decorative wooden cross while giving voice to such thoughts as ". . . sounds, colors, words have a miraculously expressive power, aside from all representation. . . ." They admired ancient ceremonies, the images of Epinal, stained-glass windows, Breton calvaries, fairy tales, and folk legends, as well as Cézanne, van Gogh, Gauguin, and Puvis de Chavannes among the artists

[84] Recounted by Agnès Humbert, *Les Nabis et leur époque: 1888–1900* (Geneva: Editions Pierre Cailler, 1954), p. 30. Reprinted by permission of the publisher.

of their time. They gave avant-garde puppet shows and collaborated with Lugné-Poe in creating sets, costumes, and programs for his experimental Théâtre de l'Oeuvre; in poetry, Verlaine and Mallarmé were their gods. While the individual styles of members of the group varied, their work was generally characterized by its flat, decorative, abstract quality and its emphatic and often sinuous outline, allying the group with the "art nouveau" direction of the turn of the century. Also characteristic, and reminiscent of another, earlier confrérie of idealistic young artists, the Pre-Raphaelites, the Nabis insisted upon the virtues of craftsmanship and experimented with the minor arts: they created not only puppets, theater sets, and costumes, but posters, wood-carvings, tapestries, and decorative screens.

Paul Sérusier: 1865–1927

A Letter to Maurice Denis from Le Pouldu, 1889

Paul Sérusier, certainly one of the animating spirits of the group whose name he had chosen, was charming, intelligent, well educated, an admirer of Plotinus, a student of Hebrew and Arabic, a dabbler in theosophy and oriental mysticism, although a devout and practicing Catholic. He had really created "The Nabis" when, in an atmosphere of conspiratorial secrecy, he revealed his "talisman" to some of his closest friends at the Académie Julian. He passed the summer of 1889 in the closest—if not always the friendliest—contact with Gauguin, sharing a room with him at Le Pouldu for a time, and writing, on the whitewashed wall, Richard Wagner's credo, adopted by the Nabis: "I believe in a last judgment where all those who in this world have dared to traffic in sublime and chaste art, all those who have dirtied and degraded it by the lowness of their feelings, by their vile covetousness, by material pleasures, will be condemned to terrible punishment. . . ."

POULDU [1889]

BROTHER NABI,

To a philosophical letter, ditto reply. I know some people that this would annoy, but you are not one of them.

First of all, forgive me the incoherence of my last letter, begun in a moment of bitterness and disgust and finished in a period of unreasonable relief. I am sorry for what I said to you about Gauguin; [85] he is not at all a practical joker, at least for those whom he knows are capable of understanding him. For two weeks, I have been living with him in the deepest intimacy; we share the same room. I have talked with him about

[85] In a letter from Pont-Aven, dated "Jour de Venus," 1889, Sérusier had accused Gauguin's works of "lack of delicacy, illogical affectation of drawing, puerility, a search for originality carried to the point of practical joking."

what had displeased me in his work; these elements were due to a few fits of contradiction, customary to modern painting.[86]

Let us return to our philosophy. I do not want to establish a formula for art. Let us subdivide and analyze:

PAINTING

I.—Art	*II.*—Craft
a) immutable principles *b)* personality	*a')* science *b')* skill

a) There exist immutable principles in art. There is a science, called aesthetics, which teaches them. This science is dead today. In the time of the blessed primitives it existed, if not in writing, at least in tradition (in Japan as well). To assure oneself of this, it suffices to see the impeccable harmony of lines and colors in their works. These principles, slowly forogtten, were rediscovered either as a whole or in part by a few exceptional geniuses like Rembrandt, Velasquez, etc., Delacroix, Corot, Manet. These principles can be deduced from principles innate within us, ideas of harmony common to all unspoiled men. They can be discovered through induction, by observing the points common to all the very different masters of every age and country: these are the laws of Harmony in line and color.

b) Personality—I respect it: it is something abstract. Given a certain quantity of lines and colors forming a harmony, there are infinite ways of arranging them. The literary aspect, in painting, is a secondary part of the personality; it can exist, it *should* exist, but only as a starting point; if it dominates, one falls into illustration. As you see, I don't want to tie down the personality with rules. Harmony is the variety that we bestow upon unity. Lacking individual personality, one can create beautiful things with the personality of a race or country; for example, Gothic cathedrals, Egyptian art.

a') Science, although not absolutely necessary, never hurts. It prevents blind groping, but one must be very careful not to confuse it with *b')* skill. The first can be taught; the second should not be: it should even be repressed. In order to express the work of art, a system of signs, a handwriting is necessary; but calligraphy is useless to literary man. The same thing necessarily happens in the case of the skillfulness of the hand as in that of Handwriting: if one pays no special attention to it, it will become so much the more personal as it is maladroit.

To summarize: *a)* and *a')* should be learned; formulas should be established for them; *b)* remains absolutely free, and *b')* one shouldn't bother with. The more *a)* and *a')* are exactly established, the more *b)* will have freedom of action.

[86] Between 1888 and 1890, the ideas of Gauguin were spread through Sérusier, although he enriched them with a deep mysticism.

I don't know if I am being very clear: I need a heavy volume to express my idea, with examples to support it; we will talk about it again. In today's painting, *a)* and *a')* do not exist, *b)* is a slave, and *b')* shines with all its brilliance: it is art in reverse; we will discuss all this this winter. . . .

Goodbye, brother, I am very glad to chat with you from time to time.

P. SÉRUSIER.[87]

THE ABC OF PAINTING

Although it was not published until 1921, Paul Sérusier's "Alphabet of Art" nevertheless embodies many of the ideas animating the Nabis in the decade of the 1890s: their anti-naturalistic bias, their emphasis on the plane surface, their insistence on the basically intellectual quality of the work of art.

A

ART AND NATURE

Nature is the totality of objects our senses reveal to us.

Since it is impossible for us to invent forms and colors, we will have recourse to those provided us by the sense of sight.

If art were reduced to imitating, by reproducing the images that we perceive on a screen, then we would only be producing a mechanical action, in which none of man's higher faculties would participate; that would be *the impression* noted with nothing added to it, a work without intelligence. Nature thus understood is no longer painting. Let us analyze, in actuality, the formation of a visual sensation.

The normally constructed man has two eyes, each one of which transmits an image to the brain, and these two images are different.

One must choose one of them and suppress the other. Instead of that, the mind constructs a third image, deducing it from the two others, which contains, in addition, the spatial localization, or relief.

Given the planar form of the painted work, it becomes necessary either to represent this relief [three-dimensionality] or to suppress it. In both cases, a simplification of the image will permit us to inscribe it on a plane surface: a new modification of the image, a deliberate modification in view of adaptation.

The sensation that the object gives us evokes notions previously acquired and stored up by the memory. Most important is the concept

[87] Paul Sérusier, Letter to Maurice Denis, Le Pouldu [1889], in *ABC de la peinture, suivi d'une correspondance inédite,* ed. Mme. P. Sérusier and Mlle. H. Boutaric (Paris: Librairie Floury, 1950), pp. 42–45.

of the object that is the result of a generalization. After having recognized and named the object, the mind works; it uses the experiences previously furnished by the other senses: form, situation in space, weight, mobility or repose, use, etc.

To these "givens" are added personal feelings: love or repulsion (beauty or ugliness).

To all these factors that modify the image is added the psychological and physiological state of the subject, which varies at each instant (sensitivity).

MENTAL IMAGE

All these coefficients have acted upon the sensation to the point of transforming it into an image that we call a *mental image*.

We are far from the primitive visual image, which no longer has anything but an effaced role.

The signs that translate love or beauty are the constructive elements of the work of art.

BEAUTY

Beauty is the love that we devote to an object, setting aside all idea of utilization for our profit, the love inspired by an aspect that satisfies our visual organs and our intelligence at the same time, because it actualizes the arrangement we desire for our greatest happiness: harmony.

HARMONY

Harmony is an arrangement of sensations such that we will not want it otherwise. It satisfies at the same time our senses, whose functioning it facilitates, and our mind, which finds in it submission to the same laws that direct itself. . . .

STYLE

Style is the totality of preferred forms that serve to construct the work, as words and turns of phrase are used in constructing a literary work. The totality of words and their relations constitute a language.

"The style is the man." Each individual has his personal style in conformity with his tastes, his intellectual culture, and his type of life. Style can be modified temporarily by psychological and physiological states.

During materialist epochs, a great deal of importance has been attached to the physiological causes summed up in the word "temperament," [88] which was supposed to explain everything, since all psychic influence was deliberately discounted. . . .

[88] Emile Zola, in an article of 1872, had defined a good work of art as "a bit of nature seen through a temperament."

B

COMPOSITION

To compose is to juxtapose forms on a given or chosen surface. These forms are necessarily borrowed from our sensations, or better, from the *mental images* they give rise to.

MODELS

To facilitate the formation of the mental image, we can repeat the sensation by the study of the model, but this means is only possible for immobile objects within a constant illumination.

To immobilize a living, thinking being is an act against nature.

Now thoughts and moral qualities can only be represented by formal equivalents. It is the ability to perceive these correspondences that makes the artist. All men possess this faculty in potentiality from the day of their birth; one's personal effort develops it; a bad education can annihilate it.

COPYING

The work of copying exercises the eye and the hand, but it fatally weakens the ability of which I spoke, and above all, the memory of forms upon which it reposes.

It matters little whether the mental image is more or less in conformity with ordinary vision.

The choice of objects whose forms we use reveals our tastes and preferences; it contributes to our style.

To make an intelligent drawing, we must use nothing but elements about which we can think. If the hand or the eye get ahead of the thought, we create mere stylishness. If we use indefinite curves, we get lost in the ocean of variations.

The straight line is the spiritual line, since it is never found in nature, whereas man tends to put it in all his works.[89]

Maurice Denis: 1870–1943: A Definition of Neo-Traditionism

The following article, first published in Art et critique *in August, 1890, under the pseudonym "Pierre Louis," when its author was not yet twenty (republished in Denis' Théories in 1912), might more aptly have been entitled "A Definition of Symbolism." The young Denis, a paradoxical mixture of mysticism and clear-headedness, who combined a boundless admiration for Cézanne (about whom he wrote an important article in 1907, in addition to painting, in 1901, the famous Hommage à Cézanne) with an insistence upon the strictly Christian function of art, here expresses, with all the arrogance of youth, his scorn for the "relativism" of the naturalist outlook. His contempt for naturalism, shared by his*

[89] Paul Sérusier, *ABC de la peinture,* pp. 7–11, 22–24.

fellow Nabis, is embodied in their reply to the admonition then current in the studios: "A painter should be stupid," to which the young dissidents, taking their lead from Gauguin, retorted: "A painter must be intelligent."

The opening paragraph of this article is a prophetic anticipation of the concepts underlying the abstract art movements of the 20th century.

I

Remember that a painting—before it is a battlehorse, a nude woman, or some anecdote—is essentially a flat surface covered with colors assembled in a certain order.

II

I am looking for a *painter's* definition of that simple word "nature," which labels and summarizes the most generally accepted art theory of this waning century.

It most probably means: the totality of optical sensations. But even if we leave aside the natural disturbances of the modern eye, who is not aware of the power of mental habits on vision? I have known young men who devote themselves to exhausting gymnastics of the optic nerve, in order to see the *trompe l'oeil* in *The Poor Fisherman;* [90] and they manage to do so, I am certain. M. Signac will prove to you, with irreproachable scientific means, that his chromatic perceptions are completely necessary. And M. Bouguereau,[91] if the corrections he makes when teaching are sincere, is absolutely persuaded that he is copying "nature."

III

Go to the museum, and consider each canvas separately, isolating yourself from the others: each one will give you, if not a complete illusion, at least a would-be-truthful view of nature. In each painting you will see what you want to see there.

If, however, through an effort of will, one happens to see "nature" in paintings, the opposite is true. There is an inevitable tendency among painters to assimilate the appearance perceived in reality to the appearances in paintings already seen.

It is impossible to determine everything that can modify modern vision, but there is no doubt that the turmoil of intellectualism that most young artists pass through results in the creation of very real optical anomalies. One sees certain grays as violets very easily if one has been trying to find out for a long time whether or not they are violet.

The unreasoning admiration for old paintings in which one

[90] A painting by Puvis de Chavannes.
[91] W. Bouguereau (1825–1905), a very successful academic painter and teacher.

searches for conscientious renderings of "nature" . . . has certainly deformed the eyes of the masters of the Ecole.

Other disturbances arise from the admiration of modern paintings which are studied in the same spirit, with infatuation. Has anyone noticed that this indefinable "nature" is perpetually modified, that it's not the same in the Salon of '90 as in the Salons of thirty years ago, and there is a fashionable "nature"—a whim changing like dresses or hats?

IV

In this way, through choice and synthesis, there arises in the modern artist a certain eclectic and exclusive way of interpreting optical sensations, which becomes the naturalist criterion, the individual identity of the painter, what literary men later call the temperament. It is a type of hallucination with which aesthetics has nothing to do, since reason depends on it rather than controls it.

V

When one says that nature is beautiful, more beautiful than any painting, while claiming to remain within the rules of aesthetic judgment, what one means is: that one's own impressions of nature are better than those of others, and this had better be admitted. But if one wants to compare the hypothetical—and dreamed-of!—richness of the original effect and the notation of this effect by such and such a consciousness? At this point arises the big question of temperament: "Art is nature seen through a temperament." [92]

This is a definition which is very equitable because it is very vague, and which leaves the important point uncertain: the criterion of temperaments. The painting of M. Bouguereau is nature seen through a temperament. M. Raffaëlli [93] is an extraordinary observer—but sensitive to beautiful forms and colors, do you think? Where does the painterly temperament begin and end?

There is a branch of knowledge—is it familiar?—which concerns itself with these things: aesthetics, which is in the process of clarifying itself and rests, thanks to the experimental research of Charles Henry,[94] upon the psychology of the Spencers and the Bains.[95]

Before externalizing one's sensations as such, their value must be determined from the standpoint of beauty.

[92] See n. 88 above.

[93] M. Raffaëlli (1850–1924), a protégé of Degas who contributed works executed in a diluted impressionistic style to the later Impressionist Exhibitions.

[94] See above, note 82.

[95] Both Herbert Spencer (1820–1903) and Alexander Bain (1818–1903) were early advocates of a system of psychology which explains phenomena in terms of a materialistic science freed from metaphysics.

VI

I don't know why painters have so misunderstood the epithet "naturalist" applied, in the philosophic sense only, to the Renaissance.

I affirm that Angelico's *Predellas* at the Louvre, Ghirlandaio's *Man in Red,* and a number of other works by the Primitives recall "nature" to me more exactly than Giorgione, Raphael, da Vinci. It is a different way of seeing—they are different imaginations.

VII

And then everything changes in our sensations, object and subject. You really have to be a good student to find the same model on the table two days in succession. There is the life, the intensity of coloring, the light, the mobility of the air, a multitude of things one cannot express. Here, I come to well known themes, very true ones, besides, and such obvious ones! . . .

IX

"Be sincere; all that is necessary is to be sincere to paint well. Be naïve. Paint what you see stupidly."

The good, infallible machines of vigorous precision that the academies have wanted to manufacture! . . .

XVIII

This age is literary to the marrow; it refines minutiae, is avid for complexity. Do you think Botticelli would have wanted us to see sickly delicacy or sentimental preciosity in his *Primavera?* Then work with this spitefulness, this hidden motive, you will end up with such formulas!

In all periods of decadence, the plastic arts fall apart into literary and naturalistic affectations. . . .

XX

All the sentiment of the work of art comes unconsciously, or almost so, from the state of the artist's soul: "He who wants to paint the story of Christ must live with Christ," said Fra Angelico. This is a truism.

Let us proceed to analysis: is Chavanne's Sorbonne hemicycle,[96] which necessitates a written explanation for the vulgar, literary? Certainly not, for the explanation is false: the Baccalaureate examiners may know that such and such a lovely form of an ephebe, languishing before an appearance of water, symbolizes studious youth. It is a beautiful form, aesthetes, isn't it? And the depth of our emotion comes from the ability of these lines and colors to explain themselves, as alone beautiful and divine with beauty. . . .

[96] A complex, traditional allegorical painting.

. . . Our . . . impression of moral order opposite the *Calvary* or the bas-relief, *Be in Love*,[97] cannot spring from the motif or motifs of nature represented, but from the representation itself, forms and coloring.

It is from the canvas itself, a plane surface coated with colors, that the emotion surges, bitter or consoling, "literary," as the painters say, without reliance upon the memory of another, previous sensation, as would be the case with a motif derived from nature.

A Byzantine Christ is a symbol; the Jesus of modern painters, though he wear the most authentic turban, is merely literary. In the one it is the form which is expressive; in the other, it is the imitation of nature which tries to be so. . . .

XXII

And this is the only form of Art, the true one. When one has eliminated unjustifiable partiality and illogical prejudice, the field remains free for the imagination of painters, to the aesthetes of beautiful appearances.

Neo-traditionism cannot linger with learned, feverish psychologies, with literary sentimentality, calling on legend, everything which is not its emotional domain.

It is arriving at definitive syntheses. Everything is contained in the beauty of the work. . . .

XXIV

Art is the sanctification of nature, of that nature of all who are content to live! The great art, called decorative, of the Hindus, the Assyrians, the Egyptians, the Greeks, the art of the Middle Ages and the Renaissance, and those works of modern art which are decidedly superior: what are they if not the transformation of vulgar sensations—of natural objects—into sacred, hermetic, imposing icons?

The hieratic simplicity of the Buddhas? Monks, transformed by the aesthetic sense of a religious race. Or compare the lion in nature to the lions of Khorsabad, which demands a genuflexion? The *Doryphoros,* the *Diadoumenos,* the *Achilles,* the *Venus de Milo,* the [*Victory of*] *Samothrace,* all are in actuality a redemption of the human form. Must one speak of the saints of the Middle Ages? Must one mention the Prophets of Michelangelo and the Women of da Vinci?

I have seen the Italian, Pignatelli, from whom Rodin drew John the Baptist and instead of the banal model, the apparition of the Voice that walks, the venerable bronze. And the man whom Puvis raised into being the poor fisherman, eternally sad—who was that?

97 References to two works by Paul Gauguin: the painting, *The Cavalry—Green Christ* (1889), and the painted wood relief, *Be in Love and You'll Be Happy* (1890).

Universal triumph of the imagination of aesthetes over the efforts of foolish imitation, triumph of the emotion of the beautiful over the naturalist lie. . . .

XXV

. . . Once more I see the *Gioconda:* what voluptuousness in that happy convention which has chased away the false and annoying life of the waxwork figure that others seek after! and the light! and the air! The blue arabesques of the background—a powerful accompaniment of the orange motif, with an overwhelming and caressing rhythm like the charm of the violins in the overture to Tannhäuser. . . .[98]

ODILON REDON: 1840–1916

The art of Odilon Redon was the product of a visionary sensibility that seemed to evolve in isolation from the main artistic currents of his time, although his mysterious, evocative works show the strongest affinities to those of the Symbolist movement. Growing up in seclusion on the family estate at Peyrelebade, near Bordeaux, the sensitive, sickly youth was deeply affected by music, poetry, fairy tales, and the sights and sounds of the dry, savage countryside around him. An early encounter with the work of Delacroix, drawing lessons with a local artist, and a close friendship with the botanist Armand Clavaud, who initiated Redon into Hindu poetry and the writing of such controversial contemporary authors as Flaubert, Poe, and Baudelaire, and also introduced him to botany, that mysterious, almost imperceptible realm hidden in the heart of nature itself, "that intermediate state between animal and plant life, of flower or being . . ."[99]—all these had effects upon Redon's artistic evolution. Study with an architect, with a sculptor, and with the eccentric, fantastic graphic artist Rodolphe Bresdin (1822–1885), as well as a brief subjection to academic discipline under Gérôme, at the Ecole des Beaux-Arts, all made their impact on the young artist; but it was not until after the Franco-Prussian War that Redon really found his own style, a style capable, in the words of one critic, of interlocking intimately, in his mind and work, reality felt *and reality* observed, *the latter often in its smallest, most casual, and most humble manifestations. "It is only," said Redon, "after making an effort of will to represent with minute care a grass blade, a stone, a branch, the face of an old wall, that I am over-*

[98] Maurice Denis, *Théories: 1890–1910*, 3rd ed. (Paris: Bibliothèque de l'Occident, 1912), pp. 1–4, 8–10, 11, 12–13.

[99] Odilon Redon, "Confidences d'artiste," May, 1909, cited by John Rewald, *Odilon Redon, Gustave Moreau, Rodolphe Bresdin* (New York: Museum of Modern Art, 1961), p. 12. Reprinted by permission of the Museum of Modern Art, New York.

come by the irresistible urge to create something imaginary." [100] *His pre-ferred means of expressing his imaginative, often fantastic visions, were the "blacks": charcoal drawing and, later, lithography, in which he cre-ated some of his most significant masterpieces—albums such as* To Edgar Poe, The Origins, Homage to Goya, The Night, *and the series inspired by Flaubert's* Temptation of St. Anthony. *Still later, Redon turned to color—iridescent, lyrical, and evocative—creating portraits, flower pieces, and vaguely mythological compositions in pastel and oil.*

Always rather aloof from the major movements of his time, Redon nevertheless came to be deeply revered by a small but significant group of artists, critics, and literary figures, including Stéphane Mallarmé, Huysmans, Maurice Denis, and the Nabis (Denis said of Redon: "He was our Mallarmé" and gave him the place of honor in his group-por-trait, Homage to Cézanne), *Octave Mirbeau, and, later, Henri Matisse. Redon participated in the founding of the* Society of Independent Artists *in 1884, exhibiting with them in 1884, 1886, and 1887, and became a charter member of the advanced* Salon d'Automne *in 1904.*

"To Myself: Journal (1867–1915)"

Redon was not only a gifted artist, but a brilliant, perceptive, and original writer as well, as is revealed in the pages of the diary that he kept for forty-eight years, and which was first published in 1922 under the title A soi-même. *Here he deals with a wide range of aesthetic, moral, and philosophical topics in an intensely personal manner.*

Confessions of an Artist, May, 1909

I have made an art of my own. I have created it with my eyes open to the wonders of the visible world and, no matter what has been said, with a constant effort to obey the laws of the natural and those of life.

I have created it as well with the love of a few masters who have led me to the cult of beauty. Art is the *Supreme Possibility,* elevated, salutary, and sacred; it brings things to birth. For the dilettante, it pro-duces nothing but mere delightful delectation, but for the artist, with anguish, it creates new seed for the new sowing. I think I have surren-dered docilely to the secret laws that led me to fashion—as well as I could, given the nature of my ability and of my dream—the things in which I completely immersed myself. If this art has run counter to the art of others (which I don't believe), it has, however, created a lasting public for me, and even valuable, helpful friendships, sweet and bene-ficial. . . .

In short, so far as I was able, I taught myself; because amid all the

[100] Odilon Redon, cited by Rewald, *Odilon Redon,* p. 23.

varied instruction I was attempting to receive, I never found a system that would have suited me.

For a year I made sculptures in the private studio of a teacher in Bordeaux. I handled that exquisite substance, so smooth and supple, called potter's clay, copying fragments of antique statues.

At this point, at the so-called School of Fine Arts, in Gérôme's studio, I made an enormous effort to apply myself to the rendering of forms. The effort was a futile one, and had not the slightest effect on my later work. Today I can admit, having given thought to the development of my powers and faculties over my whole life, that I went to the Academy moved by a sincere desire to follow in the footsteps of other painters: to be a pupil as they had been. I expected approbation and justice. But I had reckoned without the form of art I was destined to follow; and without my own temperament too. The teacher tortured me. Whether he recognized that my desire to study was serious and sincere, or whether he saw in me a defenseless and willing victim, I do not know, but it was obvious that he was trying to inculcate in me his own way of seeing things, to make me his disciple—unless, of course, he was trying to destroy my passion for art itself. He overworked me; he was strict; and his criticisms were so savage that the whole classroom became charged with emotion as soon as he came anywhere near my easel. But all to no effect.

He exhorted me to enclose within a contour a form that I myself saw as quivering. Under the pretext of simplification (yet why?), he made me close my eyes to the light and neglect the vision of substances. I have never been able to keep away from these latter. I have a feeling only for the shadows, and the apparent depths; all contours are without doubt abstractions. The teaching I received did not suit my nature. The professor had the most complete, the darkest ignorance of my natural gifts. He did not understand me at all; his obstinate eyes were shut to the things I saw. Two thousand years of evolution or of transformation in the understanding of optics are almost nothing beside the difference created by our two opposing souls. There I was, young, sensitive, and inevitably of my times, having to listen to goodness knows what rhetoric, springing from works of a certain past. This professor forcefully drew a stone, a column-shaft, a table, a chair, an inanimate accessory, a rock—all inorganic nature. His pupil saw nothing but the expression, the expansion of feeling triumphing over forms. A link between the two: impossible; union: impossible; submission, which would have led the pupil to sainthood, was impossible. . . .

As a beginner, I aimed always at perfection, and, believe it or not, at perfection of form. But let me tell you now that you will be unable to find anywhere in my work a single conventionally modeled form. By which I mean a form perceived objectively, for itself alone, according to the rules of light and shade, and the conventional system of perspective.

At the very most it can be said that, because one should always try to master everything, I did often try at first to reproduce visible objects according to these old-fashioned recipes; but I did so only as an exercise. Today, in my conscious maturity, I insist that my art is limited to the effects of *chiaroscuro* alone. The only supplementary aid I employ, admittedly a powerful one, is the abstract line, that medium that comes from so deep within, and acts so directly on the mind. The art of suggestion can produce nothing that is not derived solely from the mysterious play of shadows, or from the rhythm of lines conceived in the mind. And where did these elements ever achieve a greater potency than in the works of Leonardo da Vinci? For it is to them he owes his mystery, and the fertility of the enchantment he casts over our minds. They are the root-words of the language he speaks. And yet it is also by his perfection, his excellence, his reason, and his humble submission to the laws of Nature that this marvelous and sovereign genius rules over the whole art of forms. He rules form because he penetrates its essence. "Nature abounds in an infinity of causes that never existed in experience," he wrote. This was for him, as doubtless for all the great masters, the manifest necessity, the final axiom. What painter could think otherwise. . . .

The art of suggestion is like an irradiation of the world by dreams from which thought has not been excluded. Decadence or not, that is how it is. Or let us say, rather, that it is a growth, an evolution of art toward the ultimate liberation of our lives, a development that will enable us to achieve our ultimate possibilities of expansion and open up to us the highest realms of moral being, providing us with that exaltation of spirit which is our deepest need.

This art of suggestion exists more freely, more radiantly in the excitations of music, where it reaches its fullest power. But, by transposing and changing forms, by combining diverse elements and creating wholes that have an organic logic of their own, although they do not obey the laws of the naturalistic world, I have made this art mine too. All the mistakes the critics made about my work in the beginning were the result of their inability to see that it was useless to define, to understand, to limit, to outline anything, because anything that is sincerely and simply new contains—like beauty itself—its own meaning within itself.

To designate my drawings by titles is sometimes to invite people to misunderstand them. The titles can be justified only if they are vague, indeterminate, and suggestive, even at the risk of confusion, of ambiguity. My drawings are not intended to define anything: they *inspire*. They make no statements and set no limits. They lead, like music, into an ambiguous world where there is no cause and no effect.

Remy de Gourmont,[101] who sets them apart from all geometric art,

[101] Remy de Gourmont (1858–1915), a Symbolist literary critic.

says they are a sort of *metaphor*. He sees only an imaginative logic in them. And in my opinion, this critic has said in a few lines more than all the pages written about my early works put together.

Suppose that you see before you arabesques and meandering lines, playing not over a surface but in space, with all the freedom for the mind that the limitless margins of the sky would provide. Suppose you see the play of these lines projected thus, and combined with other assorted elements, including a human face. If the face is as idiosyncratic in feature as the ones we see every day in the street, with its accidental truth made immediate and quite real, then you have before you the usual composition of many of my drawings.

They are, then, since I can attempt no more precise explanation, the repercussions of a human expression, placed, by a permissible fantasy, in a play of arabesques. And my intention is to excite, by these means, imaginative fictions in the spirit of the beholder, fictions that will be charged with a significance exactly commensurate with each spectator's sensibility and with his imaginative aptitude to enlarge things or to diminish them.

And, moreover, everything derives from universal life: a painter who would not draw a wall vertically would draw badly because he would be diverting the mind from the idea of stability. He who would not make the water horizontal would be doing the same thing, to cite only a few very simple examples. But there exist in vegetative nature secret and normal tendencies of life that a sensitive landscapist must not disregard: a tree trunk, with its forceful character, thrusts out its branches in accordance with the laws of expansion and of its sap, which a true artist should feel and represent.

There is a way of drawing which the imagination has freed from the encumbrances of naturalistic particularities, so that it can apply itself freely to the representation of imagined things. I have produced several fantasies with the stalk of a flower, or with a human face, or again with elements taken from bone structures, that, as I believe, are drawn, put together, built, exactly as they had to be. They are as they are because they have an organism. Whenever a human figure cannot give the illusion that it is about to leave the frame, so to speak, and begin to walk, or act, or think, then it is not a truly modern drawing. My whole originality consists, then, in making unbelievable things live in our human world according to the rules of the believable. This I accomplish by putting the logic of the visible world as far as I can at the service of the non-visible. . . .[102]

102 Odilon Redon, "Confidences d'artiste" [May, 1909], reprinted in *A soi-même: Journal (1867–1915)* (Paris: Librairie José Corti, 1961), pp. 9, 22, 27. Reprinted by permission of the publisher. Portions of the translation of this text were taken from "Odilon Redon: To Myself," *Portfolio*, No. 8 (Spring, 1964), pp. 104–106, trans. Richard Howard. Reprinted by permission of *Art News*.

The Sketch

MAY, 1868

A sketch that attempts to be a finished picture can never contain resources as lasting as those to be found in the fragmentary studies that have been made with no thought for order or final composition. When you are in need of reliable information in the studio, it is not the former, studied sketch that you will refer to. Whereas the simple sketch, made without preconceptions, with the simple desire to approach what you see as humbly as possible, will, on the contrary, remain a reliable document: fertile, inexhaustible, and never to be tired of. Corot said to me: "If you are not sure of something, then put something you are sure of beside it." And he showed me some pen drawings in which the leaves, in heavy clusters, were drawn almost as though they had been etched. And then he said to me: "Go paint every year in the same place; copy the same tree." [103]

The Artist and the Dilettante

[c. 1871]

What distinguishes the artist from the dilettante? Only the pain that the artist feels. The dilettante looks only for pleasure in art.[104]

Notes for a Lecture Delivered in Holland in 1913

I have examined the black passages in my work very closely, and it is above all in the lithographs that they attain their true brilliance; a brilliance without admixture; for the charcoal drawings I did before them and subsequently were always executed on pink, yellow, or sometimes blue tinted paper. The use of these papers indicates the attraction color had already begun to exert upon me, an attraction I was to surrender to entirely later on.

Black is the most essential color. It derives its exaltation and its life, undeniably, from the profound and secret sources of health. The mute, vital ardor produced by charcoal depends upon good diet and rest, or, to put it better, upon the fullness of physical strength. That is to say, it appears in its best and fullest beauty at the heart of our careers, be they short or long. It is exhausted later on, in old age, when nourishment is less well assimilated. You can always, at that point, spread black pigment on a surface, but the charcoal remains coal, the lithograph crayon conveys nothing; in a word, the medium remains in our eyes just what it seems: an inert, lifeless thing. Whereas, at the happy moment of propitious effervescence and strength, it is the very vitality of a

[103] Odilon Redon, Journal entry of May, 1868, cited in *Portfolio,* p. 107.
[104] Odilon Redon, Journal entry of about 1871, cited in *Portfolio, loc. cit.*

being that spurts forth from it, his energy, his thought, something of his soul, the reflection of sensitivity, a residue of his substance in some way.

Black must be treated with respect, for nothing can degrade it. It holds no charm for the eye and awakens no sensuality. Black, far more than all the resplendent colors of palette and prism, is the medium of the mind. Good engravings will always be more appreciated in serious countries where man is forced by the harshness of the climate to shut himself up at home and cultivate his own thoughts. In the lands of northern Europe, for instance, as opposed to the Mediterranean regions, where the sun takes us out of ourselves and enchants us. Engravings are very little appreciated in France, except when they are impoverished with color. But this gives a different result: it destroys the engraving and makes it more suitable for a child's picture book.[105]

The Intellectual Painter

MAY 14 [1888?]

A painter is not intellectual if he paints a nude woman that gives us the idea that she is just about to get dressed again.

The intellectual painter shows her in a nakedness that soothes us because she doesn't hide it; she permits herself to be that way, without shame, in an Eden, for glances which are not ours but those of a cerebral world, an imaginary world created by the painter, where stirs and flows that beauty which, incapable of giving rise to immodesty, on the contrary confers upon all nakedness a pure attraction that does not debase us. The naked women of Puvis de Chavannes never get dressed, nor do many others from the past, in the lovely women's quarters of Giorgione or Correggio. . . .

There is one woman, in Manet's *Déjeuner sur l'herbe,* who would hurry to get dressed after the nuisance of her discomfort on the cold grass, in the midst of those unidealistic gentlemen who surround her and chat with her. What are they saying? Nothing nice, I suspect.

As for painting substances, and nothing else, even very well, with virtuosity, one tastes the pleasure of it just as much in painting the dress as that which it hides. To paint a piece of cloth, material, is much more honest and purely decisive than to show us the nude for the nude's sake—that is to say, something human without any heroism.

When Michelangelo affirmed that it was silly to prefer a man's shoes to his feet, it was because he saw human nature at its very heart, in that vital and active center which stirred up those lobes with which he was excessively endowed, to create his style, his great style, the as-

[105] Odilon Redon, Notes for a lecture delivered in Holland on the occasion of an exhibition of his works, January, 1913, *A soi-même,* pp. 124–125. Portions of this translation were taken from *Portfolio,* p. 108.

cendance of which is a triumph of his own thought over ours. Beneath the closed eyelids of his slave, how much cerebral action is aroused! He sleeps, and the attentive thought going on beneath that marble forehead carries our own to a feeling, thinking world. The sleep of a slave awakens our dignity.[106]

GUSTAVE MOREAU: 1824–1898

Often dismissed as a literary eclectic and academician, Gustave Moreau was, more profoundly, a sensual visionary. His fantasies, arising from the decadent splendor of his imagination, were translated by his intellect into the equivalent forms of his paintings.

Moreau's success at the official Salons was due in part to the appeal of his subjects, drawn from classical, eastern, and Christian myth, but much more to his virtuosity in handling classic form and composition, and in enriching tradition with a dazzling plenitude of recherché detail. This approval culminated in Moreau's appointment as Chef d'Atelier at the Ecole des Beaux-Arts.

In the conception of his themes, Moreau revealed an artistic aim closely related to that of the Symbolist writers, Baudelaire, Mallarmé, and Huysmans: that is, the evocation through symbols of a transcendent experience in the realm of pure beauty. For Moreau, Beauty (with a capital "B") which, coldly unconscious of his aspiration, nevertheless seduces and destroys the artist, was symbolized by woman: Helen of Troy, Delilah, or Salome.

Moreau's Statements on Art

The following selections from Moreau's personal notebooks convey to the mind what his paintings evoke in the senses and in the imagination. He expresses his rejection of everyday reality and his faith in art as the means by which his passionate desire for the reality of a transcendent universe may be realized.

Oh noble poetry of living, impassioned silence! Oh beautiful art, mirror of physical beauties, which, beneath a material covering, reflects equally the great flights of the soul, the mind, the heart, and the imagination, and replies to these divine needs of human beings of all times!

It is the language of God! The day will come when the eloquence of this mute art will be understood; it is that eloquence whose character, nature, and power over the mind have not been definable, to which I

[106] Odilon Redon, Journal entry, May 14 [1888?], *A soi-même*, pp. 94–95.

have given all my attention, all my efforts; the evocation of thought by line, arabesque, and plastic means: this is my goal.

1897

I have suffered too much during my life from that unjust and absurd opinion that I am too literary for a painter. All that I write to you in my picture to please you does not need to be explained by words; the meaning of this painting, for one who can read a bit in plastic forms, is extremely clear and limpid. It is necessary only to love, to dream a bit, and not to content oneself in a work of imagination, under the pretext of simplicity, clarity, naïveté, with a disgusting a, e, i, o, u.[107]

I believe neither in what I touch nor what I see. I only believe in what I do not see, and solely in what I feel.

My brain, my reason, seem ephemeral to me, and of a questionable reality. My internal feeling alone seems eternal to me, and incontestably certain.

Photographic truth is merely a source of information.

I love my art so much that I will only be happy when I create it for myself alone.[108]

Joris-Karl Huysmans on the Art of Gustave Moreau

Joris-Karl Huysmans (1848–1907), although originally associated with the Naturalist literary circle around Zola, in his mature works drew his inspiration from Baudelaire and expounded an aesthetic mysticism fundamental to the Decadent movement. Although he lived quietly, employed as a clerk in the Ministry of the Interior, in his books Huysmans deals with the unexpected, the exotic, the rarefied emotional states of his own fantasies. While his deliberate perversity and elaborate prose style may put off modern readers, in his own day he was honored by the presidency of the Académie Goncourt and was made an Officer of the Legion of Honor.

An Appreciation of Moreau from "Certains"

In Certains (1889), a collection of critical essays, Huysmans reveals his sympathy with Moreau's art and his admiration for the painter's style. His excessively purple prose seems to be equalled by the pictorial style of his subject!

[107] Gustave Moreau, cited in Introduction to *Catalogue sommaire des peintures, dessins, cartons et aquarelles exposés dans les galeries du Musée Gustave Moreau* (Paris: L. Portail, 1926), n.p. Reprinted by permission of the Musée Gustave Moreau. These statements were probably drawn from one of the artist's unpublished notebooks.

[108] Gustave Moreau, cited without dates by Ragnar von Holten, *L'Art fantastique de Gustave Moreau* (Paris: Jean-Jacques Pauvert, 1960), p. 3. Reprinted by permission of the publisher.

Removed from the mob that pours out the spiritual ipecac of great art for us every Mary's month, M. Gustave Moreau has refrained from immobilizing canvases beneath the muslins that dry streaming, like miserable wall-hangings, in the windowed shed of the palace of Industry.[109]

He has abstained from fashionable exhibitions as well. The sight of his works, confined to a few dealers, is therefore rare; in 1886, however, a series of his watercolors was shown by the Goupils in their galleries on the Rue Chaptal.

There was an auto-da-fé of lofty skies aflame in the room that contained them; globes crushed by bleeding suns, hemorrhages of stars flowing in purple cataracts onto tumbled tufts of clouds.

Against these backgrounds of dreadful din, silent women passed, naked or decked out in fabrics mounted with cabochons like the old bindings of evangeliaries, women with floss-silk hair, with hard, staring pale blue eyes, with flesh of the icy whiteness of milt; motionless Salomes bearing in chalices the radiating head of the Precursor, macerated in phosphorus, beneath quincunxes with clipped leaves of an almost black green; goddesses riding hippogriffs and streaking the agony of the clouds with the lapis lazuli of their wings, feminine idols, with tiaras, standing on thrones with steps submerged in extraordinary flowers or seated in rigid poses on elephants with green-manteled foreheads, with breastpieces coped with orphrey,[110] seamed, like those of the cavalry, with little bells, with long pearls, elephants stamping upon their heavy images which a sheet of water, splashed by the columns of their ring-encircled legs, reflected.

An identical impression arose from these diverse scenes: the impression of spiritual onanism repeated in a chaste flesh; the impression of a virgin, provided in a body of a solemn grace, of a soul, exhausted by solitary ideas, by secret thoughts of a woman, seated within herself, and mumbling to herself in the sacramental formulas of obscure prayers, insidious appeals to sacrilege and debauchery, to tortures and murders.

Far from that room, in the dreary street, the dazzling memory of these works persisted, but the scenes no longer appeared in their totality; they disintegrated in memory into their indefatigable details, into their minutiae of strange accessories. The execution of those jewels with contours engraved in the watercolor as though with crushed pennibs, the delicacy of those plants with entangled stems, with stalks like the guipure of the surplices embroidered for prelates in former days, the upsurge of these flowers resembling in their forms religious silver work and water flora, water lilies and pyxidia, calyxes and algae, all that sur-

109 This sentence is almost incomprehensible in French, and therefore extremely difficult to translate.
110 Rich embroidery.

prising chemistry of shrill colors, brought to their highest pitch, goes to one's head and inebriates the sight, which staggers, stupefied, alongside the new houses without seeing them.

On reflection, while walking, observing, and seeing with an eye once more calm that scandal of modern taste—the street: those boulevards on which vegetate trees orthopedically corseted with steel and bandaged in cast-iron circlets by the Department of Roads and Bridges, those pavements shaken by enormous omnibuses and by ignoble rented carriages, those sidewalks filled with a hideous crowd in search of money, women degraded by childbirth, debased by frightful trades, men reading sordid newspapers or dreaming of fornications and deceits in front of shops where the licensed pirates of businesses and banks spy on them to rob them, one understands still better the work of Gustave Moreau, independent of any period, fleeing into the beyond, soaring into dream, far from the excremental ideas secreted by a whole people.[111]

Descriptions of Moreau's Paintings from "A Rebours"

In the novel A Rebours *(Against the Grain or Against Nature, 1884), the hero Des Esseintes, who is a projection of Huysmans himself, finds in Gustave Moreau the expression of his own desires and dreams. The paintings discussed are the* Salome *of 1876 in the Huntington Hartford Collection, New York, and* The Apparition *painted in the same year, in the Lehmann Collection, New York.*

Of all others there was one artist who most ravished him [Des Esseintes] with unceasing transports of pleasure—Gustave Moreau.

He had purchased his two masterpieces and night after night he would stand dreaming in front of one of these, a picture of Salome. . . .

Her face wore a thoughtful, solemn, almost reverent expression as she began the wanton dance that was to rouse the dormant passions of the old Herod; her bosoms quiver and, touched lightly by her swaying necklets, their rosy points stand pouting; on the moist skin of her body glitter clustered diamonds; from bracelets, belts, rings, dart sparks of fire; over her robe of triumph, bestrewn with pearls, broidered with silver, studded with gold, a corselet of chased goldsmith's work, each mesh of which is a precious stone, seems ablaze with coiling fiery serpents, crawling and creeping over the pink flesh like gleaming insects with dazzling wings of brilliant colors, scarlet with bands of yellow like the dawn, with patterned diapering like the blue of steel, with stripes of peacock green. . . .

In the work of Gustave Moreau, going for its conception alto-

111 J.-K. Huysmans, "Gustave Moreau," *Certains* (Paris: Tresse & Stock, 1899), pp. 17–20.

gether beyond the meager facts supplied by the New Testament, Des Esseintes saw realized at last the Salome, weird and superhuman, he had dreamed of. No longer was she merely the dancing-girl who exhorts a cry of lust and concupiscence from an old man by the lascivious contortions of her body; who breaks the will, masters the mind of a king by the spectacle of her quivering bosoms, heaving belly, and tossing thighs; she was now revealed in a sense as the symbolic incarnation of the world-old Vice, the goddess of immortal Hysteria, the Curse of Beauty supreme above all other beauties by the cataleptic spasm that stirs her flesh and steels her muscles—a monstrous Beast of the Apocalypse, indifferent, irresponsible, insensible, poisoning, like Helen of Troy of the old Classic fables, all who come near her, all who see her, all who touch her. . . .

Moreover, the painter seemed to have wished to mark his deliberate purpose to keep outside centuries of history; to give no definite indication of race or country or period, setting as he does his Salome in the midst of this strange Palace with its confused architecture of a grandiose complexity; clothing her in sumptuous, fantastic robes, crowning her with a diadem of no land or time shaped like a Phoenician tower such as Salammbô [112] wears, putting in her hand the scepter of Isis, the sacred flower of Egypt and of India, the great lotus blossom. . . . An irresistible fascination breathed from the canvas; but the water color entitled "The Apparition" was perhaps even yet more troubling to the senses. . . . Like the old king, Des Esseintes was overwhelmed, overmastered, dizzied before this figure of the dancing-girl, less majestic, less imposing, but more ensnaring to the senses than the Salome of the oil painting. . . .

As Des Esseintes used to maintain: never before at any epoch had the art of water color succeeded in reaching such brilliancy of tint; never had the poverty of chemical pigments been able thus to set down on paper such coruscating splendors of precious stones, such glowing hues as of painted windows illuminated by the noonday sun, glories so amazing, so dazzling of rich garments and glowing flesh tints.

And, falling into a reverie, he would ask himself what were the origin and antecedents of the great painter, the mystic, the Pagan, the man of genius who could live so remote from the outside world as to behold, here and now in Paris, the splendid cruel visions, the magic apotheoses of other ages.

Who had been his predecessors? This Des Esseintes found it hard to say; here and there, he seemed influenced by vague recollections of Mantegna and Jacopo de'Barbari; [113] here and there, by confused memo-

112 Heroine of the novel by that name, by Flaubert.
113 Jacopo de'Barbari (c. 1440-50–1515), Italian artist, known primarily for his engravings, which influenced those of Dürer.

ries of Da Vinci and the feverish coloring of Delacroix. But in the main, the effect produced by these masters' work on his own was imperceptible; the real truth was that Gustave Moreau was a pupil of no man. Without provable ancestors, without possible descendants, he remained, in contemporary art, a unique figure. Going back to the ethnographic sources of the nations, to the first origins of the mythologies whose bloodstained enigmas he compared and unriddled, reuniting, combining in one the legends derived from the Far East and metamorphosed by the beliefs of other peoples, he thus justified his architectonic combinations, his sumptuous and unexpected amalgamations of costume, his hieratic and sinister allegories, made yet more poignant by the restless apperceptions of a nervous system altogether modern in its morbid sensitiveness; but his work was always painful, haunted by the symbols of superhuman loves and superhuman vices, divine abominations committed without enthusiasm and without hope.

There breathed from his pictures, so despairing and so erudite, a strange magic, a sorcery that moved you to the bottom of the soul, like that of certain of Baudelaire's poems, and you were left amazed, pensive, disconcerted by this art that crossed the last frontier-lines of painting, borrowing from literature its most subtle suggestions, from the art of the enameler its most marvelous effects of brilliancy, from the art of the lapidary and the engraver its most exquisite delicacies of touch. These two images of Salome, for which Des Esseintes' admiration was boundless, were living things before his eyes where they hung on the walls of his working study on special panels reserved for them among the shelves of books.[114]

EDVARD MUNCH: 1863–1944

The long career of Edvard Munch, like those of many of the painters coming into artistic maturity in the 1880s and 1890s, is marked by a ceaseless effort to work out suitable pictorial equivalents for intense emotions or obsessive ideas.

Although he was born in Norway and lived there most of his life, the decisive influences on Munch's artistic evolution were those he received in Paris, where he lived and worked intermittently from 1885 until the early years of the 20th century, and, slightly later, those received from Berlin. Melancholy, introverted, and pessimistic by nature, Munch soon found naturalism and the freer, more colorful innovations of the Impressionists, which had overwhelmed him during his first trip to Paris in 1885, inadequate for the expression of his inner vision.

114 J.-K. Huysmans, *A Rebours* (*Against the Grain*), trans. P. G. Lloyd [?] (London: The Fortune Press [1946]), pp. 58–63.

Drawing on the expressive pictorial discoveries of such artists as van Gogh, with his violently subjective perspective and distortions of form, and upon the evocative simplifications, two-dimensionality, and non-naturalistic color schemes of Gauguin and the Synthetists, Munch created a vivid pictorial counterpart for his own brooding sense of the essentially dark, tragic quality of the human situation, close in many ways to that of his fellow Scandinavians, Ibsen and Strindberg.

Munch's most significant works are chiefly those produced in the decade of the nineties, whose very titles proclaim their symbolic intentions and Symbolist proclivities: The Shriek, Anxiety, The Kiss, Mystic Shore, Starry Night, The Vampire, Jealousy, The Death Bed, The Dance of Life, *etc. In their intensifications of two-dimensional surface pattern and abstract, sinuous, linear contour, these paintings, as well as their extremely successful graphic counterparts—for Munch, primarily under the stimulus of Gauguin's woodcuts of the nineties, was prolific and original as a graphic artist, exploiting the potentialities of each of his media to its fullest advantage—may be seen as part of the* fin de siècle *current known as* art nouveau *or* Jugendstil.

Munch's epic aspirations are embodied in his project for the Frieze of Life, *conceived as a vast cycle of paintings to deal with "the modern life of the soul" in all its contradictory aspects: the relation between man and woman, seen both as madonna and vampire; the genesis and freedom of life and the anguish and sorrow of death; loneliness, anxiety, jealousy, and melancholy; nature as fruitful and productive and yet capable of inducing that state of unfathomable terror embodied in the shrill colors and distorted contours of* The Shriek. *Many of Munch's paintings of the nineties, in which the artist crystallized his own memories, emotions, and attitudes into more universal symbolic expressions, were actually intended for the* Frieze of Life, *which was never completed (in part, one suspects, due to the inherent inexhaustibility of the theme itself). Although incomplete, it was nevertheless partially exhibited a number of times, twenty-two pictures from the cycle being shown at the Berlin Secession of 1902 and a group again exhibited at Blomqvist's gallery in Oslo in 1903, 1904, and 1918.*

Munch on the Genesis of the "Frieze of Life"

In these notes, probably written in conjunction with the 1918 Exhibition in Oslo, the artist recalls the origins of his life's work, presumably at St. Cloud in 1889, as well as its subsequent evolution.

St. Cloud 1889

Spanish Dancer—1 Franc—I go in.

There was a long hall with galleries on both sides—under the galleries people were sitting at round tables. —In the middle they were

standing about—bowler hat to bowler hat—with a few women's hats in between!

At the far end, above the bowler hats, a little lady in lilac-colored tights was dancing on a rope—amid the air filled with blue-grey tobacco smoke.—

I strolled in. I looked round for a pretty girl's face—no—yes, here was one that didn't look bad.—

When she noticed me looking at her, it was as though a mask was pulled over her face, and she stared into the air; I found a chair—and dropped slackly and wearily into it.

People clapped—the lilac-colored dancer bowed with a smile and disappeared.—

Singers from Rumania came on. —It was love and hate, longing and reconciliation—and beautiful dreams—and the soft music fused with the colors. All these colors—the scenery with the green palms and the blue-grey water—the strong colors in the clothes of the Rumanians —in the blue-grey haze.

The music and the colors caught my thoughts. They followed the light clouds and were carried by the soft notes into a world filled with gay, light dreams.—

I had the need to do something—I felt it would go so easily—it would take shape under my hands as though by magic.—

Thus they would get to see it.

A strong, bare arm—a brown powerful neck—a young woman lays her head against the arched chest.

I should like to depict this as I saw it now, but in a blue haze.—

These two at the moment in which they are not themselves, but only a link in the chain of a thousand generations.—

People would understand the sanctity, the grandeur of the theme and would take off their hats as they do in church.—

I should like to paint a series of such pictures. —We should stop painting interiors with people reading and women knitting. We should paint living people who breathe and feel and suffer and love.

I felt I should manage this—it would be so easy! —The flesh would take shape and the colors would live.—

Then came an interval, the music fell silent.

I was a little sad.

I remembered how often I had felt the same sort of thing before —and when I had finished the picture people shook their heads and smiled.

I was outside again in the blue "Boulevard des Italiens"—with the bright electric lamps and the dim gas lanterns—with the thousand strange faces glowing wraithlike in the electric light.

In the following three years I gathered together several drafts and pictures for a frieze, which was exhibited for the first time in Berlin in

1893. They were the pictures: *Scream, Kiss, Vampire, Loving Women,* and so on.

This was in the time of Realism and Impressionism.—

I was either in a state of morbid emotional excitement or in a joyful mood when I came across a landscape that I felt like painting. I would fetch my easel—set it up and paint the picture from nature.—

It would turn out to be a good picture—but not the picture I had wanted to paint. —I couldn't paint it as I had seen it in my morbid or joyful mood.—

This happened often. —In such cases I used to scratch out what I had painted—I searched in my memory for the first picture—the first impression—and tried to find it again.

When I first saw the sick child [115]—the pale face with the deep red hair against the white pillow—I received an impression that vanished while I was working. I set down a good but different picture on the canvas. —I painted the picture several times in the course of a year—scratched it out again—ran the colors into one another—and tried again and again to capture my first impression—the transparent, pale skin—the quivering mouth—the trembling hands.—

I had painted the chair with the glass too exactly; it distracted attention from the head. —When I looked at the picture I saw only the glass and the surroundings. —Should I remove the whole thing? —No, it helped to give the head depth and make it stand out. —I scratched the surroundings half out and left everything present in moderation—one saw the head and the glass.

Further I discovered that my own eyelashes had contributed to the pictorial impression. —I therefore indicated them as a shadow over the picture. —The head became the picture so to speak. —Wavy lines came into being in the picture—peripheries—with the head as a central point. —I later used these wavy lines frequently.

At last I stopped exhausted. —I had largely achieved the original impression, the quivering mouth—the transparent skin—the tired eyes. But the picture was not finished as to color—it was too pale and grey. Consequently the whole thing looked as heavy as lead.—

I resumed work on this picture in the course of 1895 and 1906—it now gained more of the strong color I wished to give it. —I painted three different versions. —They are all dissimilar and each one in its own way represents a contribution toward portraying what I felt at the first impression. . . .

[115] *The Sick Child,* a theme to which Munch returned many times during his career and which he treated in drypoint and color lithography as well as in oil. The earliest painted version dates from 1885–1886; the latest from 1926; the graphic works are from the nineties.

One evening I was walking along a path—on one side lay the city and below me the fjord.

I was tired and ill—I stopped and looked out across the fjord—the sun was setting—the clouds were dyed red like blood.

I felt a scream pass through nature; it seemed to me that I could hear the scream.

I painted this picture—painted the clouds as real blood. —The colors were screaming.—

This became the picture *The Scream* from the *Frieze of Life*.

When a military band came down Karl-Johann Street one sunlit spring day, my mind was filled with festival—spring—light—music—till it became a trembling joy—the music painted the colors.—

I painted the picture and made the colors tremble in the rhythm of the music. —I painted the colors that I saw.[116]

I painted picture after picture after the impressions that my eye took in at moments of emotion—painted lines and colors that showed themselves on my inner eye—on the retina. —I painted only the memories, without adding anything—without details that I could no longer see. —Hence the simplicity of the pictures—the apparent emptiness.—

I painted impressions from my childhood—the blurred colors of days gone by.

By painting colors and lines and shapes that I had seen in an emotional mood, I wanted to make the emotional mood ring out again as happens on a gramophone.

This is how the pictures of the *Frieze of Life* came into being.[117]

From a Brochure on the "Frieze of Life," Oslo, 1918

I have been working on this frieze, with long intervals, for close on thirty years. The first rough drafts date back to 1888–1889. *The Kiss,* the so-called *Yellow Boat, The Riddle, Man and Woman,* and *Fear* were painted between 1890 and 1891, first shown in the Tostrupgården, here in this city, and later the same year in my first exhibition in Berlin. The following year fresh works were added to the series, including *Vampire, The Scream,* and *Madonna,* and it was exhibited as an independent Frieze in a private gallery on the Unter den Linden, Berlin. In 1902 some of these pictures were placed on view in the Berlin Secession as a continuous frieze on the walls of the great entrance hall—under the title *From the Modern Life of the Soul.* Finally the Frieze was exhibited in 1903 and 1904 at Blomqvist's.

Certain art critics have sought to prove that the intellectual con-

116 *Military Band on Karl-Johann Street, Oslo,* 1889.

117 Edvard Munch, in John H. Langaard and Reidar Revold, *Edvard Munch* (New York: McGraw-Hill Book Company, 1964), pp. 49–51, 53. Reprinted by permission of the publisher.

tent of this Frieze was influenced by German ideas and my contact with Strindberg in Berlin; I trust that the foregoing comments will suffice to refute this assertion.

The themes and moods of the various panels sprang directly from the controversies of the eighties and constitute a reaction against the Realism then prevalent.

The Frieze is conceived as a series of decorative pictures which will collectively present a picture of life. They are traversed by the curved shoreline; beyond lies the ever-moving sea, and under the treetops is life in all its fullness, its variety, its joys, and its sufferings.

The Frieze is a poem on life, love, and death. The theme of the largest picture, *Man and Woman in the Forest,*[118] showing the two figures, perhaps stands somewhat apart from the others, but it is as necessary to the Frieze as a whole as the buckle is to the belt. It is a picture of life as of death; of the forest, that sucks its nourishment from the dead; of the city that rises beyond the treetops. It is a portrayal of the powerful forces that support our lives.

As I have already mentioned, the impulse to paint most of these pictures came to me already in my early youth. The project took such a grip on me that it never let me go, although I received no further incentive from outside to continue this work; much less was I influenced by anyone who might have had an interest in seeing the whole group of pictures gathered in one room. Hence, in the course of the years many pictures from the cycle have been sold separately, among them *Ashes, Dance of Life, Scream, Sickroom,* and *Madonna;* the pictures on the same themes exhibited here are later copies. I always held the view that the Frieze should be housed in a room that would provide a suitable architectural frame, so that each picture could stand out individually without detracting from the whole; but unfortunately up to the present no one has been interested in bringing this plan to fruition. . . .

The Frieze cannot be regarded as a single, coherent work, since I have worked on it with long intervals. Because of the long period of time involved it was, of course, impossible to employ the same technique all through. I look upon many of the pictures as studies; it was my intention to carry out the whole project as a unit, as soon as the right room for the purpose was available.

I am exhibiting the Frieze afresh, firstly, because I consider it too good to be forgotten, and secondly, because it has meant so much to me artistically all these years that I myself should like to see it as a collection.[119]

[118] Also known as *Two People* or *The Circulation of Matter,* 1899.
[119] Edvard Munch, in Langaard and Revold, *Edvard Munch,* pp. 56–57.

Art and Nature

Art is the antithesis of nature.

A work of art can only come from within a man.

Art is the form of the picture that has come into being through the nerves—heart—brain, and eye of man.

Art is man's urge to crystallization.

Nature is the single, great realm upon which art feeds.

Nature is not only that which is visible to the eye—it also presents the inner pictures of the soul—the pictures on the reverse side of the eye.—[120]

JAMES ENSOR: 1860–1949

Although James Ensor continued painting well into the 20th century, he must be considered within the context of the 19th, for he created his most significant works between about 1880 and 1900. Born in the Belgian seaside resort of Ostend, for Ensor the impressions of the ocean, of the exotic curio and souvenir shops, and above all, of the wild and colorful carnival that took place each year in his native city, were important elements in his mature artistic vision. After a period of study at the Brussels Academy (1877–1880), he settled down in Ostend, where, in a garret-studio over his parents' home, he created his major works, escaping only intermittently to Brussels, where he found encouragement from a small group of sympathetic friends, and where, in 1883, he became a founding member of the Belgian avant-garde group, Les XX (The Twenty), with whom he exhibited until the circle dissolved in 1893. Yet even Les XX found many of his works needlessly shocking, and forced Ensor to withdraw them from their exhibitions.

Beginning as a painter of richly impastoed, rather dark toned and evocative interiors, genre scenes, and still lifes, in about 1885 Ensor turned to the bizarre, fantastic, and disquieting themes, the brilliantly colored palette, and free, inventive compositions which characterize his best known works. Constantly reviled by scandalized and unfriendly critics in the Belgian press, Ensor created such original and personally motivated works (often, although not always, inspired by his own sense of persecution) as The Entry of Christ into Brussels, The Tribulations of St. Anthony, Skeletons Trying to Warm Themselves, Masks Confronting Death, *and* Portrait of the Artist Surrounded by Masks; *in addition,*

120 Edvard Munch, *Ibid.*, p. 62.

Ensor was extremely productive in the field of etching, where his bizarre wit and trenchant sense of ironic detail often anticipate similar qualities in the work of Paul Klee.

Constantly changing his style, obsessed with the idea of masks and disguises, creating a half-terrifying, half-humorous world of hypocrisy and weakness, haunted by the ever-present specter of death—he even went so far as to etch his own portrait as he would appear in 1960—Ensor, in his macabre but poetic productions, at his best, creates a sense of anguish anticipating that image of alienated man alone in an absurd and disquieting universe, later projected by writers like Kafka, Beckett, and Sartre. In their formal and imaginative freedom these works look forward to the achievements of such avant-garde art movements of the 20th century as Expressionism, Surrealism, and their variants.

Original in his writing as well as in his art, Ensor, like the Symbolists, and above all, Rimbaud, saw vivid and often fantastic "correspondences" in words: ". . . I adore you, words who are sensitive to our sufferings, words in red and lemon yellow, words in the steel-blue color of certain insects, words with the scent of vibrant silk. . . ." [121]

Three Weeks at the Academy: Episodic Monologue

Written in 1884, the year in which the Brussels Salon rejected all the artist's paintings, Ensor's first prose work, "Three Weeks at the Academy," was published in L'Art moderne, *the literary organ of Les XX. A devastating parody of the instruction he received at the Academy, written in a witty, punning French that defies literal translation, the little play, like so many of Ensor's works, is based on personal experience. At the Brussels Academy he had indeed been forced to work with three dissimilar teachers: Joseph Stallaert, a romantic; Jef van Severdonck, a painter of military scenes; and Alexander Robert, a historical painter. The "future member of Les XX," their silent victim, is of course Ensor himself.*

Three Weeks at the Academy

Episodic Monologue

The scene is the painting classroom.

Characters:

Three Teachers
The Head of the Academy
A Classroom Attendant

[121] James Ensor, cited by Paul Haesaerts, *James Ensor* (New York: Harry N. Abrams, Inc., 1959), p. 194. Reprinted by permission of the publisher, Harry N. Abrams, Inc.

Silent Character:

A FUTURE MEMBER OF LES XX.

NOTE: The authenticity of the small talk that follows is guaranteed.

FIRST WEEK

Professor Pielsticker: You are a colorist, Monsieur, but ninety painters out of a hundred are.

Your Flemishness is always coming out, no matter what you do. I find the French artists very good; at an exhibition you can tell them at once from their neighbors. They are very strong in composition.

It's wrong to think that the teacher spoils a sketch when he corrects it. When I was your age I thought so too, but now I see that my teacher was right.

You're not making progress! This isn't rounded at all!

(Showing a sketch by another pupil.) Now, here's one who is going places! Unfortunately, he is too lazy.

You're already trying to render the atmosphere instead of waiting till your drawing is good enough.

Remember, you still have two semesters of classical art! After that you'll have plenty of time for atmosphere, color, and the rest.

You don't want to learn! To paint like that is positively mad, wicked!

I *cannot help* complimenting you on your drawing; but why do you have to make drawings against the Academy?

SECOND WEEK

Professor Slimmervogel: You've done your background instead of the figure; it's not difficult to do a background.

You do the opposite of what you're told. Instead of beginning with your strong accents, you begin with the light ones. How can you judge the whole? You must do your strong accents with black vine and burnt Sienna.

There's something funny going on here; never before have I seen a painting class like the one this year. I'd be ashamed if a stranger came in.

I don't see anything in this. There is color, but that's not enough. It lacks strengh. You're putting the paint on too thick. You seem to be looking for something all right. But you've looked enough now.

Was it Mr. Pielsticker who corrected your sketch? But it isn't his week. How annoying!

THIRD WEEK

Professor Van Mollekot: What's that? It's much too brown, you know! Was it Slimmervogel who corrected you?

You started out so well. Your drawing is so good. But you ruin everything you do.

Believe me, I'm telling you this for your own good. Put your sketch next to the model. You're afraid to paint. You must paint with flat brushes, lay it on thick, but you mustn't keep working it over. You're not putting it on thick enough. I know you know how to do it, but you have to show it to other people. You're doing a landscape? You're wasting your time on landscape!

The Head: But you're making your drawing as you go along! Bad! Bad! You're going to drown in all that paint. It's feeling that ruins you, and you're not the only one. Last week you made a good drawing, but now it's the same thing all over again. Do you have trouble with your eyes by any chance? A sculptor would be quite at a loss if he had to make something from your drawing.

Was it Mr. Slimmervogel who retouched this?

The Classroom Attendant: Mr. Pielsticker and the Head are very angry at you for what you submitted in the painting competition. If you'll promise me that you'll do another subject, I'll speak to the Head, and you can join the nature class.

MORAL: The pupil quits the Academy and becomes a *vingtiste*.

FURTHER MORAL: The Salon rejects his paintings.[122]

Reflections on Art

As an art critic, Ensor was violently anti-rationalistic, proclaiming reason the enemy of art: "All rules, all canons of art belch death." [123] *His aesthetic pronouncements, strongly tinged with irony, are trenchant and often disturbingly outspoken. Above all, he insists on the right of the artist to change, to vary, to modify previous positions and attitudes on the basis of new experience. In the words of one critic, "he did not merely 'individualize' himself, he 'momentarized' himself."* [124]

Artistic Vision

1882

Vision is modified by observing. The first vision, that of the vulgar, is the simple line, dry without any effort for color. The second period is that when the more practiced eye discerns the values of tones and their delicacies; this is already less understood by the vulgar. The last is that where the artist sees the subtleties and the multiple plays of

122 James Ensor, "Three Weeks at the Academy: Episodic Monologue" (1884), in Haesaerts, *James Ensor,* pp. 355–356.
123 James Ensor, cited by Haesaerts, *James Ensor,* p. 226.
124 Paul Haesaerts, *loc. cit.*

light, its planes, its gravitations. These progressive efforts modify the primitive vision and line suffers and becomes secondary. This vision will be little understood. It demands a long observation, an attentive study. The vulgar will only discern disorder, chaos, lack of correctness. And thus art has evolved from Gothic contour through the color and movement of the Renaissance to arrive at modern light! [125]

Condemnation of the Pointillists: 1911

Let us condemn the dry and repugnant procedures of the Pointillists, already dead to light and to art. They apply their polka dots coldly, methodically, and unfeelingly within their chilly, correct outlines, achieving only one of the qualities of light, vibration, without succeeding in presenting its form. This overcontrolled procedure, moreover, prevents any further research. Art of cold calculation and narrow vision, how far you are already outdistanced in vibration!

Oh triumph! the field of observation becomes infinite, and liberated vision, sensitive to the beautiful, will always modify itself and discern with the same acuteness the effects or outlines where form or light dominate.

Wide-ranging efforts will always seem contradictory. The narrow-minded demand that you perpetually begin all over again; they want identical continuations. The painter must repeat his little works and condemn everything beyond them. That is the opinion of certain tag-hanging censors, who classify our artists like oysters in their beds. Ah, how advantageous odious pettiness is to the hack workers of art! [126]

[125] James Ensor, "Réflexions sur l'art" (1882), originally published in "Album de *La Plume*," 1899, and republished in *Les Ecrits de James Ensor* (Brussels: Editions "Sélection," 1921), p. 95.

[126] James Ensor, from "Réflexions sur quelques peintres et lanceurs d'éphemères," originally published in *Pourquoi Pas?* December 21, 1911, republished in *Les Ecrits de James Ensor*, pp. 23–24.

Index